BIOART AND THE VITALITY OF MEDIA

Robert Mitchell

UNIVERSITY OF WASHINGTON PRESS

Seattle and London

© 2010 by the University of Washington Press
Printed in the United States of America
Design by Thomas Eykemans
13 12 11 10 5 4 3 2 1

UNIVERSITY OF WASHINGTON PRESS
PO Box 50096, Seattle, WA 98145, USA
www.washington.edu/uwpress

LIBRARY OF CONGRESS CATALOGING-IN-PUBLICATION DATA
Mitchell, Robert, 1969–
Bioart and the vitality of media / Robert Mitchell.
 p. cm. — (In vivo)
Includes bibliographical references and index.
ISBN 978-0-295-99007-1 (hardback : alk. paper)
ISBN 978-0-295-99008-8 (pbk. : alk. paper)
1. Biotechnology in art. I. Title.
N72.B56M58 2010
701'.05—dc22 2009043907

The paper used in this publication is acid-free and 90 percent recycled from at least 50 percent post-consumer waste. It meets the minimum requirements of American National Standard for Information Sciences—Permanence of Paper for Printed Library Materials, ANSI z39.48-1984.

IN VIVO

The Cultural Mediations of Biomedical Science

PHILLIP THURTLE and ROBERT MITCHELL, Series Editors

IN VIVO: THE CULTURAL MEDIATIONS OF BIOMEDICAL SCIENCE is dedicated to the interdisciplinary study of the medical and life sciences, with a focus on the scientific and cultural practices used to process data, model knowledge, and communicate about biomedical science. Through historical, artistic, media, social, and literary analysis, books in the series seek to understand and explain the key conceptual issues that animate and inform biomedical developments.

The Transparent Body: A Cultural Analysis of Medical Imaging
by José Van Dijck

Generating Bodies and Gendered Selves:
The Rhetoric of Reproduction in Early Modern England
by Eve Keller

The Emergence of Genetic Rationality: Space, Time,
and Information in American Biological Science, 1870–1920
by Phillip Thurtle

Bits of Life: Feminist Studies of Media, Biocultures, and Technoscience
edited by Anneke Smelik and Nina Lykke

HIV Interventions: Biomedicine and the Traffic between Information and Flesh
by Marsha Rosengarten

Bioart and the Vitality of Media
by Robert Mitchell

Contents

Acknowledgments

DESPITE THE BREVITY OF THIS BOOK, I HAVE NEVERTHELESS ACCU-
mulated many debts while writing it. I extend my thanks to all the
artists whose work is reproduced in this book, but I owe special thanks to
Beatriz da Costa, davidkremers, Natalie Jeremijenko, Eduardo Kac, Marta
Lyall, and Marta de Menezes, who generously gave of their time to talk with
me about their own, and other, bioart projects. I also want to thank Robin
Held and Jens Hauser, who illuminated for me some of the intricacies of
curating bioart in a gallery context, and Richard Lewontin, who helped me
track down the original image of the *Achillea* clones reproduced in Figure 1.6.
And I owe a debt to Mark Poster, for whom I wrote—now quite a long time
ago—a graduate seminar paper in which I speculated about what it might
mean to write history from a Deleuzean/Guattarian perspective. This is a
question that has remained with me ever since, and it is one to which I hope
to have developed at least a partial answer here.

Many people have helped me think about bioart and related topics, and I
especially want to thank Helen Burgess, Sarah and Thomas Clark, Shannon
Callies, Jane Gaines, Eric Garberson, Orit Halpern, Jens Hauser, Mignon
Keaton, Lisa Lynch, Robert Markley, Richard Shiff, Kristine Stiles, Eugene
Thacker, Phillip Thurtle, Alys Weinbaum, and Marek Wieczorek. My thanks
as well go to Tim Lenoir and Priscilla Wald for organizing a yearlong "Inter-
face" John Hope Franklin Humanities Institute seminar and Sawyer sym-
posium at Duke University, at which I presented early versions of parts of
this book, and to all the members of the University of California Humani-
ties Research Institute Speculative Globalities group (Aimee Bahng, Cesare
Casarino, Bishnupriya Ghosh, Colin Milburn, Geeta Patel, Kavita Philip,
Rita Raley, Bhaskar Sarkar, and Sudipta Sen), as well as Kavita Philip and
Stefka Hristova, who provided invaluable feedback on versions of two of the
chapters. I am also grateful for the support of the following Duke University

people and institutions: Srinivas Aravamudan and Grant Samuelsen at the John Hope Franklin Humanities Institute; Bob Cook-Deegan and Lauren Dame at the Center for Genome Ethics, Law, and Policy; and Hunt Willard at the Institute for Genomics, Society, and Policy. I also gratefully acknowledge the support of the National Human Genome Research Institute and the Department of Energy (CEER Grant P50 HG003391, Duke University, Center of Excellence for ELSI Research).

I want to extend my sincere thanks to all of those at, and associated with, the University of Washington Press. Jacqueline Ettinger once again has been the model of a patient and helpful editor. I am also extremely grateful for the comments provided by the two anonymous readers for the University of Washington Press, though I especially want to thank Cary Wolfe—one of those readers, who subsequently allowed the Press to pass on to me his identity—for his exceptionally incisive, extended, and critical comments on the middle section of this book. Cary of course bears no responsibility for any of the weaknesses of this book, but his comments have helped to make it better. And I want to extend an especially heartfelt thank you to Jenny Rhee, who tirelessly—yet always cheerfully!—helped me track down references, images, and typos, and to Pamela J. Bruton, who did a fabulous job of copyediting.

Finally, I want to thank Inga Pollmann, who not only suffered through numerous readings of, and discussions about, each of the chapters of this book but who also has been a constant source of inspiration and love for me.

BIOART AND
THE VITALITY
OF MEDIA

INTRODUCTION
Living Art

Instead of finding ways to represent and distill life using paint or marble or pixels, the artists use life itself—bacteria, cell lines, plants, insects and even animals—as the medium to ask the questions that art has always asked. In ways that art has not been in a long time, the work can feel genuinely subversive, even dangerous.

I T'S ALIVE! THAT, AT ANY RATE, IS THE PROMISE—OR THREAT, DEPEND- ing on one's perspective—of a new mode of art that goes by a number of related names, such as "bioart," "biotech art," "life art," "genetic art," and "transgenic art."[1] The subject of several recent exhibitions and a respectable handful of journalistic and academic articles, bioart projects frequently place living beings—for example, microorganisms such as *E. coli* or tissue cultures drawn from larger organisms—in the space of the art gallery. For her artwork *Nature?* (1998), for example, Marta de Menezes collaborated with a Dutch biology laboratory, and—using the same techniques of cauterization that the scientists employed to study developmental processes of butterflies—produced living butterflies with asymmetrical wing patterns, which she exhibited in an enclosed greenhouse at the Ars Electronica 2000 Next Sex exhibition in Linz, Austria (figs. 1.1 and 1.2).[2] In *Disembodied Cuisine* (2001–2), the Tissue Culture and Art Project—a collective of artists based in Australia—drew on existing techniques of biological tissue culture in order to grow frog muscle cells around a biopolymer template in the form of a steak, creating what the group describes as a "semi-living" object. The frog steak was exhibited at L'art biotech, an exhibition held in March 2003 at Le

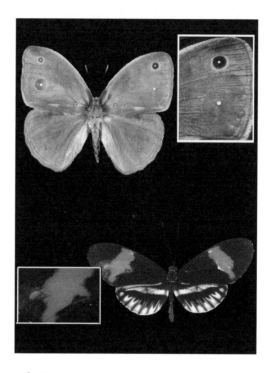

FIGURE I.1 Marta de Menezes (Portuguese, 1975–), *Nature?* (1998). Close-up of butterflies (*Bicyclus anynana*) with asymmetrical wing markings. The wing patterns of these butterflies were modified in the laboratory of Professor Paul Brakefield, Leiden University, the Netherlands (1999–2007). Collection of Museo Extremeño de Arte Contemporáneo, Spain. Image courtesy of the artist.

Lieu Unique in Nantes, France, and near the end of the show, the Tissue Culture and Art Project hosted a collective meal at which the frog steak was flambéed and eaten (figs. 1.3 and 1.4).

As both *Nature?* and *Disembodied Cuisine* highlight, bioart generally involves the artistic use of biotechnology, as bioartists employ biological laboratory techniques and technologies both to create their living works of art and to keep these entities alive in the space of an art gallery. What distinguishes bioart from other forms of art, in fact, is its claim to employ bioengineered life as an artistic medium. Whereas earlier forms of art employed media such as oil and acrylic paint, gelatin silver prints (i.e., photographs), stone, or steel, bioartworks employ media such as the bacterium *E. coli* tb-1

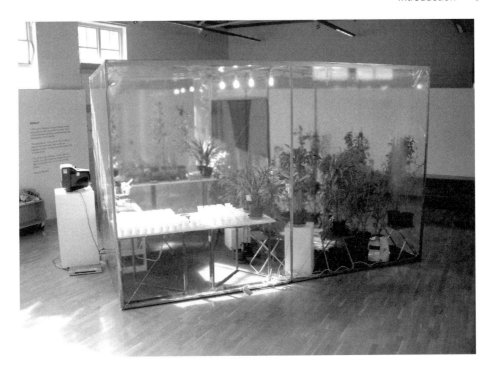

FIGURE I.2 Marta de Menezes (Portuguese, 1975–), *Nature?* (1998). The altered but-
terflies live in the greenhouse environment in the center of the gallery space. The
wing patterns of these butterflies were modified in the laboratory of Professor Paul
Brakefield, Leiden University, the Netherlands (1999–2007). Collection of Museo
Extremeño de Arte Contemporáneo, Spain. Image courtesy of the artist.

(as well as a biological medium, such as agar, which keeps the bacteria alive,
and chemicals such as x-gal and iptg, which interact with the *E. coli*), cloned
trees (as well as the soil necessary to sustain them), or the "artist's body
tissue, rat aortic smooth muscle cells, bovine cellular matrix, [and] cell
media."[3] Though bioart thus in a sense partakes of a more general contem-
porary trend toward "multimedia" installation art, it nevertheless employs
multiple media and installations primarily for the sake of integrating living
cells or tissues into a work of art.

Bioart by no means represents the first instance in which artists have bor-
rowed techniques and materials from new forms of science and technology
(one could probably make the argument, in fact, that historically artists have

FIGURE I.3 The Tissue Culture and Art Project, *"Tissue Engineered Steak No. 1" 2000,*
a study for *Disembodied Cuisine* (2000–2003). "Pure natal sheep skeletal muscle cells
cultured onto/into a degradable polymer (PGA) scaffold to create the semi living
steak." Produced as part of Oron Catts's and Ionat Zurr's Research Fellowship in
Tissue Engineering and Organ Fabrication, Massachusetts General Hospital, Har-
vard Medical School. Image courtesy of The Tissue Culture and Art Project. Photo:
Oron Catts and Ionat Zurr.

often been among the first to exploit the capacities of new technologies and
the implications of new forms of science). However, for many advocates and
critics of bioart, the use of bioengineered living beings as an artistic medium
seems to cross a technical or moral threshold (or both). Advocates often sug-
gest that bioart creates "unprecedented possibilities for art," for even if it may
seem simply to represent "a logical next step in contemporary art, which has
eagerly embraced new approaches and nontraditional materials: video and
computers beginning in the 1960's and 70's, digital technology and the Inter-
net in the 90's," bioart, by using the materials of life itself for the purposes of
art, can "credibly claim to have made a more revolutionary break with tradi-

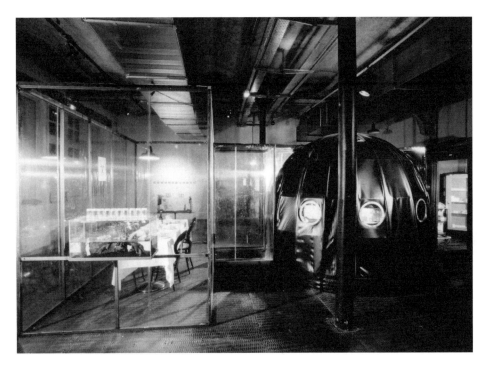

FIGURE I.4 The Tissue Culture and Art Project, *Disembodied Cuisine* (2000–2003), installation for L'art biotech exhibition, 14 March 2003, Le Lieu Unique, Nantes, France. At right is the room in which the frog steak was grown; at left is the "dining room" in which the frog steak was consumed. Image courtesy of The Tissue Culture and Art Project. Photo: Axel Heise.

tion" than these earlier artistic appropriations of technology.[4] Yet precisely because it does seem to represent a "revolutionary break with tradition," other commentators have adopted a tentative or critical stance toward this new form of art. In his otherwise generally laudatory *New York Times* article, for example, journalist Randy Kennedy nevertheless wonders whether bio-art might be dangerous, for it often involves the use of living tissues and organisms that can replicate outside the control of the artist.[5] Taking up this theme of danger, Michael Crichton's novel *Next: A Novel* (2006) adopts a far more critical stance, including a brief description of an actual bioart project among many fictional examples in his book of biocommerce gone wild.[6]

And in a legal case that I discuss in chapter 2, many different law enforcement agencies were involved in the arrest and investigation of bioartist Steve Kurtz, who was wrongly suspected of being a bioterrorist because of biological laboratory equipment and organisms found in his home.

As these strong responses suggest, bioart has had the effect of calling into question what exactly ought to count as "art." Can one really create *art* out of bioengineered living entities? What is an artistic "medium" if it can include living and semi-living entities? Do the artist and gallery spectators bear some sort of responsibility toward the living entities or tissues that make up bioart? (And if so, what kind of responsibility?) Or is all of this "bioart" simply a sensational exploitation of living beings and tissues for the purposes of generating publicity for, and advancing the careers of, bioartists?

In this book I attempt to provide at least partial answers to these questions, though from a perspective that is outside the field of art history proper. Since the late 1990s, I have been interested in, and writing about, the emergence of various biomedical "tissue economies" in the United States—that is, formal and informal systems by means of which tissues (human or otherwise) move between researchers and between researchers and corporations.[7] In 2000, I taught an undergraduate class at the University of Washington that explored both biomedical and artistic approaches to tissue economies, and Marta Lyall—an artist then teaching at the University of Washington—gave a guest lecture for my course. I became fascinated with one of Marta's then-current projects, which involved growing bonelike structures in a nutritive medium, and after the course concluded, I began to search out other examples of biologically based art.[8]

At about the same time, my colleague and frequent collaborator Phillip Thurtle began planning a course with Elizabeth Rutledge, a molecular biologist at the University of Washington. The course was to focus on points of intersection between biological and artistic techniques and—particularly exciting from my perspective—it was to include a laboratory component through which students in the humanities would learn biological laboratory techniques and then engage their laboratory experience in some "artistic" way. Yet I also found significant the sheer number of obstacles that Phillip and Elizabeth encountered as they moved from planning the course to its actual implementation. Linking science and the humanities at a major university, it turns out, is a surprisingly difficult thing to do. The salary

differences between the humanities and the sciences, for example, make co-teaching bureaucratically challenging, while locating lab space in perennially overbooked biology labs is very, very difficult (and receiving clearance to teach lab techniques in other parts of campus is essentially impossible). Even with plenty of goodwill on both sides, collaborations between those in the humanities and those in biological sciences do not just happen on their own but depend upon flexibility and a tactical sense of how to make such collaborations attractive not just to the participants but to administrators as well.

I had a chance to experience some of these same difficulties myself in the context of a coauthored DVD-ROM project that explored the worlds of biotechnology from the perspectives of law, biology, and the humanities. For this project, I contacted a number of bench scientists about filming several basic biology laboratory processes. Though the biologists whom I approached were, without exception, extremely generous with their time, filming in biology laboratories turned out to be tricky work. At any given time, at least in the labs that I visited, many, many experiments were being conducted by many, many different experimenters, and staying out of the way was difficult. Filming thus generally had to occur late at night or on weekends (or late at night on weekends!), and even then I found myself literally climbing on furniture to film without disturbing experiments in progress. I found that I was constantly scrambling to make sure I fully understood not only the biology of the specific techniques that I was filming but also the rapidly changing history of those techniques (in the early 2000s, for example, molecular biologists were using techniques to isolate genes of interest that were quite different from those they had employed only a few years earlier). For a humanities scholar, "sticking" to the milieu of the biology lab proved to be something like jumping onto a moving vehicle, in the sense that I had to get up to speed before I could even make an attempt to inhabit this other space.

These experiences thus heightened my interest in artists who not only had made their own way into biology labs but had then been able to transplant materials and techniques from the lab bench into their artworks and from there into the space of the art gallery. I had a chance to see a number of such "bioart" projects exhibited together in 2002 at the Gene(sis): Contemporary Art Explores Human Genomics exhibition at the Henry Art Gallery

in Seattle. The physical location of this gallery was an important part of this experience for me because the Henry Art Gallery is located in the northern, "humanities" part of the campus of the University of Washington. As a result, when I looked at these projects, what I saw first and foremost were biological materials, techniques, and tools that I had only otherwise seen in the southern, "science" part of campus. By using living entities as part of their artistic media, these artworks themselves served as a sort of channel, or medium, that brought biological materials and techniques into another part of a major research institution, and from there into the public space of an art gallery. It thus seemed to me that what was at stake in this kind of art was not simply the development of a new means of "artistic expression" but also—and equally important—a subtle shifting and bending of the relationships between the sciences and the humanities, and between the inside and outside of biology labs.

Thinking of bioart as a medium that established new flows of biological materials and techniques helped me to link this form of art back to my interest in biomedical tissue economies. For some time I had been especially interested in the Bayh-Dole Act, a 1980 piece of legislation that (as I discuss in more detail in chapter 3) had significantly altered relationships between universities and corporations by making it much easier for universities to patent and lease inventions produced on their campuses. It seemed to me that, for better or for worse, this legislation had been so successful in large part because it employed the patent system itself as a kind of medium for creating new flows of biological materials and techniques between the inside and the outside of the university. It thus struck me that bioart was appropriating this same approach—that is, it too sought to function as a medium for creating new flows of biological materials and techniques between the inside and the outside of the research university—even if for quite different ends than in the case of patents. The extraordinarily reflexive nature of bioart's relationship to media—the fact that its use of living beings as artistic media itself served as a medium for altering relationships between biological laboratories and the public—suggested to me that bioart could serve as a useful object of analysis through which to investigate how exactly these "media" function more generally in our present moment.

As this brief biographical sketch probably suggests, *Media Life* is not written from an explicitly "art historical" approach to bioart. This is in part a

matter of making a virtue out of necessity, since I was not trained in the field of art history. However, it is more fundamentally a consequence of the fact that I approach bioart in this book less as an end in itself than a means, or medium, for a more general reflection on the nature of "media."

Bioart seems to me to be an especially useful object of analysis for this project of rethinking media for several reasons. First, insofar as bioart links artistic goals and techniques with biological technologies, bioartworks also frequently end up bringing together two quite different senses of media. On the one hand, bioart draws on the more familiar sense of "medium" as a material means through which thoughts, information, images, sounds, colors, and textures are stored and transmitted from one place or time to another (it is in this sense that one speaks of newspapers and television as instances of "mass media," for example). On the other hand, bioart also draws on the sense of "media" used by biologists, for whom the term refers to fluids or solids that are employed to keep living cells developing, dividing, and transforming during the course of an experiment. Bioart links these two conceptions of media by situating biological media and technologies within a milieu—namely, the art gallery—that has traditionally been associated with the sense of media as a means for storage and communication.

Second, and equally significant, bioart produces in its "spectators" an *embodied* sense of this link between these two senses of media, for by using living beings—or by revealing ways in which spectators are bound, beyond their control, to other forms of life—bioart frames spectators as themselves media for the transformative powers of life.[9] As a consequence, bioart enables an embodied experience of what seems to me to be the fundamental (i.e., generative) sense of media—namely, medium as a condition for transformation—and it encourages a sense of "life" as less a property or informational pattern that is proper to organisms than a perpetual process of emergence.[10] My goal in this book is to describe bioart in a way that allows readers to establish their own initial link to bioart—and, through bioart, to the transformations of social space of which bioart is both a part and a complication—and thus to articulate further the embodied sense of medium and the sense of life as emergence that bioart itself encourages.

In order to arrive at an embodied conception of media through the example of bioart, I develop an argument that has three basic stages. In summary

form, the argument runs as follows: I begin with a general orientation to what I mean by "bioart," distinguishing between two different modes of bioart. Then, in the second stage of my argument, I describe the "historical conditions of possibility" of bioart: these include both those changes in technology and social relations that make biotechnology a viable object of interest for artists and those changes in the conditions of art spectatorship that make it possible for bioart to "*feel* genuinely subversive, even dangerous." Finally, in the third stage, I draw on the use of both biological and communicational media in vitalist bioart to develop a concept of "media life" that is able to account for the link between the "objective" and "subjective" conditions of possibility of bioart (i.e., the link between changes in technology and social relations, on the one hand, and experiences of these changes, on the other).

The first stage of my argument—defining bioart—occupies chapter 1. I begin by noting that commentators have so far not agreed upon what, precisely, ought to count as "bioart": some argue that it really is nothing more than a concept that links many different kinds of works of art that deal with biotechnology, while others seek to restrict bioart to those works of art that in fact employ a specifically biotechnological medium. My solution to this debate is to introduce a third term, that of the *problematic*. This concept, which I draw from the work of philosopher Gilles Deleuze, allows us to overcome the potentially unproductive dichotomy between "immaterial concepts" and "material media" and instead to see both concepts and media as tactics of linkage within a larger social-material field: that is, ways of establishing new connections between bodies, institutions, and ideas.[11] The concept of the problematic thus allows us to distinguish between kinds of bioartworks in terms of the tactics that they employ to alter this larger social-material field, and I focus on a distinction between what I call the *prophylactic* and the *vitalist* modes of bioart. Whereas prophylactic bioart seeks to protect spectators of art from what are understood as the unhealthy excesses of the problematic of biotechnology, vitalist bioart endeavors to transform this problematic by involving spectators more closely within it.

In the remainder of this book I focus primarily on vitalist bioart. Though in both its prophylactic and vitalist modes, bioart endeavors to transform relationships between bodies, institutions, and ideas, the "promiscuous" tendency of vitalist bioart—that is, its persistent effort to transform by *linking*

the various elements of the problematic of biotechnology—makes it a more useful focal point for the second stage of my argument, namely, understanding how art has become a transformative part of this problematic. Chapters 2 and 3 begin with the "objective" historical conditions of possibility of vitalist bioart, focusing on the technological, social, political, and legal changes that have made it possible for twentieth-century artists to use the tools and techniques of biotechnology as artistic media. Chapter 2 outlines three "eras" of vitalist bioart (1930s, 1980s–1990s, and the period since 2001), while chapter 3 focuses more closely on the two most recent eras in order to explain more specifically *how* bioart alters biotechnological relationships between people. In this latter chapter, I employ the concept of "folding" as a description of what occurs when bioartists become part of those informal exchanges of materials and information that normally occur only between scientists and normally take place only within the milieu of biological research institutions. Creating bioartworks requires pulling, bending, and folding these tools, techniques, and relationships into other spaces, which in turn produces new wrinkles in a commercially oriented "innovation ecology" that first emerged in the 1980s and 1990s in the United States (and has since been exported to many other parts of the world).[12]

Chapter 4 turns to the "subjective" side of the historical conditions of possibility for vitalist bioart, taking up the question of *why* vitalist bioart can end up feeling "genuinely subversive, even dangerous," for many people. As some critics of bioart have noted, we often must take bioartists at their word that they have truly altered living (or semi-living) matter, and given this, it is indeed a bit peculiar that watching a butterfly fluttering about within an enclosure of plastic and metal or gazing through a plastic porthole at a moist mass of fleshlike substance can produce intense feelings. Understanding how vitalist bioart produces strong reactions thus requires, first, a more nuanced analysis of the experience of bioart and, second, an understanding of how bioartists draw on traditions of artistic framing to produce a sense of presence and strange, transgressive, and sometimes even infectious vitality. For the former task, I draw on the concept of *affect,* which allows us to understand the experience of vitalist bioart as an oscillation between a sense of agency and a sense of passivity. For the latter task, I highlight the ways in which vitalist bioart draws on two twentieth-century techniques of artistic framing: the readymade and performance art. However, I also note that in

hybridizing the traditions of the readymade and performance, vitalist bioart revives an older Romantic-era understanding of the artistic frame as fundamentally a connective medium—a "vector of infection," so to speak—that is perhaps best articulated in the work of Immanuel Kant.[13]

This understanding of the artistic frame as a connective medium leads to the third and final stage of my argument, which occupies my fifth chapter. My focus here is on the development of a theory of media able to account for the fact that vitalist bioart employs media both to communicate *and* to transform. I propose that, just as vitalist bioart revives a Romantic-era understanding of the frame as a connective medium, it also returns to a Romantic-era sense of a medium as something that employs communication as a means for transformation. However, thinking through the relationship between media-as-communication and media-as-transformation is not a simple task, and it is one that became increasingly difficult during the nineteenth and early twentieth centuries, as biology appropriated one understanding of medium, and the humanities, another. As a consequence, there is a tendency to privilege one of these meanings over the other, and to avoid this problem, I turn to the concepts of *metastability* and *individuation* developed by the twentieth-century philosopher of technology Gilbert Simondon. Simondon's concepts, I suggest, allow us to see vitalist bioart as a concrete instance of the possibility of thinking the communicational and biological understandings of media together.

I suspect that my emphasis on the historical conditions of possibility of bioart may leave some readers wishing for more extended analyses of specific works of art, more biographical details about artists whom I consider, and more explicit discussions of how bioart relates to other contemporary modes of art. Yet I hope that my approach will also end up compensating for these omissions, and in the sixth and final chapter—which forms something of a coda to the argument I outlined above—I suggest that my conception of media life helps us to reframe questions in art history about our "postmedium condition" as well as debates in media studies about what precisely ought to count as "new media." The former question concerns the increasing dominance and importance of multimedia installation art—a state of affairs that has encouraged some to wonder whether *multi*media art signals the end of artistic interest in media *specificity,* that is, the question of what distinguishes different artistic media from one another. The debate about "new

media," for its part, has revolved around a similar question, as media critics have sought to understand whether the emergence of digital image technologies and digital audio means the end of intrinsically separate media—whether, that is, "a total media link on a digital base . . . erase[s] the very concept of medium," as media theorist Friedrich Kittler has claimed.[14]

As Mark B. N. Hansen has recently suggested in his "new philosophy" of new media, these two questions should be brought to bear on one another, and this can occur first and foremost when we consider the embodied aspects of media.[15] Though I follow Hansen in emphasizing the importance of embodiment, *Bioart and the Vitality of Media* is premised on the position that, in order fully to think the embodiment of media, we must also consider that other "new medium" of the twentieth century: biological new media. Insofar as many bioartworks are multimedia installations that depend upon both biological media and computational technologies, bioart thus ends up bringing all of these concerns together. More to the point, bioart brings these media concerns together in a way that allows us to think the *vitality* of media, those ways in which media do more than "transmit" and "communicate" but, in addition, help bring new structures into being.

1

DEFINING BIOART
Representation and Vitality

"**B**IOART" IS IN MANY WAYS A CONFUSING TERM, WITH UNCERTAIN
reference. Like related terms such as "genetic art" and "transgenic
art," bioart has been used to describe many different kinds of works of art.
Consider, for example, the following four works of art, which have all been
described as examples of either bioart or genetic art:

1 Alexis Rockman's oil and acrylic painting *The Farm* (2000) depicts a pos-
 sible use of genetic engineering to create "consumer-friendly" plants
 and animals (fig. 1.1). Exhibited at the 2000 Paradise Now: Picturing the
 Genetic Revolution at Exit Art in New York, the left side of Rockman's
 painting represents "ancestral versions of internationally familiar ani-
 mals," but as one moves to the right, the plants and animals seem to have
 been genetically modified to increase their exchange value: the tomatoes
 in the foreground have been structured to grow into a shape that can
 be easily transported; the chicken standing on the post at the far right
 has four extra wings, presumably to maximize the number of "buffalo
 wings" that can be processed from a single chicken; and so on.[1] Though
 these plants and animals are presented in a colorful, bucolic setting, they
 nevertheless seem deformed and "unnatural."
2 Catherine Wagner's *-86 Degree Freezers (Twelve Areas of Crisis and Concern)*
 (1995), also exhibited at Paradise Now: Picturing the Genetic Revolu-
 tion, is a series of twelve black-and-white photographs, each depicting a
 freezer of the sort commonly used in biological research (fig. 1.2). In biol-
 ogy laboratories, researchers employ freezers both to store media and to
 slow down biological processes in cells (which in turn makes it possible
 to better coordinate the temporality of cell processes with the tempo-

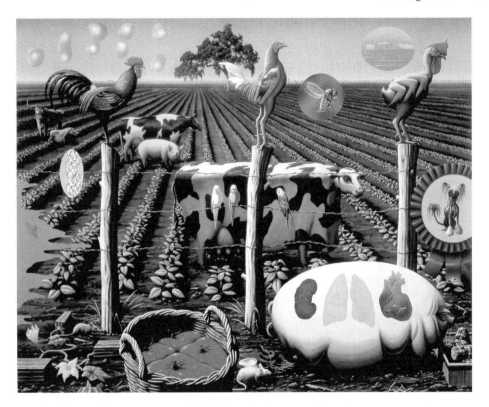

FIGURE 1.1 Alexis Rockman (American, 1962–), *The Farm* (2000). Oil and acrylic on wood panel; 96 × 120 in. Leo Koenig Gallery. Image courtesy of the artist.

rality of a particular experiment). Though in one sense Wagner's work simply documents twelve different uses of a common research tool, the subtitle of her work—*Twelve Areas of Crisis and Concern*—highlights in a very precise way the kind of emotional engagement that links researchers with their living materials. Though living cells and animals do indeed function for biological researchers as means for asking and answering questions about life processes, dealing with living cells and animals also requires a quite literal "concern" for these entities; without such concern, the cells or animals will die, making it more difficult to conduct current or future experiments. Wagner's subtitle links this concern of scientists to a sense of the word "crisis" that harks back to its Greek root. "Crisis" stems from *krinein,* "to decide," and Wagner's subtitle emphasizes

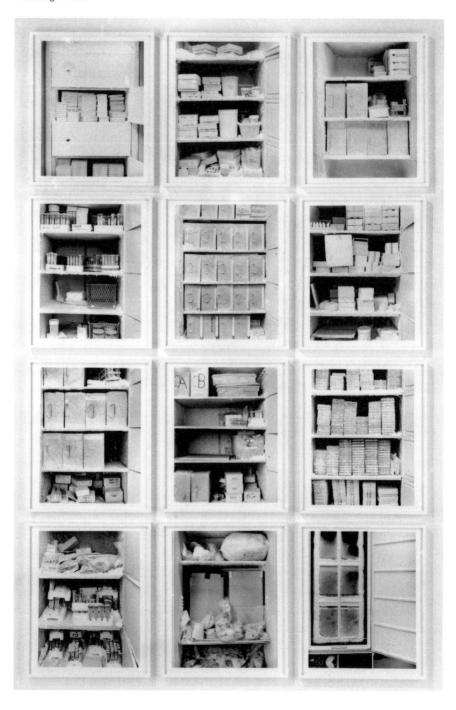

that scientists' concern for their samples is linked to a felt need to make decisions: to use the samples for this or that purpose, for example, or to begin or end an experiment. Insofar as the freezers pictured in Wagner's work contain cells drawn from human subjects with disorders such as breast cancer and HIV, these scientific modes of crisis and concern are themselves then linked to more widespread feelings of crisis and concern about the need for cures for these diseases. What is thus significant about Wagner's work, then, is its capacity to recontextualize scientific freezers in order to highlight the *affective* aspects of scientific research: that is, those senses of crisis and concern upon which scientific research depends but which often go unnoticed by both scientists and laypeople.

3 Though davidkremers's *Gastrulation* (1992) looks like an abstract oil painting, it is in fact an image produced by living bacteria that were genetically altered and then sealed within acrylic plates coated with agar (a food source for bacteria). The colors result from both "naturally occurring enzymes and protein combination" (fig. 1.3). "Gastrulation" is the term for an embryological process that occurs in many animals: during gastrulation, three germ layers are created within the embryo, which create the conditions for the later formation of organs. As davidkremers notes in a discussion of a related bacteria biopainting, "in our earliest days we look as if we could develop into whales or mice as easily as people."[2] *Gastrulation* thus both represents our biological proximity to other species while at the same time employing living beings as part of its medium.

4 For her project *One Tree* (1998 to present), Natalie Jeremijenko worked with a botanist to create one thousand "identical" tree clones that were raised in protected laboratory conditions (figs. 1.4a–1.4b). Between 1998 and 2001, these tree clones were exhibited in sets of pairs in different galleries: for example, as plantlets at Yerba Buena Center for the Arts in San Francisco in 1998–99 and as saplings at Exit Art in New York in 2000. Pairs of tree clones were subsequently planted in public parks and private sites around San Francisco. Though these tree clones by definition share the

FIGURE 1.2 Catherine Wagner (American, 1953–), *-86 Degree Freezers (Twelve Areas of Crisis and Concern)* (1995). Twelve-panel typology; gelatin silver prints; 20 × 24 in. each. Courtesy of Stephen Wirtz Gallery.

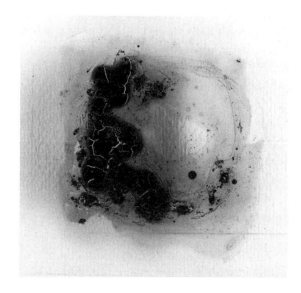

FIGURE 1.3 davidkremers (American, 1960–), *Gastrulation* (1992). Ethidium bromide, bromphenol blue, agar, x-gal, iptg, *E. coli* tb-1, alizarin red-3, synthetic resin on acrylic plate; 24 × 24 in. Image courtesy of the artist. Photo: davidkremers.

same genetic code, the different environmental conditions to which they are exposed as they grow outdoors result in trees that look quite different from one another. Even more significant, even in the case of the pairs of trees—each of which grows in the *same* environment as the other—the resulting trees look different. *One Tree* thus highlights the limits of understanding identity solely as a function of the underlying genetic "code" of an organism.[3]

An oil painting, a set of photographs, a biopainting, and a multisite "landscape installation"—all these works of art engage biotechnology, but they do so in quite different ways. Alexis Rockman's *The Farm* and Catherine Wagner's *-86 Degree Freezers (Twelve Areas of Crisis and Concern)*, for example, take biotechnology as their theme, in the sense that both works bring some aspect of these scientific processes associated with biotechnology to the attention of the viewer. However, they do so by means of media—namely, painting and photography—that themselves seem to have relatively little, if anything, to do with genetics, transgenics, and biotechnology. davidkremers's *Gastru-*

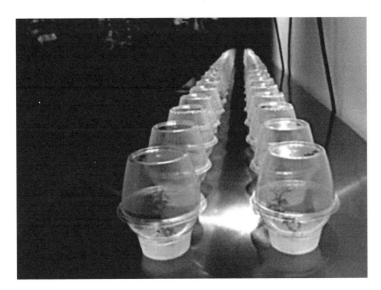

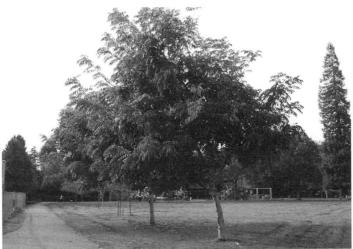

FIGURE 1.4 Natalie Jeremijenko (Australian, 1966–), *One Tree* (1998–present).
(a) One thousand clones of the same Paradox walnut tree, micropropagated in soil
culture. (b) Photograph from winter 2008 of trees that were identified by Canopy
(a nonprofit "urban forest" advocacy group serving as one of the stewards of *One
Tree* plantings) as some of the *One Tree* Paradox walnut saplings planted in 2003 in
Rinconada Park in Palo Alto, California. Plantlets (shown here) exhibited in 1998–99
at the Yerba Buena Center for the Arts in San Francisco; saplings later exhibited in
2000 at Exit Art in New York. Photo of trees in Rinconada Park: Thomas Clark.

lation and Natalie Jeremijenko's *One Tree,* by contrast, employ genetically altered entities—namely, genetically altered bacteria and cloned trees—as part of the medium of the work of art itself. Moreover, parts of Jeremijenko's *One Tree* continue to live into our present, which makes it difficult even to establish precise dates and locations for the "exhibition" of this work.[4]

The sense that these otherwise very different works of art are nevertheless all examples of a new kind of art has been encouraged by several important art exhibitions that have presented alongside one another works that employ traditional media and works that employ biotechnological media.[5] While more recent exhibitions such as L'art biotech (2003) and sk-interfaces (2008) have focused more exclusively on works of art that employ biological media, these earlier exhibitions nevertheless have encouraged a persisting sense that the term "bioart" ought to encompass all those works of art that engage biotechnology in some way.[6] This impression was also fostered by early discussions of bioart in academic journals, such as *Art Journal,* and by *The Molecular Gaze* (2004), Suzanne Anker's and Dorothy Nelkin's overview of "art in the genetic age," which grouped together many different kinds of works of art, distinguishing them less by medium than by theme—for example, works that thematize "genetic information," those that highlight "monstrosity," those that emphasize "transgenics," and so on.[7] Yet one might reasonably ask: if all four of my examples above are instances of bioart, in what way are they linked to one another?

BIOART, CONCEPTS, MEDIA

In seeking to answer this question, commentators have tended to fall into two camps, one side arguing that these works are unified by a *concept,* the other side arguing that the members of a privileged subset of these works are unified by their *media.* Literary critic and art historian W. J. T. Mitchell has made the strongest case for the view that these works are in fact unified by a "theme."[8] He notes that, since 2000, "scores of exhibitions and shows explicitly on this theme [i.e., the theme of biotechnology, or what Mitchell calls "biocybernetic reproduction"] have been organized."[9] Yet he also notes that the works exhibited show "no consensus on artistic strategies," and there remains "considerable uncertainty about what sort of medium or form [this art] ought to employ" (331–32). Mitchell contends as well that the

claim of some bioartworks to employ living entities as part of their medium
depends as much on the spectator's imagination as the actual work of art, for
"[t]here is, in a very real sense, nothing to see in the work but documents,
gadgets, black boxes, and rumors of mutations and monsters" (228). In this
sense, Mitchell suggests, bioart is best understood less as a new kind of art
than as a new mode of conceptual art—that is, part of a tradition of art less
interested in either the specificity of particular media or what Mitchell calls
"visual payoff" than in using the work of art to point to an idea or concept
(228).[10] From this perspective, what unifies the various works of art I have
described above is their shared interest in generating "critical debate" about
biotechnology. However, as a consequence, it is a matter of relative indiffer-
ence whether a particular work of art employs paint, sculpture, or muscle
cells as its medium.

By positioning bioart as a sort of return to conceptual art strategies from
the 1960s, Mitchell's account implicitly draws on a narrative about twenti-
eth-century art that aligns conceptual art with what Rosalind Krauss has
described as our postmedium condition. Krauss summarizes this narrative
in particularly concise form, describing a dialectic of modern art that begins
with an attempt to determine what is specific to each artistic medium but in
the end paradoxically negates the very concept of separate media. In the con-
text of painting, for example, the effort of early and midcentury painters to
"abstract" from painting everything that was not specific to this medium—
that is, to rid painting of representation, figures, lines, and so on—pro-
duced paintings that were so bare that they tended to highlight their status
as three-dimensional objects. Yet this blurred the boundaries between the
medium of "painting" and the supposedly separate medium of "sculpture,"
which in turn set the stage for conceptual art. In Krauss's narrative, con-
ceptual art was premised on the principle that, in an era in which the very
idea of the specificity of particular artistic media had become problematic,
media were best used as simply occasions for generating "statements" about
art. (This also seemed to have the added benefit of insulating conceptual art
from the economic sphere within which media-bound artists labored, thus
making it possible for art to critique the "commodity form in which paint-
ings and sculpture inevitably participated as they were forced to compete in
a market for art that increasingly looked like any other.")[11] Bioart, within
Mitchell's account, is simply conceptual art with a bad memory, for insofar

as it valorizes biological media, it forgets its founding premise, that media are simply occasions for generating concepts and debate.

Starkly opposed to this view of bioart as primarily conceptual in nature are those critics who point to the *medium* as the unifying principle of bioart. Critics in this camp tend to banish from the category of bioart works that employ traditional artistic media, such as oil paint or sculpted wood or metal. Eduardo Kac, for example, contends that one must distinguish between artists who simply engage biotechnology as a topic and those who "engage with biotechnology on a material level" by employing biotechnology as "their very medium."[12] Kac is willing to consider as bioart only those works of art that employ biotechnology as a medium, for, he argues, bioart proper "must be clearly distinguished from art that exclusively uses traditional or digital media to address biological themes, as in a painting or sculpture depicting a chromosome or a digital photograph suggesting cloned children. Bio art is in vivo" (19).

Pace Mitchell's claim that bioart is often simply a collection of "documents, gadgets, black boxes, and rumors of mutations and monsters," Kac argues that bioart engages biotechnology in very specific ways. Real bioart, Kac suggests, "employs one or more of the following approaches": "(1) the coaching of bio-materials into specific inert shapes or behaviors; (2) the unusual or subversive use of biotech tools or processes; (3) the invention or transformation of living organisms with or without social or environmental integration" (18). As an instance of the first approach, we could point to davidkremers's *Gastrulation*, which employs biomaterials, but in order to create a static image. The second approach is exemplified by a work such as *Free Range Grains* (2003–4), by the Critical Art Ensemble, Beatriz da Costa, and Shyh-shiun Shyu. For this project, exhibited in locations such as the Schim Kunsthalle in Frankfurt, Germany, and the ESC Gallery in Graz, Austria, the group encouraged members of the public to bring corporately produced food products—produce such as tomatoes, for example, or processed food such as Wheaties and Cheerios—into the art gallery to have these foodstuffs tested for genetic modifications (fig. 1.5). This project thus employed typical elements of a biological research lab—pipettes and genetic gel sequencing plates, for example—but for an "unusual or subversive use." Jeremijenko's *One Tree* exemplifies the third approach, for Jeremijenko and her botanist collaborator not only transformed living plants but also literally integrated

FIGURE 1.5 Critical Art Ensemble, Beatriz da Costa, and Shyh-shiun Shyu, *Free Range Grains* (2003–4). Members of the artist group responsible for creating *Free Range Grains* test spectator-submitted food items for genetic modifications. *Free Range Grains* brings into the gallery space both tools from a biological research lab and products produced in the corporate sphere. Installation pictured: ESC Gallery, Graz, Austria. Image courtesy of Beatriz da Costa and Steve Barnes. Photo: Critical Art Ensemble.

these modified plants into the environment of the Bay Area.

Implicit in Kac's articulation of these different ways of employing biotechnology is the suggestion that bioart in fact demands a new mode of aesthetic expertise. Thus, in the same way that someone relatively familiar with traditional forms of painting can easily and quickly determine whether a specific work employed oil paints or watercolors, so too can spectators familiar with the media of biotechnology distinguish between actual biological media and "documents, gadgets, [and] black boxes."[13]

BIOART AND THE PROBLEMATIC OF BIOTECHNOLOGY

It is difficult to adjudicate this conflict between bioart understood as a new mode of conceptual art and bioart understood as a media-based practice, for these two positions are in a sense trying to account for two different problems. Mitchell is trying to account for the heterogeneous collection of works of art that have in fact been grouped together under the rubric of bioart (or related rubrics, such as genetic art or transgenic art). Proponents of an understanding of bioart as a media-specific form of art, by contrast, want to limit that term to a specific subset of those works of art that have been exhibited (implying, in a sense, that earlier exhibitions may have inappropriately linked bioart and non-bioart). Thus, whereas Mitchell sees relatively little point in dwelling at length on the particular media of these works of art, and instead focuses on what he sees as the social effect that they attempt to achieve—namely, the provocation of debate through the presentation of concepts—proponents of the other view insist that one must begin by understanding more fully the specific biotechnological media employed by the works of art themselves.

I would like to hold on to the intuitions that motivate both of these positions—that is, both the intuition that bioart ought to encompass the variety of works of art that have in fact been presented as engaging biotechnology and the intuition that there is something quite new in the artistic use of biotechnological media. However, it seems to me that we can hold on to both of these intuitions only if we think of bioart not solely in terms of its relationship to art traditions, but also in its relationship to what we might call the *problematic* of biotechnology. By referring to biotechnology as a "problematic," I mean that biotechnologies are situated within a field that is made up of relationships between inorganic matter and living beings, as well as human social institutions and relations. Biotechnologies encourage a constantly shifting tension between these elements, exploiting aspects of the world in ways that render some sorts of relationships between humans— and between humans and other elements of the natural world—more likely and others less likely.[14] From this perspective, what the various works of art I have described above share is less a specific origin in one artistic tradition than a common effort to situate themselves *within* this problematic—that is, to become one of the elements that help determine these biotechnological

transformations of relationships between humans and between humans and among other elements of the natural world.[15]

By understanding the various examples of bioart that I have cited above as linked by their relationship to the problematic of technology, we can distinguish between different tactics for establishing that relationship. Mitchell's emphasis on the importance of "critical debate" for the tradition of conceptual art highlights one possibility, which I shall call the *prophylactic tactic*. The premise of the prophylactic tactic is that art can best intervene in the problematic of biotechnology by separating and insulating both itself and its spectators from this problematic. Artists who adopt this tactic often seek to produce this prophylaxis by employing non-biotechnological media, such as paint, sculpted wood or metal, and photography, in ways that allow them to re-present aspects of biotechnology.

Rockman's *The Farm* is a particularly clear example of the prophylactic tactic. *The Farm* seeks to represent for us in our present a biotechnological future that has not yet—and may not—come to pass. Rockman cannot *present* the future in its own terms and materiality—he, like the rest of us, simply has to wait for the future to arrive—but he can re-present a possible future in another medium (in this case, painting). However, Rockman's use of oil paints allows him to introduce a barrier between his representation of biotechnology and biotechnology itself. The medium of oil paint distinguishes his work of art from contemporary biotechnologies insofar as it relies upon and models a lower-tech—and presumably more virtuous—relationship to the natural world. Rather than employing relatively new "high-tech" means of representation, such as digital photography, *The Farm* relies on traditional, centuries-old techniques of creating colors from plant and animal matter and applying these to a surface of hardened plant matter (the wood panel on which the image is painted). In both its content and form, *The Farm* seeks to establish a protected space for the viewer, thereby enabling a "critical" perspective on biotechnology by means of re-presentation.

Whereas the prophylactic tactic is premised on the principle that art best engages the problematic of biotechnology by re-presenting it in other media, the *vitalist tactic,* by contrast, is premised on the principle that art best engages the problematic of biotechnology when it becomes itself a medium for this latter.[16] As Kac notes, there are several means through which to accomplish this, ranging from the "subversive" use of biotechnological tools or processes

to the integration of bioengineered organisms into the environment. However, all of these different tactics depend upon *presenting* biotechnology to people rather than re-presenting biotechnology by means of nonbiological artistic media. This desire to present, rather than represent, biotechnology depends in a sense on a desire for "authenticity." The colored shape that we see in davidkremers's *Gastrulation,* for example, is not intended to be significant in and of itself but is rather supposed to be grasped as a visualization of the actual life processes of the altered *E. coli* that are suspended within the acrylic frames of the biopainting. In similar fashion, though Jeremijenko's *One Tree* "illustrates" a theoretical claim that has been emphasized by biologists such as Richard Lewontin (fig. 1.6), her project suggests that such a theory becomes meaningful—or, at any rate, becomes particularly meaningful—only when people can experience its consequences in an authentically embodied and environmental fashion. Yet authenticity is not the goal in and of itself. Rather, the point of employing authentic biotechnology is that it immerses gallerygoers *within* alternative practices of biotechnology. Thus, rather than seeking to protect gallerygoers from the effects of biotechnology, the vitalist tactic seeks to use spectators themselves as a means, or media, for generating new biotechnological possibilities.

Though this distinction between the prophylactic and the vitalist tactics of bioart often seems to map onto a difference between "representation" and "presentation," it cannot in fact be reduced to this distinction (which is of itself of relatively limited utility).[17] The prophylactic approach to bioart indeed often employs representation as one tactic for protecting viewers from biotechnology. However, representation is by no means tied exclusively to this tactic, for it can also be employed in a vitalist fashion. Wagner's *-86 Degree Freezers (Twelve Areas of Crisis and Concern),* for example, re-presents objects—namely, biological research freezers and their contents—that she could have exhibited "for real" in the space of the gallery. Yet Wagner's image nevertheless seems more aligned with the vitalist than with the prophylactic tactic. In part, this is because Wagner's use of photographic reproduction allows her to document actual research uses of freezers rather than, for example, installing "mock" freezers in a gallery space. (It is very unlikely that researchers would have allowed Wagner to bring their own working freezers into the gallery space, since this would have made it quite difficult to use these freezers to conduct actual research.) However, the vitalist aspect

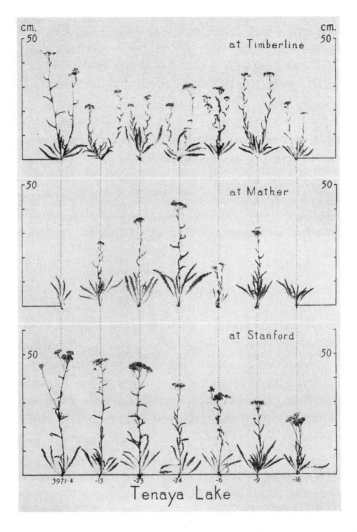

FIGURE 1.6 The image at the bottom represents seven individual instances of the herb *Achillea*, each growing at the same low altitude and each with a different genotype. Two cuttings were taken from each plant. One cutting was planted at a medium altitude, and the other at a high altitude. Though the three plants in each of the seven "columns" are clones of one another, each has grown quite differently, depending on the altitude. Moreover, there is no one genotype that grows "best" at all altitudes. Source: Jens Clausen, David D. Keck, and William H. Hiesey, *Experimental Studies on the Nature of Species,* vol. 3, *Environmental Responses of Climatic Races of Achillea* (Washington, DC: Carnegie Institution of Washington, 1948), 80. Image in public domain.

of Wagner's image is due in greater part to the fact that these photographs align the embodied immobility of a viewer who stands, gazing at the work, with a site of embodied stasis within the laboratory (i.e., the freezers with their frozen samples). Wagner's work, in other words, links these two sites of stasis—the freezers in the scientific lab, on the one hand, and the gallery which allows the spectator to stand before the work of art, on the other— through the shared moods of crisis and concern, in the sense that both the scientists who employ the freezers and the spectators who gaze at this image can share a sense of urgency and solicitousness about these samples. As a consequence, *-86 Degree Freezers (Twelve Areas of Crisis and Concern)* does not so much protect gallery spectators from biotechnological processes as provide a medium for linking spectators and scientists through this shared sense of crisis and concern.

My distinction between the prophylactic and vitalist tactics of bioart is thus not, in the final analysis, a distinction grounded in the "ontology" of bioartworks—that is, it is not a distinction that is based solely on the specific media employed by bioartworks. It is, rather, what we might think of as a "contextual" distinction, one that is grounded in the relationships that a work of art facilitates between its spectators and biotechnology. Both the prophylactic and vitalist tactics are committed to altering the topology of the problematic of biotechnology, and both treat spectators of art as embodied elements within this problematic. However, whereas the prophylactic tactic seeks to produce a protective membrane for the spectator through which other elements of this problematic will then be parsed, the vitalist tactic seeks actively to forge new connections within this problematic. (As I shall discuss in chapter 4, we can employ this distinction between prophylactic and vitalist tactics beyond the problematic of biotechnology, for it is a distinction that seems to describe as well the ways in which other forms of art have positioned spectators within other, nonbiotechnological problematics.)

One consequence of the contextual nature of my distinction is that the "same" work of art can operate in either a prophylactic or a vitalist fashion, depending on the context in which it appears. A partial awareness of this fact seems to be at the root of the claim that bioartworks that employ the tools and techniques of biotechnology simply—even if unwittingly— serve as "public relations" for the biotech industry by producing unreflective excitement about biotechnology and thus facilitating "business as usual."[18]

As I shall suggest in chapter 4, this kind of critique is insufficiently attentive to what it means to "produce excitement," but it nevertheless highlights the extent to which bioartists have themselves also been attentive to the importance of context. Jeremijenko, for example, was quite unhappy to learn that the Paradise Now exhibition, in which her *One Tree* project had been exhibited, had been largely funded by biotech companies, such as Affymetrix and Orchid BioSciences, and by Howard Stein, a financial expert who had an interest in ensuring that biotech received a warm public welcome in the United States.[19] In response, she produced a satirical poster entitled *Invest Now,* which employed the same cover image as the Paradise Now exhibit but replaced the names of the artists exhibiting in the show with the names of the corporate sponsors of the show. *Invest Now* is an example of a prophylactic tactic that functions in the service of a vitalist tactic, for the poster is intended to prevent *One Tree* (and other bioartworks exhibited in Paradise Now) from being appropriated to "business as usual" and to allow these works of art instead to function in a vitalist manner, creating new forms of connection within the problematic of biotechnology.

VITALISM, ART, AND EXPERIMENT

"Vitalist" may seem like a strange adjective with which to describe a tactic of bioart that seeks to involve spectators in biotechnological processes. However, I have two reasons for choosing the term. First, and perhaps most obviously, the term points to the importance of processes of life for these works of art. Vitalist bioartworks are designed to bring art to life—and life to art—quite literally. Yet I am also drawing on the historical resonance of the term "vitalism." "Vitalism" is understood by historians of science as a theoretical approach in biology and philosophy, one which holds that researchers cannot explain life and living processes fully by means of the laws of chemistry or physics, but they must, in addition, investigate laws or principles that are specific to living bodies. This approach to life was especially important in the late eighteenth and early nineteenth centuries and again in late-nineteenth- and early-twentieth-century biological theory and philosophy.[20] However, in both of these periods, the search for laws specific to living beings was contested by "materialist" or "mechanistic" biologists, who argued that, in the final analysis, life *could* be fully explained by the laws of chemistry and phys-

ics. For much of the twentieth century and into the present, vitalism has fallen out of favor in the biological sciences. The term now functions within the life sciences primarily as a sort of charge of heresy leveled against biologists or laypeople who (so the charge implies) have fallen prey to the hazy concepts and sloppy thinking that characterized earlier (and, implicitly, less rational) approaches to life. To be charged with vitalism is now equivalent to being charged with a "retreat" into a quasi-religious faith in unseen and unseeable "powers" and "forces" of life.

Insofar as "vitalism" currently functions primarily as a term of censure, there is clearly some danger in using this term to describe a particular kind of contemporary art that links itself explicitly to biological science. There is the risk, for example, that labeling a mode of bioart "vitalist" will be taken to mean that bioartists appropriate the tools and techniques of biological science for mystical and unscientific ends. Calling a certain mode of art vitalist, in other words, risks encouraging a cultural stereotype of artists as wild-eyed stargazers, who perpetually embark on fruitless searches for the "meaning of life." In addition, biological vitalism has been associated historically with conservative—and even totalitarian—political beliefs. (Historians of biology have noted, for example, that some physiologists and biologists who argued for an ineffable principle of life in the register of biology often also committed themselves to ineffable principles of "divine authority" or "blood and soil" in the political realm.)[21] Thus, in calling a mode of bioart vitalist, we also risk suggesting that this art in some way encourages questionable political commitments.

Yet, I suggest, it is worth taking this risk, for by describing a particular mode of contemporary art as vitalist, we can both better understand this art and, at the same time and by the same token, open up a new perspective on the history of biological vitalism. Vitalist bioart is, as I will document throughout this book, primarily exploratory and experimental: that is, rather than seeking—or seeking to safeguard—the "meaning of life," vitalist bioart instead explores what life can *do*. Can *E. coli* be coaxed to make a painting—and if so, what will it look like? What differences among one thousand clones of the "same" tree will we actually see and feel as they mature? How much of *my* food—that is, the particular food that sits in my kitchen cupboard—contains genetically altered ingredients? Can we use a project such as *Disembodied Cuisine* to understand the laboratory as less like a

site of revelation and more like a "kitchen in which nothing is programmed, [but rather] recipes are . . . tried out"?[22]

This experimental approach to life links vitalist bioart to an underappreciated mode of scientific vitalism, one that I would like to call *experimental vitalism*. Most histories of vitalism have focused on what I call *theoretical vitalism*: that is, the kind of vitalism practiced by biologists who begin with the premise that life cannot, *in principle,* be fully explained by the laws of chemistry and physics. Experimental vitalism, by contrast, is a practice that begins with a sense that life cannot be fully explained by *current* scientific concepts and assumptions and then develops experiments in order to provoke new questions and approaches to living beings.[23] A number of important discoveries and conceptual innovations were made by researchers whom we can describe as experimental vitalists; these include John Hunter's work on blood and coagulation in the mid– to late eighteenth century and Hans Driesch's work in the late nineteenth and early twentieth centuries on embryological development.[24] In describing one tactic of bioart as vitalist, I have in mind this sense that science must keep itself open to the future, to concepts and practices that have not yet come into being.

We can arguably see all conceptual and technical innovations in biological science as vitalist in this latter, experimental, sense of the term. It is true, of course, that scientific experiments are often understood as means for simply confirming or invalidating hypotheses and concepts that have already been developed in advance by a researcher. However, as historians of science such as Gaston Bachelard, Georges Canguilhem, Ludwig Fleck, and Hans-Jörg Rheinberger have emphasized, this understanding of experiments as oriented toward "answers" and "confirmation" misses the forest for the trees, confusing a local function of experiments with the more general function of experiments within a particular science. Though it is true that experiments often do provide answers to particular questions and sometimes function to validate or invalidate existing theoretical concepts, Rheinberger stresses that "a research system [as a whole] is organized in such a way that *the production of differences* becomes the organizing principle of its reproduction."[25] Though a specific experiment may aim to answer a particular question or clarify a concept, experimental *systems* in science persist only to the extent that they continue to create new questions and concepts.[26]

My reasons for describing a specific kind of bioart tactic as vitalist are

thus twofold. First and foremost, my hope is that this label provides us with a better understanding of what is specific to these kinds of works of art. At the same time, though, I hope that this term will also allow these works of art to illuminate for us the experimental dimension of science itself. Vitalist bioart is vitalist neither in the sense that it necessarily assumes any sacred essence of life nor in the sense that it is tied to a conservative politics, but rather in the sense that it is bound to an experimental approach to both life and science.

2

THE THREE ERAS
OF VITALIST BIOART

I N THE LAST CHAPTER, I SUGGESTED THAT WE DESCRIBE AS *BIOART* those works of art that establish a relationship to what I called the problematic of biotechnology. I outlined as well two different tactics for establishing this relationship: the prophylactic tactic, which employs art as a means for creating a protective membrane through which other elements of the biotechnological problematic can be parsed; and the vitalist tactic, which seeks to combine the tools of biotechnology with spectatorship as a medium for creating new relationships within this problematic. As this description suggests, both of these bioart tactics depend upon—for they both position themselves within—the problematic of biotechnology. Yet at the same time, vitalist bioart is in a sense far more dependent upon this problematic, for whereas prophylactic bioart often relies on "old" artistic media, such as stone, oil-based paints, or iron (i.e., media that predate the relatively recent biotechnological revolution), vitalist bioart more frequently appropriates quite recent biotechnological tools and techniques.[1]

When, and how, did it become possible for artists to employ the tools and techniques of biotechnology in works of art? What, in other words, are the "historical conditions of possibility" of the vitalist tactic of bioart? The next three chapters are all devoted to answering this question. This chapter initiates this effort by providing a relatively brief overview of the history of the vitalist tactic of bioart. My history begins in the very late nineteenth and early twentieth centuries, with the emergence of biotechnologically oriented industrial methods of plant and animal farming and production, though vitalist bioart proper appears a few decades later, in the 1930s and 1940s, when the photographer and plant breeder Edward Steichen began to appropriate new techniques of plant hybridization. The second moment of

my story is set during the 1970s and 1980s and emphasizes the new scientific, artistic, and legal relationships to living beings enabled by new techniques of DNA manipulation. I end with a third, quite recent, moment, in which new worries about the relative ease with which biological entities can be manipulated have led to changes in the social topology of exchange between biologists and artists.

I acknowledge at the outset that making historical claims about the emergence and key moments of a "new" kind of art is always a risky—and probably intrinsically unsatisfying—endeavor, as one can invariably locate earlier instances or precedents or parse the periods of a history differently. Nevertheless, this too is a risk worth taking, for by examining how earlier, twentieth-century works of art established relationships to the problematic of biotechnology, we will be able to understand more fully the contours of this problematic itself, especially in its legal and political dimensions. This in turn will help us to understand more concretely what it means for recent vitalist bioart to "establish new relationships" within the problematic of biotechnology.

THE FIRST ERA: PLANTS AND THE SCIENCES OF HEREDITY

As a number of critics have pointed out, it is difficult, if not impossible, to determine when humans "first" began to use living beings for aesthetic purposes: grasses, shrubs, and trees, for example, have been bred and used for ornamental purposes for many centuries, as have animals such as horses and dogs.[2] Nevertheless, I join historian of bioart and bioartist George Gessert in pointing to Edward Steichen as the first vitalist bioartist. Steichen was born in 1879 in Luxembourg but grew up in the United States, where he trained as a fine painter. He was also quite interested in photography and during World War I served as director of the Naval Photographic Institute. After the war, Steichen established his reputation as an art photographer and was director of photography at the Museum of Modern Art (MoMA) until 1962. However, of more importance here is the fact that in 1936 Steichen staged an exhibition of genetically altered delphiniums at MoMA.

Though Steichen is now best known as a successful photographer, he was also an avid delphinium plant breeder. His interest in plant breeding was long-standing and was linked to an interest in scientific theories of heredity.

As Ronald J. Gedrim notes, in 1911 Steichen had conducted poppy-breeding experiments in an effort to disprove the "Weismann Theory" of inheritance.[3] (Weismann had argued that only the "germ plasm" was involved in heredity, and thus, as a consequence, characteristics acquired by an entity in its own lifetime could not be passed on to offspring.) As a delphinium breeder, Steichen became particularly interested in scientific work in the early 1930s that showed that the drug colchicine could be used to double the chromosomal count in plants. Most plants are (like humans) "diploid," which means that plant cells carry two sets of chromosomes. However, applying colchicine to young cuttings created tetraploid plants, or plants with four sets of chromosomes. Steichen found that this technique allowed him to refertilize strains of delphiniums that previously had been infertile, which in turn opened up more possibilities for hybridization between different varieties of delphiniums. Thus, as Steichen wrote in 1949, genetic science had a direct impact on artistic possibilities:

> The science of heredity when applied to plant breeding, which has as its ultimate purpose the aesthetic appeal of beauty, is a creative art. Instead of words or pigments or tone, the plant breeder works and struggles with factors and forces that have been locked up within the various species of plants he may employ for tens of thousands of years. The very process of breaking up long closely inbred habits opens up gates that release new forms, patterns and colors.[4]

Steichen was also aware of the importance of large numbers of samples for successful breeding, and he bred tens of thousands of plants in order to expand his "palette" of options by locating those small "difference[s] in color and texture" that make "the good [delphiniums] shining and luminous."[5]

If Steichen's understanding of delphinium breeding as an art form owed much to his interest in the science of heredity, the opportunity to exhibit his plants as "art" depended upon his relationship to MoMA. MoMA had opened in 1929, and its directors had sought to use the museum as a venue for expanding the public's sense of what ought to count as art. In 1934, for example, MoMA had staged the Machine Art exhibition, which included objects such as household appliances; in 1935, it had hosted the African Negro Art exhibition, which challenged the assumption that works of art had to be

FIGURE 2.1 Edward Steichen (American, 1879–1973), *Edward Steichen's Delphiniums* (1936). Museum of Modern Art, New York (24 June through 1 July 1936). Image permission courtesy of Joanna T. Steichen. Image (IN50.2) courtesy of The Museum of Modern Art / Licensed by SCALA / Art Resource, NY. Photo: Edward Steichen.

the product of a single, identifiable "artist"; and in 1936, it held the exhibition Cubism and Abstract Art. Steichen was able to convince the museum trustees to allow him to exhibit his delphiniums as art, and in 1936, he staged an exhibition entitled Edward Steichen's Delphiniums. The exhibition ran for eight days, with different delphiniums brought in every two to three days (fig. 2.1). Steichen's goal was, as noted in the press release for the show, "to develop the ultimate aesthetic possibilities of the delphinium."[6]

The exhibition itself was, by all accounts, quite successful, from both horticultural and artistic points of view. The exhibition was described in scores of local and national newspapers, and according to a contemporary review in the *New York Times,* Steichen's delphiniums "represent[ed] what many authorities . . . consider decidedly the finest development in delphiniums so

far attained in this country."[7] The exhibition also encouraged the sense that the limits of "art" were constantly expanding, whether for good or bad. As a columnist for the *Chicago News* noted: "If sticks and stones, bits of newspapers, and other objects suggested by the 'cult of the ugly' can be passed on the canvasses of Picasso, Braque, Duchamp, and Picabia and called 'art,' why not beautiful flowers?"[8] Though the tone of this description implies a criticism of the expansion of the limits of art encouraged by MoMA, there is nevertheless also a recognition of the "framing" function of the museum: that is, simply exhibiting the delphiniums in the museum implicitly encourages a gallerygoer to view them *as* "art."

Even as Steichen's 1936 delphinium exhibition explicitly linked new techniques in genetic manipulation with attempts to broaden the concept of modern art, it was also related, albeit more implicitly, to legal and social changes associated with modern plant breeding. Just six years before Steichen's exhibition, the U.S. Congress had passed the 1930 Plant Patent Act (*U.S. Code* 35, § 1), which made it possible to patent domesticated plants, such as apples, pears, and roses, that could be reproduced asexually (e.g., by grafting or cloning).[9] This legislation was a response to two large shifts in late-nineteenth-century U.S. agricultural practices. U.S. markets for livestock and produce in the early nineteenth century tended to be local, and claims by distributors to "own" a specific variety of animal or plant were generally regulated locally and informally. However, by the end of the nineteenth century, large national distribution companies, such as the Stark Brothers Nursery, had come to dominate the business of agricultural supply. These companies found it difficult to protect their claims that they owned specific plant varieties, since anyone with access to one of their plants—including paying customers—could make more of the original simply by making cuttings. In addition, whereas agricultural suppliers early in the nineteenth century had tended to accommodate the desire for novelty by importing new varieties of plants and animals from abroad, late-nineteenth- and early-twentieth-century plant breeders, such as Luther Burbank, increasingly created new varieties through large and expensive domestic breeding programs. Thus, to protect what they saw as their "invention" of new plant varieties, breeders and distributors created the National Committee on Plant Patents in 1906. The 1930 Plant Patent Act was in large part a result of their industry advocacy, and it positioned breeders as "inventors" of new varieties of plants.

Steichen's interest in presenting plant breeding as a form of modern art thus occurred at precisely the same time as plant breeding was itself being legally reconfigured as an "inventive" economic activity. Steichen himself was well aware of possible intersections between the artistic and commercial aspects of his delphinium breeding. Though he initially refused to sell "STEICHEN DELPHINIUMS," he suggested in the exhibition catalog that they might one day be available for purchase, and he did indeed eventually make many varieties available commercially.[10] Moreover, for Steichen, the links between art and economy were as important as those between art and science:

> There has never been a period when the best thing we had was not commercial art . . . the great art in any period was produced in collaboration with the particular commercialism of that period or by revolutionists who stood clear and clean outside of that commercialism and fought it tooth and nail and worked for its destruction. In the twilight zone of the "art for art's sake" school all things are stillborn. (352)

Steichen's point was not that all great art necessarily takes the form of commodities but rather that great art is produced only when it bears an explicit relationship to the commercial field. Art produced to be sold or given away is one way to relate to the commercial field, while art that opposes the market is another way of relating explicitly to the commercial field. Neither of these possible relationships to the economic field has a monopoly on great art, according to Steichen; rather, what is important is an explicit stance vis-à-vis the market. Whether or not Steichen's claim is true for art in general is not a question I can consider in this book, but—as we will see in the next several chapters—it certainly seems to be the case for vitalist bioart.

THE SECOND ERA: RECOMBINANT DNA AND THE INNOVATIONS OF LIFE

George Gessert has noted that no major artists followed Steichen's lead in plant breeding in the immediate postwar period, and he suggests that this may have been a consequence of a general distrust of "eugenic" breeding projects (artistic or otherwise) in the aftermath of World War II.[11] However,

Steichen's method of artistic plant breeding was also not easily imitated, for it required a rare combination of breeding skill and personal wealth. Steichen's ability to locate those "difference[s] in color and texture" that make "the good ones shining and luminous" depended not only on his application of new techniques of genetic manipulation but also on his ownership and management of many acres of land, which allowed him to breed tens of thousands of plants a year. Such resources clearly were not available to every artist, and this no doubt contributed as well to the paucity of vitalist bioart in the immediate postwar period.

However, following the emergence of new molecular biological techniques of genetic manipulation in the 1970s, interest in the artistic possibilities of genetic manipulation revived. Steichen's delphinium breeding was exemplary of the early-twentieth-century science of heredity—that is, a science of heredity that was not yet "molecular biology." By the 1930s, biologists had developed a great deal of knowledge about heredity, including the principle that "traits" are passed between parents and progeny by means of "genes," and that chromosomes must serve an important, if not exclusive, function as the vehicles by means of which genes are passed between generations. Geneticists had also developed extremely detailed charts of inheritance patterns in a number of "model organisms," such as fruit flies.[12] Nevertheless, the specific mechanism by means of which genes were transferred between parents and progeny was not clear. It was not until the 1940s and 1950s that researchers established that chromosomes were composed of long, twined strings of deoxyribonucleic acid (DNA), and that DNA must serve as the basic mechanism through which traits were passed between generations. With this discovery, and the related concept that genes should be understood as "encoded information," the paradigm of molecular biology was born.[13]

By the early 1970s, biologists had developed ways of breaking up strings of DNA at particular locations and of combining DNA from one organism with that of another. Many of these new techniques depended upon the use of enzymes to "snip" DNA strings and the use of microorganisms to transport DNA from one organism to another. In a key paper on a "recombinant DNA" technique published in 1973, for example, researchers outlined a method for employing a plasmid (a circular ring of DNA found within an *E. coli* cell but outside the *E. coli* nucleus) as a "vector" for moving short strings of DNA from one cell to another.[14]

Joe Davis was one of the first bioartists to begin working with these new tools. Based in Boston, Davis came to molecular biology through his interest in another, and seemingly unrelated, field of science: the search for extraterrestrial life. Davis was intrigued by scientific projects in the 1970s and 1980s that sought to initiate contact with extraterrestrial beings, such as NASA's inclusion of messages in the *Pioneer* and *Voyager* space probes and the transmission of information about earth and humans from earth-based radio transmitters. However, Davis was not as convinced as were astronomers and physicists that these messages would be received on other planets or, if they were received, be easily decoded, and he was disturbed by the seeming censorship of sexual matters from these messages. Davis was interested in encoding information in a less immaterial, more embodied fashion, and he wondered whether the genetic manipulation of bacteria might make it possible to create "living codes" that would be able not only to make many copies of themselves but also to "survive the space environment for extended periods of time."[15]

In 1986, Davis worked with molecular biologists at Harvard and Berkeley to create a sort of proof-of-concept work of art for this idea, which Davis entitled *Microvenus*. *Microvenus* is a string of DNA nucleotides created from the ground up, so to speak, and formed into a specific shape by Davis's biologist colleagues (fig. 2.2). The shape chosen by Davis has a sexual symbolism, for, Davis writes, the DNA string has the form of "a graphic icon that is identical with an ancient Germanic rune and other iconography originally used to represent life and the female earth," and it bears a vague resemblance to "female genitalia."[16] However, the symbolic significance of the shape employed by Davis is arguably less important than the fact that *Microvenus* employs DNA as carrier of a message that is replicated by living beings (namely, *E. coli*). This work of art was not initially exhibited, in the usual sense, but rather (as Davis put it in 1996) "now resides in a bacterium that is a delicate 'living carriage' that cannot ordinarily withstand exposure to air and sunlight" (72). (Though Davis described *Microvenus* in an article published in 1996, it was officially "announced" at the 2000 Ars Electronica festival in Linz, Austria.)

Davis's focus on DNA and his use of recombinant DNA and synthetic biology techniques highlight the difference between *Microvenus* and an earlier bioart project such as Steichen's delphiniums. Steichen's project combined a

FIGURE 2.2 Joe Davis (American, 1953–), *Microvenus* (1986). (a) Microphotograph of the cloned Microvenus *E. coli* bacteria, some of which are in the process of dividing. (b) A representation of the DNA sequence, which Davis says has the form of "a graphic icon that is identical with an ancient Germanic rune and other iconography originally used to represent life and the female earth." Project announced at the 2000 Ars Electronica festival in Linz, Austria. Images courtesy of the artist. Photo: Joe Davis.

massive agricultural breeding program with a relatively rough technique of genetic modification (the use of colchicine to intervene in embryological processes). Davis's *Microvenus,* by contrast, exploits more recent techniques that allow researchers to intervene in heredity and reproduction at a much more local and targeted level (the level of individual amino acids) and to transfer genetic material between organisms. If Steichen's delphinium blooms exemplified biotechnological manipulation in the era of early-twentieth-century sciences of heredity, Davis's *Microvenus* is an instance of bioart in the era of molecular biology.

Even as *Microvenus* exemplifies the difference between the first and second eras of vitalist bioart, it also exemplifies two different periods within molecular biology itself. Richard Doyle has noted that, between the 1950s and

the 1970s, molecular biology often operated in a "cryptographic paradigm," in the sense that research was focused on "cracking the code" of life and discovering hidden "secrets" of heredity. While this goal of code cracking has certainly persisted beyond 1970, the invention of tools of genetic manipulation, such as the recombinant DNA techniques noted above, subtly changed the aims of many researchers, inaugurating what Doyle calls a "pragmatic" paradigm of molecular biological research.[17] Rather than seeking to crack the code of life, many researchers were now more interested in what became possible when one mixed genetic material from different organisms. These researchers were less interested in uncovering preexisting secrets than in *inventing* new forms of life, such as transgenic bacteria, mice, fish, and so on.

As I will discuss at length in the next chapter, this interest in research invention is linked to a broader economic shift that places great value on "innovation." However, at this point, I want to emphasize simply that Davis's *Microvenus* is compelling in part because it recontextualizes the first, cryptographic period of molecular biology within the second, pragmatic period. Thus, though Davis draws on the language of codes and information from the first era of molecular biology, *Microvenus* is not about cracking a code but rather about manipulating genetic material to create a new form of coding—codes that are, in principle, intended to connect humans with entirely unknown forms of life that may exist on other planets.

Like Davis's *Microvenus*, Eduardo Kac's *Genesis* (1999) exemplifies a recontextualization of the cryptographic period within the pragmatic period of molecular biology. However, in addition, it exploits the feedback loop between computers and biology that is so central to contemporary biological research. Like Davis's *Microvenus*, Kac's project focuses on questions of coding, and *Genesis* involves four acts of translation. Kac began by translating a sentence from an English version of the Old Testament into Morse code (fig. 2.3). This Morse code text was then translated into another (essentially arbitrary) code that uses only the capital letters A, T, G, and C. Since A, T, G, and C function within molecular biology as the textual shorthand for the nucleotides adenine, thymine, guanine, and cytosine, which make up DNA, Kac was able to send this line of text to a laboratory, where technicians linked together adenine, thymine, guanine, and cytosine in the order stipulated by Kac's "text."[18] The result was what Kac calls an "artist's gene": that is, a string of DNA made in accordance with Kac's "sentence." This artificial gene, as

Let man have dominion over the fish of the sea and over the fowl
of the air and over every living thing that moves upon the earth

Morse to DNA conversion principle

DASH (-) = T **A = WORD SPACE**

DOT (.) = C **G = LETTER SPACE**

CTCCGCGTATTGCTGTCACCCCGCTGCCCTGCATCCGTTTGTTGCCGTCGCCG
TTTGTCATTTGCCCTGCGCTCATGCCCCGCACCTCGCCGCCCGCCCCATTTCC
TCATGCCCCGCACCCGCGCTACTGTCGTCCATTTGCCCTGCGCTCATGCCCCG
CACCTCGTTTGCTTGCTCCATTTGCCTCATGCCCCGCACTGCCGCTCACTGTC
GTCCATTTGCCCTGCGCTCACGCCCTGCGCTCGTCTTACTCCGCCGCCCTGCC
GTCGTTCATGCCCCGCCGTCGTTCATGCCCCGCTGTATTGTTTGCCCTGCGCC
CACCTGCTTCGTTTGTCATGCCCCGCACGCTGCTCGTGCCCC

FIGURE 2.3 Eduardo Kac (Brazilian, 1962–), *Genesis* (1999). Transgenic work with
artist-created bacteria, ultraviolet light, Internet, video (detail); one of two editions;
dimensions variable. Kac created the Genesis gene by first converting a sentence
from the Bible to Morse code. The next step was the conversion of the Morse code
into a DNA code. Kac then had the DNA specified by the code synthesized to create
the Genesis *E. coli* bacteria strain. Collection Instituto Valenciano de Arte Moderno
(IVAM), Valencia, Spain. Image courtesy of the artist.

FIGURE 2.4 Eduardo Kac (Brazilian, 1962–), *Genesis* (1999). Transgenic work with artist-created bacteria, ultraviolet light, Internet, video (detail); one of two editions; dimensions variable. Overview of the *Genesis* installation. The circle on the wall is a projection of the *E. coli* contained in a petri dish in the center of the room. Collection Instituto Valenciano de Arte Moderno (IVAM), Valencia, Spain. Image courtesy of the artist. Photo: Otto Saxinger.

well as a cyan fluorescent marker, was then inserted into a plasmid, and the lab used the plasmid as a vector for inserting this "Genesis gene" into a number of *E. coli* bacteria. These *E. coli*, as well as additional *E. coli* that lacked the altered plasmid but contained a yellow fluorescent marker, were placed in a medium that encouraged the bacteria to grow and divide. A video projector and ultraviolet light were then placed above the petri dish, so that spectators were able to see an enlarged image of the bacteria in real time (fig. 2.4).

E. coli replicate every twenty minutes, and as the bacteria in the petri dish divide, the colors on the screen change and thus help spectators visualize both the inter- and intragenerational movement of the Genesis genetic sequence. (The colors, in other words, serve as a way of visualizing the movement of the genetic sequence both as it is passed from one generation to the next and as it moves from one *E. coli* bacterium to another as part of the normal plasmid exchange between bacteria.) The *Genesis* installation also

included an Internet component, which allowed people to view the installa-
tion over the Web. Online viewers could also alter the amount of ultraviolet
light to which the *E. coli* were exposed by clicking on a button. Kac states
that "[t]he energy impact of the UV light on the bacteria is such that it dis-
rupts the DNA sequence in the plasmid, accelerating the mutation rate," and
this too will have an effect on the colors that viewers see projected on the
wall. In the fourth, and final, translation in the project, the mutated *E. coli*
were sequenced by a laboratory, and the Genesis gene portion was translated
back into English, resulting in a transformed "sentence."

While both Davis's *Microvenus* and Kac's *Genesis* encode information into
genetic material, Kac's *Genesis* emphasizes as well the feedback loops that
continually reconnect "dry" information with "wet" biology within contem-
porary biological research and biotechnology. Commentators in the human-
ities have often criticized molecular biologists for "dis-embodying" life,
suggesting that molecular biologists see the particular bodies of living cells
and organisms as of secondary importance compared with the apparently
immaterial genetic "codes" and "information" that these bodies carry.[19] How-
ever, as Eugene Thacker has noted, the *practice* of molecular biology is much
more complicated than this critique suggests. In the laboratory, research-
ers may "disembody" biological and genetic information into computers, but
they do so often only as a means to "reembody" computer information into
living entities. Thacker provides as an example the microarray (also called a
DNA chip), which "is literally a tiny silicon chip upon which single strands
of 'sticky' DNA are attached."[20] Microarrays allow researchers to test the
cDNA or cRNA in cells of interest—for example, biopsies taken from cancer
patients—for the presence (and amount) of particular mutations. Much of
this latter work is done by digitizing the information from the microarray
and performing complex statistical analysis on the information. However,
this digital information can then become the starting point for new "wet"
experiments with cancer drugs. Thus, biologists, Thacker suggests, have "an
interest in digitization [only] inasmuch as the digital transforms what is
understood as biological" (6).[21] Digital information about the body is not an
end in itself for molecular biologists but rather leads back to new "wetware"
experiments that again involve biological media.

By embodying linguistic code within chemicals and encoding chemicals
into linguistic code, Kac's *Genesis* exploits this feedback between embodied

and encoded media that is central to contemporary biological research. Kac himself argues that his emphasis on different moments of translation highlights the ethical responsibilities that link texts and biology. His sentence from the Bible, for example, "was chosen for its implications regarding the dubious notion of (divinely sanctioned) humanity's supremacy over nature," and he used Morse code to translate linguistic text into a gene-friendly code because, "as first employed in radiotelegraphy, [Morse code] represents the dawn of the information age—the genesis of global communications."[22] However, like the molecular biological practices upon which it relies, *Genesis* is premised on the principle that simply representing a linguistic sentence and its genetically "encoded" form is not enough. Rather, this sentence and code must also be used to modify biological processes, and these modified biological processes must then themselves modify the source text. Kac's *Genesis* is not interested in the "disembodiment of information" that many scholars in the humanities have come to see as the hallmark of molecular biology but rather exploits the feedback loops between dry and wet biology upon which the practice of molecular biology in fact depends.

THE THIRD ERA: BIOART AND BIOTERRORISM

Davis and Kac were able to integrate the practices and techniques of molecular biology into their artworks in large part because they were able to link themselves to larger scientific research communities. Steichen, in a sense, had worked on his own, for though he depended upon publicly accessible scientific literature for his knowledge of new theories and techniques of genetic intervention, he was able to breed his delphiniums without significant assistance from scientists interested in heredity.[23] Davis and Kac, by contrast, rely heavily on assistance from scientific research communities for materials (plasmids, synthetic DNA sequences, biological media, and so on), laboratory space, and basic scientific know-how and techniques. Most vitalist bioart produced since the mid-1980s, in fact, depends upon these informal material and informational "gifts" from biological researchers to bioartists (and thus this too is a point of difference between the first and second eras of vitalist bioart).

Precisely because vitalist bioart depends so heavily upon these links between biological researchers and bioartists, a recent court case involving a

bioartist and a research scientist seems likely to alter these relationships and thus mark the transition to a third era of vitalist bioart. This court case had its origin in a sad event: on 11 May 2004, Hope Kurtz suffered a heart attack in her home and died. Hope Kurtz was married to Steven Kurtz, a professor of visual studies at the State University of New York at Buffalo and cofounder of the Critical Art Ensemble artist group. When emergency workers arrived at the Kurtz home, they noticed several petri dishes that Kurtz intended to use as part of an upcoming Critical Art Ensemble bioart project. The police who accompanied the paramedics apparently became worried that Kurtz might be a bioterrorist, and Kurtz's house was sealed. In the hours and days afterward, agents from the Federal Bureau of Investigation (FBI), the Joint Terrorism Task Force, Homeland Security, the Department of Defense, the Buffalo Police Department, the Buffalo Fire Department, and the state marshal's office all began investigations of Kurtz and his home. Kurtz was held and questioned for a day, and many of his friends and colleagues have since been questioned by the FBI.

On the basis of the information received from Kurtz and his acquaintances, the commissioner of public health for New York State quickly determined that the biological samples in Kurtz's home were harmless and that Kurtz was not a terrorist. However, the FBI subsequently charged both Kurtz and Robert Ferrell, the former head of the Department of Genetics at the University of Pittsburgh's School of Public Health, with mail fraud. Since the passage of the Patriot Act in 2001, successful prosecution of this charge could lead to a maximum sentence of twenty years in prison for Kurtz and Ferrell.

The basis of the government's case was that Ferrell had sent bacteria to Kurtz through the mail.[24] Sending bacteria through the mail is in and of itself neither illegal nor unusual—this is a standard method, in fact, used by biologists to exchange materials with one another. However, the FBI alleged that Ferrell's use of the mail to send these materials to Kurtz, specifically, was illegal, for Kurtz was not a registered member of the American Type Culture Collection (ATCC). The bacteria that Ferrell sent to Kurtz were initially obtained from ATCC, an enormous nonprofit repository of cell lines (i.e., an organization that accepts cell lines from researchers and then makes these available to other researchers at relatively low cost). ATCC stipulates that in order to purchase biological materials from their organization, the purchaser must register with the company. Registered customers can then

pass on products they have purchased from ATCC, but only to other regis-
tered customers. Ferrell was registered with ATCC, but Kurtz was not. The
FBI thus argued that Ferrell had engaged in mail fraud insofar as he and
Kurtz had failed to observe the conditions stipulated by ATCC. Though it is
probable that this ATCC provision is frequently (albeit unknowingly) vio-
lated as biological researchers exchange materials with one another, the FBI
prosecution of Kurtz and Ferrell made it clear that exchanges between scien-
tists and artists would receive much closer scrutiny in the future.

In 2007, Robert Ferrell—apparently exhausted by the case, recurring
cancer, and several strokes—pled guilty to a lesser misdemeanor charge.
Kurtz's case went on for another year but was finally decided in Kurtz's
favor in early 2008. The federal judge Richard J. Arcara ruled that the case
against Kurtz was "insufficient on its face," and the government decided not
to appeal this judgment. Yet despite this "positive" outcome for Kurtz (and
slightly less positive outcome for Ferrell), their lengthy and expensive trials
have cast a long shadow over the sort of collaboration between scientists and
artists upon which vitalist bioart depends. Publicly, scientists have rallied
around Ferrell and Kurtz: in 2004, for example, the editors of *Nature* called
on their readers to support Kurtz, and bioartists more generally. Yet there is
little doubt that the high visibility of this case within the biology commu-
nity will encourage many researchers to think twice before working with
bioartists in the future.[25]

It seems fairly certain that the FBI's interest in Kurtz and Ferrell was
largely a response to concerns about bioterrorism that were amplified by the
al-Qaeda airplane attacks on the World Trade Towers in 2001. At the same
time, though, this case should not be seen solely in the light of concerns
about bioterrorism, for it is also exemplary of a more general trend toward
greater and greater "rationalization" of exchanges of biological material and
information between individuals and between institutions. Within uni-
versity hospital systems, for example, it has become increasingly common
to use "informed consent" forms as a means for establishing clearly that
patients relinquish any legal rights in the samples they provide for research
purposes.[26] In similar fashion, many universities require that researchers
fill out Material Transfer Agreements (MTAs) before sending any biological
materials to scientists at other universities. (MTAs establish in advance the
legal rights of each group to both the materials in question and any inven-

tions developed from the materials.)[27] From this perspective, the FBI case against Kurtz and Ferrell is evidence of a more general interest on the part of governmental bodies, regulatory institutions, and universities in discouraging informal exchanges of biological materials between individuals and groups.

In this sense, then, the government case against Kurtz and Ferrell marks a third era of vitalist bioart, one in which artists and scientists have to contend with a legal and political context in which the exchange of biological materials is subject to increasing legislation. The consequences of this context for vitalist bioart were in some ways already evident before the case against Kurtz and Ferrell. The curator of the Gene(sis): Contemporary Art Explores Human Genomics exhibition, for example, discovered that, because the site of the show—the Henry Art Gallery—was affiliated with the University of Washington, it was also subject to the university's biosafety regulatory policies. The university exerted its authority by forbidding the use of live *E. coli* in the exhibition, with the result that in that exhibition Eduardo Kac's *Genesis* did not employ actual *E. coli* but instead projected a videotaped image of *E. coli* on the gallery wall. Other curators have run into similar problems: Jun Takita's transgenic moss-brain installation *Light, Only Light* (2004, 2008) at the 2008 sk-interfaces exhibition in Liverpool, England, for example, had to be significantly altered the day before the show because of university worries about biosafety issues.[28] Insofar as this relatively strict regulatory atmosphere seems likely to persist into the indefinite future, vitalist bioartists will likely have to contend with both the threat of prosecution and exhibition cancellations for some time to come.

3

BIOART AND
THE FOLDING
OF SOCIAL SPACE

FOR MANY SCHOLARS IN THE SCIENCES AND THE HUMANITIES—THE present writer included—the legal charges against Steven Kurtz and Robert Ferrell came as a shock. The federal case against Kurtz and Ferrell seemed to constitute a clear overreaction on the part of the U.S. government, and it was frightening to believe that a respected geneticist and a scholar-artist might go to jail for engaging in the kind of materials exchange that was such a part of everyday science. These charges thus seemed to some to be more of a post-9/11 "communication" directed at all those interested in criticizing the federal government or large corporate interests, with Kurtz's and Ferrell's legal problems serving as the medium of this message.

Though I have little doubt that this kind of consideration did play into the decision to prosecute Kurtz and Ferrell, I would nevertheless like to use this case as a point of departure for a different kind of consideration, one that focuses more on why a collaboration between an *artist* and a *scientist* might inspire such distrust. That the federal case focused on mail fraud—and that federal authorities indicted not just Kurtz but also Ferrell—highlights the fact that contemporary vitalist bioartists are not isolated, Victor Franken-stein–like figures, tinkering with biological techniques and samples in their backyards or basements. Rather, vitalist bioartists depend upon the same sorts of exchanges of materials and information that make academic (and, to a lesser extent, corporate) biological research possible. Of necessity, vital-ist bioartists must link themselves to larger scientific research communities, for it is only by working with researchers that bioartists can learn the tech-niques and obtain the biological materials that they employ in their art. Joe Davis, for example, worked with biologists at the University of California,

Berkeley, and at Harvard University on *Microvenus;* Natalie Jeremijenko's *One Tree* required the assistance of a botanist; and Steve Kurtz and the Critical Art Ensemble have consistently created their art projects in consultation with scientists such as Robert Ferrell. Vitalist bioart, in short, is an inherently collective endeavor, dependent upon the processes of so-called normal science, such as the formal and informal circuits of communication by means of which colleagues pass on techniques and samples to one another.

Yet even as vitalist bioart participates in these processes of normal science, it at the same time transforms these processes, creating new linkages of information, biological materials, and groups of people. It was no doubt in part an awareness of this transformative dimension of vitalist bioart that led to the federal case against Kurtz and Ferrell, and in this chapter and the next I will investigate these new linkages enabled by vitalist bioart from two different perspectives. I focus first on a theoretical account of the way in which bioart creates social changes, and then I turn, in the next chapter, to a theoretical account of how an individual's "sense" of these changes produces an affective charge.

My primary goal in this chapter is to account for the social and political environment within which vitalist bioart operates. As I noted in chapter 1, bioart is often understood as positioning itself in some way vis-à-vis corporate interests in biotechnology, but here I want to describe more precisely how bioart could so position itself. My argument, in short, is that bioart operates within an "ecology" of relationships between research environments, corporate environments, and the public that was legally and politically formalized in the late 1970s and early 1980s through a congressional act (the Bayh-Dole legislation). In the context of biotechnology, this legislation introduced subtle but far-reaching changes in the relationship between academic science and business, yet what is particularly significant is that it did so by using new patent legislation as a way of creating a small "fold" in the space between research institutions and corporations, drawing these two closer to one another. Vitalist bioart, I argue, operates *within* this ecology rather than, for example, "outside" it, from some position of distance. However, the fact that vitalist bioart is immanent to this ecology is in a sense its strength, for it is thereby able to appropriate this same logic of the fold, bringing elements of this ecology that were distant from one another close together and separating elements that were linked. It is thus likely that an

awareness of this innovative capacity of vitalist bioart itself—its capacity for creating social change by appropriating the logic of the fold—made the collaboration between Kurtz and Ferrell seem so threatening to federal authorities, and so worthy of serving as an example.

BAYH-DOLE AND THE ECOLOGY OF INNOVATION

In chapter 2, I noted that the second era of vitalist bioart depended upon new tools and techniques of molecular biology that first began to emerge in the 1970s. These new tools and techniques allowed researchers to focus not just on "cracking the genetic code" but also on combining elements from different living beings to create new entities. In the United States, significantly, this interest in biological innovation emerged in a political and cultural context that was itself committed to the more general virtues of "innovation." In the early 1970s, a series of government and university studies appeared that purported to show a loss of "innovativeness" in U.S. industry when compared with other countries (particularly Japan and West Germany). This supposed decline in U.S. innovation was measured by a "decreasing number of U.S. patents issued to U.S. inventors and an increase in patents issued to foreign investors," and some commentators concluded that the U.S. was in the midst of a national "innovation crisis."[1]

Some members of the U.S. Congress decided to address this innovation crisis, and numerous congressional hearings were held on this topic in the late 1970s. Many congressional witnesses argued that the real source of this problem was the U.S. government itself, for—so the argument went—the government often patented inventions produced with the help of federal grants but then did not develop these inventions commercially. The Bayh-Dole Act, a piece of legislation introduced by Senator Birch Bayh, a Democrat from Indiana, and Senator Robert Dole, a Republican from Kansas, proposed to address this problem. The Bayh-Dole Act sought to solve the U.S. innovation crisis by establishing a new "innovation ecology" that would make it much easier for universities, individuals, and private corporations to patent inventions that had benefited from federal funding.[2]

I will suggest below that vitalist bioart is itself part of—or at least positioned within—this innovation ecology enabled by the Bayh-Dole Act, and so it is important to establish here precisely what this legislation accom-

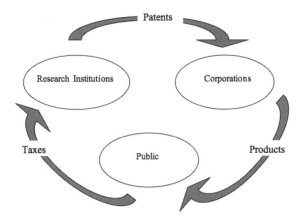

FIGURE 3.1 The "innovation ecology" facilitated by the Bayh-Dole Act. Beginning at the bottom and moving to the upper left: money, information, and samples flow from the public to research institutions. Research institutions then make basic discoveries, which are channeled to the corporations. As a result of competition between corporations, useful drugs and therapies then flow to the public, in exchange for money.

plished. The Bayh-Dole Act was passed in 1980, and it was intended to facilitate innovativeness by encouraging particular flows of money and materials within this innovation ecology. The innovation ecology was to have three primary nodes: the public, research environments (such as universities), and corporations (fig. 3.1). In the context of biotechnology, for example, the public—through the intermediary of its taxes and federal institutions such as the National Institutes of Health—would provide research institutions with money (and, in some cases, members of the public were encouraged to provide researchers with data and tissue samples).[3] Research institutions were to use the federal grants that they received to conduct basic research about biological processes. Research institutions would employ "technology transfer offices" to isolate "inventive" aspects of the basic research conducted by their personnel, and they would then seek patents on these inventive aspects. The research institution would lease these patents to corporations, in exchange for money (which would be employed for further research). Corporations, for their part, were to turn the patented protoproducts that they leased

from research institutions into actual products, such as therapies, diagnostic devices, and drugs. Through a process of competition between corporations, the public would finally receive the "fruits" of this ecology—namely, the ability to purchase new commodities.

The Bayh-Dole Act thus promised to solve a national economic problem while simultaneously expanding consumer options. By granting universities and corporations exclusive economic rights to inventions made with the help of public tax money, the U.S. government would encourage innovation on the part of U.S. industries, thus making these industries more competitive vis-à-vis trading partners such as Japan and West Germany. In return, U.S. consumers would receive a wealth of helpful health products and services. Whether or not the innovation ecology has delivered on this latter promise remains a debated question. However, it is certain that this legislation has indeed encouraged a massive increase in the number of successful U.S. patent applications—many of which are submitted by major (and often publicly funded) U.S. research institutions—and U.S. consumers are awash in an ever-increasing deluge of biotechnological products and therapies. Moreover, the logic of Bayh-Dole has effectively been exported to many other countries through international agreements such as the 1994 Agreement on Trade Related Aspects of Intellectual Property Rights (TRIPS), which for some is evidence of the success of this innovation ecology. As I will discuss below, these changes are not universally seen as a sign of "success," and bioart is often understood as a form of criticism of the shortcomings of this innovation ecology. There is little disagreement, however, that this environment has provoked major shifts in the relationships among the public, research institutions, and corporations.

What is perhaps most striking about this innovation ecology is the relatively simple means by which it achieved such significant social change. The Bayh-Dole legislation did not seek to increase innovativeness through the creation of, say, a large national "center for innovation" or a series of new research institutions. Rather, this legislation simply sought to position existing business practices in closer proximity to existing research practices. Patents were to serve as the medium of this "stitch" (fig. 3.2). The Bayh-Dole legislation was motivated by the premise that uncertainty about property rights had discouraged both research institutions and corporations from following up on some protoinventions developed in research institutions.

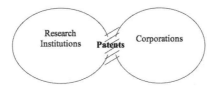

FIGURE 3.2 New patent rights as the "stitch" that enables the innovation ecology.

Academic researchers and research institutions, for their part, were more interested in the academic prestige that accompanied new discoveries and thus were unlikely to follow up themselves on "mere" applications of discoveries or protoproducts. Corporations, on the other hand, *were* interested in product development, but they were faced with a heterogeneous "field" of protoproducts produced in research institutions. While some of these protoproducts clearly belonged to research institutions, it was not clear who ultimately owned others (namely, those developed with the assistance of federal tax money). The new patent law homogenized this field by allowing universities to assert property rights even on developments produced with the help of federal grants. Technology transfer offices within research institutions could then seek out within this homogeneous field those particular protoproducts that they thought might be of interest to corporations.

Thus, though the innovation ecology itself was quite complicated, with many different kinds and directions of flows of information, money, and materials, what brought this ecology into existence was a small and simple fold in the space between research institutions and corporations, a fold that brought the processes of science and business closer to one another.[4] This fold, moreover, was understood, not as a temporary patch, but rather as a means for establishing an entirely new "ecology." Thus, once the innovation ecology came into being, it would perpetuate itself. Like a natural ecology, such as the cycle of evaporation and condensation that continually transforms lake water into clouds and back again, this innovation ecology would persist into the future, continuing to shower biomedical innovation down upon an ever-healthier public.

Though my description of the Bayh-Dole Act as producing a "fold" of social fabric is in a sense a metaphor, it is nevertheless one that I would

like to pursue as a way of understanding both this legislation and, later in this chapter, bioart itself.[5] This concept of the fold helps us in at least three ways. First, thinking of research institutions, corporations, and consumers as embedded within a "fabric" helps us to make sense of how the relatively small legal changes introduced by the Bayh-Dole Act could nevertheless produce such wide-reaching effects. The legal changes introduced by the legislation were small in the sense that they did not seek to dictate specific transformations in the day-to-day practices of either academic researchers or businesspeople. It was important to the bill's proponents, in fact, for each of the systems encompassed by the innovation ecology to retain its own, and quite different, forms of complexity: academic research was to remain academic research, business was to remain business, and the public was to remain the public. However, by creating a small fold that drew academic research closer to corporate product investment decision making, a new *dimension* of interaction between these systems would emerge—and thus, even as academic science remained academic science, it would interact with business in a new way. This new dimension of interaction in turn would enable relatively large changes in the relationships among research, business, and health.

As I note in the next section, many critics have questioned whether Bayh-Dole has in fact allowed academic science to remain academic science. However, my point here is that the concept of the fold allows us to understand how older forms of practice can persist and retain their own dynamics even as new forms of social practice emerge. Even nearly thirty years after the passage of Bayh-Dole, for example, the practices of biological academic research remain substantially different from the practices of corporate biotechnology.

Second, insofar as it appeals to notions of stretching and bending, the concept of the fold also allows us to consider how some parts of a system might change in different ways than others. Within the system of academic research, for example, the Bayh-Dole Act has arguably altered the practices of biologists working on human genetics far more than it has altered the practices of, say, the *E. coli* research community.

Third, the concept of the fold helps to focus our attention on the *specific means* through which folds are produced. I take it as axiomatic that it is in fact quite difficult to create folds. To create a fold, one must locate a specific

technique, tool, or practice that will successfully draw two separate systems together. A specific technique, tool, or practice can successfully establish a fold only if it is located along a virtual "crease" between systems—that is, an axis that links two systems through some sort of isomorphism. In the case of the Bayh-Dole Act, intellectual property rights functioned as the specific tool through which a fold was created, and they did so in large part because this tool established a virtual axis between university funding and corporate profit.[6] Yet precisely because the fabric that a fold draws together remains both malleable and in tension, it is never certain that a fold will "take." Nor, even if it does take, is there any guarantee that a fold will necessarily persist, for—as I note in the next section—the social field can always be refolded in new ways.

BIOART, CRITIQUE, AND DISTANCE

As I noted above, there is by no means universal agreement that the development of this innovation ecology has been for the best. Some critics charge that though this ecology should work in principle, in actual practice it has run into serious problems. Demands for reform of the Bayh-Dole Act are motivated by the premise that the fold created by the original legislation did not in fact leave the existing and separate dynamics of science and business in place but instead blurred the boundaries between the research institution and the corporation. Reformers suggest, for example, that researchers who hope to become patent owners may be less willing to "freely" share information and materials with other researchers, and this resistance in turn hinders the free flow of information and materials upon which the research sphere is supposed to depend.[7]

Other critics—often less hopeful that this ecology can simply be reformed—argue that this small fold between science and business has created unintended folds in other areas of social practice and encouraged injustices at the level of both individuals and groups. They charge, for example, that this system implicitly encourages medical researchers to treat patients and patient populations as "raw material" from which economic value can be freely derived. Moreover, this innovation ecology subtly changes the relationships between the public and health care, positioning the public as "consumers" of health care that is largely to be provided by corporations (rather

than, for example, as citizens for whom health care is a responsibility of government). In addition, this ecology encourages the belief that health will be primarily a matter of access to proprietary therapeutics and drugs—rather than, for example, changes in lifestyle—and that those with the economic means have a quasi right to extend their lives as long as is medically possible. Finally, it is not entirely clear how a system that was originally intended to establish U.S. economic dominance over its trading partners will necessarily translate into an equitable *global* system of health care production.[8]

Bioart frequently has been aligned—both by bioartists themselves and in popular and academic discussions of bioart—with these more global criticisms of the contemporary innovation ecology. Bioartists such as Natalie Jeremijenko and Critical Art Ensemble, for example, explicitly stress the "critical" dimensions of their work, while for W. J. T. Mitchell, bioart should be understood as really nothing but the "critical debate" about biotechnology that bioartworks inspire, whatever pretensions particular bioartists may have about their use of life as a medium.[9] Though more laudatory of bioart than Mitchell, legal scholar and bioethicist Lori B. Andrews also describes bioart as a "public policy medium," in the sense that it collectively facilitates public debate about "the manner in which [biotechnologies] are being integrated into society," while the editors of *Nature*, in their defense of bioart, argue that Steve Kurtz and the Critical Art Ensemble "provoke public discussion" by "us[ing] scientific tools to produce commentaries of the ways science and capitalism are shaping modern society."[10]

This understanding of bioart as a mechanism for generating critique generally relies implicitly on a "public sphere" model of social change.[11] Within this model, bioartists are understood as sufficiently distant from their object of critique that they can perceive aspects of the relationships between science and business that remain hidden to groups with specific interests, such as scientists and businesspeople. From this position of relative disinterest, bioartists are then able to produce works of art that allow members of the public to inform themselves more fully about the realities of biotechnology. This knowledge allows these members of the public to adopt their own stance of distance from the special interests that currently control discussion of biotechnology. In this way, bioart contributes to a collective public dialogue about the future direction of biotechnology.[12]

FOLDS WITHIN FOLDS

Though bioart may indeed encourage critical debate, I would like to take a different approach to the question of how it produces social change. A different model seems necessary, for understanding bioart primarily as a contribution to a public sphere of debate—and understanding this contribution as premised on a distance between bioart and academic science and business—strikes me as insufficient for several reasons. First, as I noted in the last chapter, contemporary bioartists almost invariably depend upon close links with research institutions (and, in some cases, with commercial entities). That bioartists do not pursue research science or business careers does not negate the fact that they nevertheless exploit their links with research scientists for their own artistic career advancement, begging the question of why this ought not to count as itself a kind of "interest." Second, many of the desires that motivate bioart seem to be drawn *from* this innovation ecology itself. So, for example, none of the bioartworks that I have described (with the possible exception of Rockman's *The Farm*) seems to mount a critique of biotechnological innovation per se. Instead, the experimental nature of these works of art suggests that what these artists desire is *more,* rather than less, innovation; what disturbs these artists, in other words, is not biotechnological innovation in and of itself but rather a sense of biotechnological innovation that is understood solely within terms dictated by contemporary linkages between research institutions and corporations. Finally, the apparently shared consensus that bioart addresses a public sphere rests on an implicit theory of art that is entirely consonant with the basic schema of the innovation ecology. Rather than understanding art as, for example, a dialectical means for creating class consciousness, this appeal to the public sphere suggests that art is a means for producing a dialogue among various "stakeholders" of the innovation ecology.

Given these problems with the premise that bioart depends upon a distance from the innovation ecology, I propose instead that we understand bioartists and bioart as *part* of this field. As a consequence, the power of bioart emerges not as a function of its distance from, or its power to "reflect on," the innovation ecology, but rather as a function of its ability to alter the flows of this ecology from within. Rather than critiquing this ecology from a separate and protected space, bioart instead appropriates the governing logic

of this ecology, producing its own folds of information, money, and materials. From this perspective, the fact that bioartists are themselves interested parties, that the desires that motivate their projects are drawn from this field, and that their vision of a public sphere seems tied to this ecology are not necessarily intractable problems or evidence of bad faith on the part of the artists. Rather, these interests, desires, and goals can serve as the vectors through which vitalist bioart produces new folds.

New folds can be produced in several different ways. So, for example, representation can be employed to create new informational flows between the various nodes of this ecology. Information flows are vital for the innovation ecology in several ways. The innovation ecology depends upon public support, in the form of both tax money (which funds research) and a willingness to purchase products produced in the corporate sphere, and to achieve this support, both governmental and corporate institutions encourage flows of information that represent both the science conducted at research institutions and the commodities produced by the corporate sphere as virtuous and safe. Catherine Wagner's *-86 Degree Freezers (Twelve Areas of Crisis and Concern)*, however, works against the premise that flows of information about research should take the form of "news" about new "discoveries," and she instead focuses on an affective aspect of science ("concern"). Moreover, whereas the Bayh-Dole legislation was based on an understanding of basic research as simply a means, or medium, for speeding along technological development, Wagner's images document the extent to which research itself operates in excess of this utilitarian employment. Rather than using a still image to "illustrate" the dynamic process through which research is transformed into products, *-86 Degree Freezers* instead documents multiple points of stasis within the research process itself, in the form of frozen samples and tools. Yet as the title of Wagner's work stresses, these frozen samples remain the focus of research "concern" (even as they also remain the focus of a public sense of "crisis"). Researchers are not concerned because these samples are frozen; rather, they have frozen these samples because they remain objects of concern even after a particular experiment has been performed. This continuing commitment itself persists because the possible uses of these samples cannot be fully specified in advance, which in turn emphasizes that research is a practice of "concern" that operates beyond utilitarian practices of currently definable interests.

Thus, though *-86 Degree Freezers (Twelve Areas of Crisis and Concern)* simply "documents" concrete research technologies and samples, Wagner employs documentation as a means for establishing a fold that connects researchers and members of the viewing public in a new way. This fold crystallizes along an axis of "concern" that draws together the various points of stasis that I described in the first chapter. Stasis, for example, links the subject of Wagner's photography—the laboratory use of freezers to slow biological processes—with her medium, still photography. However, it also links the embodied stance of the artist herself as she discovered this point of rest within the laboratory and documented it with the embodied stance of the art gallery spectator as he or she observes the photograph. Equally important, Wagner's static image of a point of stasis within the laboratory provides the spectator with a means for adopting an embodied position that is structurally similar to that of the laboratory scientist as the latter suspends biological processes. Wagner's photograph assembles these moments of embodied stasis, creating a new axis of concern that links the artist, the researcher, and the gallery spectator to one another.[13]

Whereas Wagner's work focuses on creating a new fold within the *informational* flows of the innovation ecology, other vitalist bioart focuses on creating folds within the flows of materials, techniques, and living entities that link research environments with the public. Kac's *Genesis*, for example, brings both research organisms, such as *E. coli*, and laboratory techniques for maintaining bacteria colonies into the space of the gallery.[14] Redirecting these flows of techniques and materials into the gallery may indeed, as Kac suggests, create in gallerygoers a critical consciousness of human dominion over other species. However, whether or not *Genesis* directly facilitates this kind of critical consciousness should not be the sole criterion by means of which we assess this work of art, for *Genesis* creates a new fold with or without this consciousness. By bringing the tools and techniques of the research environment into the art gallery, *Genesis* transforms the spectator of this work from a "message recipient" into a part of the environment of the *E. coli* in the project.[15] This does not mean that the spectator's consciousness is of no importance for this work. However, *Genesis* uses the level of the spectator's awareness of the specific aspects of the project as a vector that allows individuals to move from the position of "environmental variable" to the position of "experimenter," in the sense that, as a spectator becomes aware

of the project, he or she can decide whether or not to alter the environment of the *E. coli* more directly.[16] However, the relationship between the *E. coli* in this project and the spectator does not *depend* upon the consciousness of the latter, for *Genesis* has already created a new fold as soon as living *E. coli* are sustained within the space of the gallery.

Vitalist bioart can also create material folds between the public and corporate environments. Critical Art Ensemble's *Free Range Grains*, for example, redirects flows of commercial food products, such as vegetables and breakfast cereals, into the gallery space and then links these commodities with biological research lab tools such as polymerase chain reaction (PCR) units and gel sequencing plates. *Free Range Grains* does not position the spectator of this work as part of the environment of a living being in the manner of Kac's *Genesis*. Yet to the extent that *Free Range Grains* creates a new circuit between corporate commodities and biological research equipment, it too creates a material fold whether or not a given spectator is aware of how the project works. And like *Genesis*, *Free Range Grains* employs a spectator's awareness of the specific nature of the project as a vector that allows a gallerygoer to occupy the position of experimenter—in this case, by bringing in commodities he or she has purchased for testing. In the case of both *Genesis* and *Free Range Grains,* the experimental approach of the bioartist also enables—and, in fact, almost demands—an experimental approach on the part of the spectator.

Though vitalist bioart often employs the space of the art gallery as the site of its material folds, it can also employ a more decentered approach. The online magazine *Biotech Hobbyist* (created by Natalie Jeremijenko, Heath Bunting, and Eugene Thacker), for example, is another vitalist bioart project that refolds social space by encouraging members of the public to become experimenters. Modeled on the figure of the electronics buff of the 1950s and 1960s and the computer buff of the late 1960s and early 1970s, the *Biotech Hobbyist* first appeared online in 1998 and takes the form of a "how-to" magazine. It outlines for readers how they may either buy or make biological laboratory technologies such as incubators and freezers, and it describes protocols for conducting experiments in, for example, tissue culture. Jeremijenko suggests that the *Biotech Hobbyist* is intended to facilitate public dialogue about the future of biotechnology by producing a truly informed public—that is, a public that has actual experience with biological research protocols.[17] Since

the *Biotech Hobbyist* employs the Internet as its publication venue, it is difficult—if not impossible, even in principle—to determine whether or not many members of the public actually run the experiments described on the site. However, as in the case of *Genesis* and *Free Range Grains*, the *Biotech Hobbyist* has already created a fold—in this case, more informational than material—by bringing together descriptions of biological laboratory protocols and household items. And like both *Genesis* and *Free Range Grains,* the *Biotech Hobbyist* employs a reader's consciousness of the project less as an end in itself and more as a means that allows members of the public to occupy the position of experimenter rather than to function simply as donor (of tax money and materials) or consumer.

INFORMATION AND FOLDS

By focusing primarily on creating folds rather than transmitting messages, vitalist bioart avoids a paradox that plagues many instances of prophylactic bioart. Prophylactic bioart often explicitly adopts a critical perspective on the ways in which corporately funded biological research positions the public as consumers of both commodities and special-interest claims about the virtues of biotechnology. As a consequence, these bioartworks often focus on altering the *content* of *information flows* within this innovation ecology. A work such as Alexis Rockman's *The Farm*, for example, reformats the content of the flow of information about the commodities produced within the corporate sphere. Rather than presenting these commodities as safe and virtuous, Rockman's dystopic image presents them as disturbing and disformed, while his medium—oil painting—provides a more embodied form of "information" about an alternative relationship to the natural world. Other works seek to produce similar "information resistance" by illuminating the implicit hopes and fears upon which the innovation ecology depends. Margi Geerlinks's digitally altered photograph *Twins* (2000), for example, which was exhibited in the 2002 Gene(sis) exhibition, represents a woman who erases the effects of age by applying a cosmetic product to her twin-image (fig. 3.3). Geerlinks's photograph suggests that public support for the innovation ecology is grounded in implicit hopes for bodily rejuvenation, while at the same time, her use of digital editing techniques suggests that this desire is grounded in an impossible analogy between computational and biological

FIGURE 3.3 Margi Geerlinks (Dutch, 1970–), *Twins* (2000). Fujichrome on perspex and dibond; 50 × 67 in. Image courtesy of the artist.

media: though it may be possible to erase the effects of age in a digital image of a human, it is not possible to do so for a living and breathing human.

Yet the sense that *The Farm* and *Twins* can liberate the public from its role as insufficiently informed consumer is premised on a belief that these works enable a "critical" perspective that is itself to be consumed by the art gallery–going public. Thus, even as the representational *content* of a prophylactic work of art may oppose consumerism, the *form* of the work of art often depends upon the premise that members of the public are indeed first and foremost "consumers."[18] The conclusion to be drawn from this is not that prophylactic bioart is either bad art or inescapably caught in a double-bind but rather that understanding such works as first and foremost "messages" is not a useful starting point. Or, to put this another way, if both the content and medium of *The Farm* and *Twins* indeed encourage a critical conscious-

ness on the part of viewers, this consciousness does not emerge as the result of a *distance* between these works of art and their objects of critique. Rather, *The Farm* and *Twins* produce a critical consciousness only to the extent that they *link* the space of the art gallery to other—presumably less "critical"—information flows about the innovation ecology. It is only by setting itself up as an information filter *within* the innovation ecology that a work of art such as *The Farm* or *Twins* can hope to alter this ecology.

By occupying the "space" of the fold rather than seeking to locate a protected, "pure" space, vitalist bioart, by contrast, ends up positioning gallerygoers in the role of environment or experimenter rather than message recipient. Such experimentation may produce knowledge and critical reflection (and for politically oriented bioartists such as Natalie Jeremijenko and the members of Critical Art Ensemble, such knowledge and reflection are the explicit goal of their projects). However, if vitalist bioart produces reflection, it does so not primarily because someone receives a message from this art but rather because this art involves gallery attendees in an embodied exploration of biological possibilities. This embodied engagement can take many forms, ranging from the decentralized processes of individual tinkering encouraged by Jeremijenko, Bunting, and Thacker's *Biotech Hobbyist* to the more centralized and collective forms of experimentation encouraged by Kac's *Genesis* or the Critical Art Ensemble's *Free Range Grains*. Whereas prophylactic bioart has a tendency to position the public as a body that receives "messages" from artists about the evils of scientific research or corporate interests in biotechnology, vitalist bioart engages the public as part of a more general social body that can be folded in ways that exceed the forms dictated by the innovation ecology.

Yet even as vitalist bioart draws on the existing experimental expertise of research scientists, it at the same time repositions research science itself within a more expanded sense of "experimentation." Insofar as vitalist bioart operates outside scientists' research agendas and paths of career advancement, it is premised on the willingness of a given researcher to take a chance, so to speak, on collaboration with an artist. What a given scientist will "get" from this collaboration cannot be specified in advance—though it is generally clear to all involved that this collaboration will not *directly* help scientists with their existing research work.[19] Because the outcomes of these collaborations are unpredictable, some scientists will no doubt remain indif-

ferent to vitalist bioart. At the same time, though, for many scientists, the unpredictable and experimental nature of vitalist bioart appeals to precisely that desire to "produce differences," to paraphrase Hans-Jörg Rheinberger's description of laboratory work, that motivated them to work in labs in the first place.[20] Vitalist bioart is thus able to employ this desire as the vector that draws together artists and scientists, thereby subtly altering the sense of "experiment" for both.[21]

4

AFFECT, FRAMING,
AND MEDIACY

BEATRIZ DA COSTA'S AND CRITICAL ART ENSEMBLE'S PROVOCATIVELY entitled *Transgenic Bacteria Release Machine* (2001–3), exhibited in 2003 at the Museum of Natural History in London, is an installation-style bioartwork that allows gallerygoers to press a button that causes a robotic arm randomly to select and open one of ten petri dish covers. One of the petri dishes contains transgenic *E. coli,* and thus, by pressing the button, a gallerygoer is engaging in a sort of biological Russian roulette, leaving it up to chance whether or not he or she—and the rest of the gallery—is exposed to the transgenic bacteria (fig. 4.1). In fact, of course, this is less risky than it may sound, since the *E. coli* cannot escape from the petri dishes, and the gallery environment itself is far more dangerous for the *E. coli* than the *E. coli* are for spectators.[1] Nevertheless, it is not hard to imagine hesitating for a moment before pressing that red button, of overcoming a bit of internal resistance before deciding to take a chance on "releasing" bacteria into the gallery space.

The interactive nature of *Transgenic Bacteria Release Machine* serves as a useful starting point for understanding the other half of the historical conditions of possibility of contemporary vitalist bioart—namely, what I will initially describe as the "subjective" dimension of those foldings of relationships among the public, research institutions, and corporate environments that I described in the last chapter. Vitalist bioart is possible only as a result of these foldings, yet describing these foldings is not equivalent to explaining why seeing recent vitalist bioartworks "in the flesh" *feels* exciting (whether this excitement takes the form of attraction or repulsion). It is true, of course, that galleries and museums are designed to produce a sense of "aura" (i.e., a sense of uniqueness and quasi-sacred distance) around works of art, and

FIGURE 4.1 Beatriz da Costa and Critical Art Ensemble, *Transgenic Bacteria Release Machine* (2001–3). The hand of artist da Costa is positioned over the interactive component of this installation: a red button, which, when pressed, will trigger the robotic arm to open one of the petri dish covers at random. Image courtesy of Beatriz da Costa.

to the extent that vitalist works of art are exhibited in these spaces, they partake of this sense of aura.[2] Yet the attraction of contemporary vitalist bioart cannot be fully reduced to this sense of aura, for many of these vitalist bioartworks also inspire a more inchoate feeling of "charge" that seems linked to being in the presence of something that lives, something that is there in the flesh as well. Bioartworks such as *Transgenic Bacteria Release Machine,* rather than simply providing an occasion for *observing* life, as would be the case with a zoo, instead seem to frame the spectator as a *medium* for other forms of life. The charge of contemporary vitalist bioartworks, in other words, depends in part on a gallerygoer's sense of becoming-a-medium—the sense, that is, of being part of a biological milieu that has logics of transformations that exceed the gallerygoer's own goals and interests.

Accounting for the historical conditions of possibility for contemporary vitalist bioart thus also means explaining how these vitalist bioartworks are able to produce this sense of becoming-a-medium. As I note below, some

commentators have been tempted to explain the experience of vitalist bioart either as the result of mindless fascination with the biotechnological equipment that this art employs or as a quasi-biological response of disgust to the "fleshiness" of these works of art. Yet these kinds of explanations tend to miss the *embodied* nature of the experience of these works of art, especially that oscillation between an embodied sense of being-an-agent and an embodied sense of being-a-medium that this vitalist bioart encourages. I thus turn to the concept of "affect" as a better way of explaining how recent bioartworks position gallerygoers, for this concept allows us to understand gallerygoers as elements within a dynamic system, thus linking the experience of vitalist bioart with the processes of folding that I described in the previous chapter. The concept of affect also helps us to understand the extent to which the sense of presence produced by contemporary vitalist bioart depends upon its hybridization of two earlier artistic traditions of "framing," namely, the traditions of the readymade and performance art (two artistic traditions that emerged, not coincidentally, during the first and second eras of vitalist bioart, respectively). By extending and linking these two traditions, contemporary vitalist bioart is able to produce an embodied sense of oscillation between a sense of distance and a sense of too-closeness, an oscillation that helps prolong the experience of affect. Vitalist bioart also illuminates an understanding of the artistic frame as a *vector* for transforming "spectators" into a work of art. Exploring this sense of the frame as a vector through Kant's analysis of disgust helps us both to distinguish the experience of vitalist bioart from that of disgust and at the same time to account for why these two experiences are often confused with one another.

BECOMING-A-MEDIUM AND
THE PROBLEM WITH "FEELINGS"

Like many contemporary installation works of art, *Transgenic Bacteria Release Machine* emphasizes the body of the gallerygoer. Rather than soliciting a silent, distant gaze, as one might imagine adopting before, say, a historical painting, installation art such as *Transgenic Bacteria Release Machine* encourages gallerygoers to walk around the work and physically engage it (in this case by pressing—or not pressing—a button). Yet in addition to soliciting these active bodily capacities of gallerygoers, *Transgenic Bacteria Release*

Machine also emphasizes the biological dependency of the body on the spaces in which it moves. By positioning the air in the gallery space as something that might link the *E. coli* in the petri dish with the inside of my body, *Transgenic Bacteria Release Machine* emphasizes a sense of being *within* a more general medium that connects the biology of my body with other forms of life. Nor need the sense of medium encouraged by works such as *Transgenic Bacteria Release Machine* and Tissue Culture and Art Project's *Disembodied Cuisine* stop at the borders of the gallery, for even simply learning that such a project is "out there somewhere" can produce a sort of adrenalized, excited concern (or even crisis) on the part of some who read or hear about this project.[3]

Though not every recent vitalist bioartwork engages this experience of biological openness so explicitly as *Transgenic Bacteria Release Machine*, most, if not all, depend upon variants of this sense of being an active part of a medium. For example, de Menezes's *Nature?* employs a relatively large-scale organism—the butterfly—that is unlikely to produce the same vague concern about "infection" solicited by a work such as *Transgenic Bacteria Release Machine*. Yet the thinness and flexibility of the plastic that divides the spectator from the butterflies emphasize that both of these organisms are in fact located within the same air and space of the gallery. The "protection" that the plastic offers, moreover, seems to be oriented in two opposed directions: on the one hand, it seems to protect the relatively fragile butterflies from the physically more powerful spectators, but on the other hand, it also seems designed to prevent these modified butterflies from escaping into the environment outside the gallery, where they conceivably might initiate transformations far beyond the powers of gallerygoers to address (a sense of environmental impact reinforced by the popular summary of chaos theory as the dictum that "a butterfly flapping its wings in Tokyo can cause a tornado in Kansas").

Jeremijenko, Bunting, and Thacker's *Biotech Hobbyist* project encourages an even more complex sense of the way in which people are dependent upon overlapping "connective media" that tie together networks of social and biological relations. If the *Biotech Hobbyist* feels slightly threatening, it is because I am aware that the communication medium on which the project relies—the Internet—is such that, even if I do not personally perform any of the experiments described on the Website, the project can nevertheless have an effect on me. Thus, the mere fact that these descriptions are avail-

able on the Internet, in combination with the fact that other people who access the Internet are potentially linked to me through the "media" of city interactions and airplane travel, means that I am linked to the consequences of what others might do with these experiments. Even Wagner's *-86 Degree Freezers (Twelve Areas of Crisis and Concern)*, which neither employs living matter nor explicitly encourages biological experimentation, nevertheless aligns the spectator's mode of "concern" before the painting with a scientific mode of concern that results in altered cells and tissues, and thus it too positions the spectator as part of a more general vector for transformation of the biological world. Vitalist bioart is constructed, in short, to enable an experience of simultaneous activity and passivity, encouraging in "spectators" a bodily sense of becoming (sometimes unwilling) participants and framing them as embodied parts of larger, dynamic systems, of which neither they nor the artists are fully in control.

Though recent journalistic and academic commentaries on vitalist bioart often register this complex sense of activity and passivity, they also tend to encounter difficulties when it comes to explaining *how* bioart produces this experience. Vitalist bioart is frequently described, for example, as something that "dazzles," "fascinates," or "disturbs"—words that capture, at least in part, the way in which vitalist bioart is designed to enable for gallerygoers a sense of being both actively and passively related to the work of art rather than simply remaining a distant spectator of the work.[4] Yet when it comes to explaining this captivation, fascination, or disturbance that vitalist bioart enables, the complex nature of this experience—the sense of being *both* agent and medium—is almost invariably lost. Critics of vitalist bioart such as Jeremy Rifkin and Carol Gigliotti, for example, end up interpreting this experience through a narrowly psychological lens, suggesting that insofar as vitalist bioart dazzles and fascinates, it renders spectators and bioartists passive, disabling their capacities for critical reflection on the tendencies and ethics of contemporary biocommerce.[5] Rifkin and Gigliotti in essence parse out agency and passivity to different "sites," locating the capacity to act entirely on the side of the surrounding context of bioart (corporately driven biotechnology) while positioning gallerygoers as the passive, entranced objects of these actions. For these critics, there is relatively little point in analyzing more specifically the experience of vitalist bioart, presumably because no matter what nuanced sense of "embodiment" this art might pro-

duce, this would in the end simply be a psychological trick for transforming potentially rational agents into unwitting media for the perpetuation of "business as usual."

Other commentators, though more attentive to the combination of activity and passivity that vitalist bioart encourages, end up reducing this experience to "natural" responses of repugnance or disgust. National Public Radio *Day to Day* host Madeleine Brand, for example, framed a story on the work of Tissue Culture and Art Project bioartists Ionat Zurr and Oron Catts with a warning to her listeners that they were about to hear a report that they "might find just a little repugnant, morally or otherwise."[6] Brand's warning seems to capture a popular (even if frequently unvoiced) perception of bioart ("That's gross!"), and her warning suggests that for many listeners, no matter how nuanced a news report might be, simply to hear about vitalist bioart is to risk feelings of repugnance. While Brand leaves unanswered the question of whether such repugnance is merited or not, her framing seems to point to that purported "deep wisdom" of repugnance proposed by Leon Kass, University of Chicago bioethicist and former chairman of the President's Council on Bioethics. In his 1997 congressional testimony against human cloning, Kass acknowledged that, though "[r]evulsion is surely not an argument," nevertheless, "in crucial cases repugnance is often the emotional bearer of deep wisdom beyond reason's power fully to articulate it." As a consequence, when we are presented with certain kinds of biological manipulation, "we intuit and feel immediately and without argument the violation of things we rightfully hold dear."[7] From this perspective, experiences of repugnance and disgust are quasi-instinctive signals that we should stop thinking and simply get away from—or, even better, get rid of—whatever has provoked these feelings. Experiences of repugnance and disgust thus allow an individual to channel—that is, to become a medium for—a deep wisdom that exceeds our powers of reason.

Unfortunately, neither of these explanations seems to describe adequately the actual experiences produced by works such as *Transgenic Bacteria Release Machine* or *Nature?* Accounts that focus primarily on the psychological effects of recent vitalist bioart—that is, the purported tendency of vitalist bioart to hinder critical reflection on biocommerce—imply that the criterion for counting something as "art" is primarily its capacity to produce rational reflection. As a consequence, such an approach has little interest in, or abil-

ity to analyze, forms of art that operate by folding bodies—both human and nonhuman—into new relationships and that function by producing embodied senses of agency and becoming-media. Explanations that emphasize disgust and repugnance, though they do a better job of capturing this embodied aspect of the experience of vitalist bioart, nevertheless also risk simplifying this experience insofar as they imply that vitalist bioart simply serves as a trigger for "natural" feelings. Neither of these explanations captures the fact that vitalist bioart encourages a hybrid sense of activity *and* passivity—a sense, for example, that I am both able to choose whether to alter the environment of transgenic bacteria (either by releasing them or changing their exposure to ultraviolet light, as in *Genesis)* and at the same time I am exposed to the decisions of others and to the effects of these living beings upon my own body and environment. Psychological and naturalist explanations of vitalist bioart in fact seem more oriented toward explaining the experience of *hearing about* vitalist bioart than accounting for the complex oscillation between an embodied sense of agency and an embodied sense of becoming-a-medium that experiences of vitalist bioart encourage.[8]

AFFECT, SPEED, AND ELEMENTS

Recent discussions of "affect," however, provide a much more promising approach for explaining this oscillation between a sense of agency and a sense of becoming-a-medium. In the work of Gilles Deleuze, Félix Guattari, and Brian Massumi, "affects" are understood, not as individual psychological responses to an existing state of affairs, but rather as what we might best describe as the "embodied indices" of the emergence of new states of affairs. Affect, in other words, emerges when an individual becomes linked in new ways to his or her surroundings (a linkage that thereby also changes those surroundings).[9] An affect is thus different from a feeling, for where "[f]eeling implies an *evaluation* of matter and its resistances"—an evaluation that is possible only from a fixed, habitual, subjective position—affects, by contrast, "relate only to the moving body itself, to speeds and compositions of speed among elements.[10] Thus, whereas a feeling emerges as *a reaction to* a state of affairs (i.e., a given constellation of "matter and its resistances"), an affect is a form of intensity that facilitates *an active transformation of* a state of affairs. Though the individual is, in a sense, the "site" at which affect is experienced,

this experience nevertheless occurs precisely when (and because) the individual is changed by serving as a vector for establishing new relationships with his or her milieu.[11]

Insofar as it highlights both the capacity-for-affecting and the capacity-for-being-affected, the concept of affect helps us to link the experience of recent vitalist bioart with my account of folding from the last chapter. As I noted there, vitalist bioart is premised on the principle that art should not seek to *protect* gallerygoers from the problematic of biotechnology but should instead alter systems of biotechnology by refolding their elements in new ways. As a consequence, vitalist bioart is not intended solely to encourage reflection on the problematic of biotechnology "as it is" and as though it were happening "elsewhere." Rather, it employs the experience of gallery-going as a medium for changing what Deleuze and Guattari call the "speeds and compositions of speed among elements" of this problematic. To refold relationships among biotechnological tools and techniques, commercial institutions, and the public means, in other words, altering the speeds and compositions of speed among these elements of the problematic of biotechnology. From this perspective, the gallerygoer is thus neither solely the "active" agent for nor solely the "passive" medium of this process but is *an element within* this process, one that has both the capacity-for-affecting and the capacity-for-being-affected. By emphasizing both the capacity-for-affecting and the capacity-for-being-affected, the concept of affect reminds us that we need to situate the experience of vitalist bioart within a dynamic process of systemic folding (rather than, for example, understanding this experience solely in terms of either psychological or natural bodily responses to particular objects or states of affairs).[12]

The concept of affect also allows a more nuanced account of the experience of recent vitalist bioartworks than do narrowly psychological or naturalistic accounts. Both psychological and naturalistic accounts tend to make sharp distinctions between mental and bodily phenomena, locating responses to vitalist bioart either "in the head" or "in the body." Yet a work such as *Transgenic Bacteria Release Machine* encourages an experience that establishes a continuum between "mental" and "physical" responses. Though *Transgenic Bacteria Release Machine* may encourage abstract conceptual responses ("Should artists be allowed to engage in biological experimentation?"), these are linked to situated thoughts ("Is *E. coli* dangerous?")

and embodied decisions ("I'll press the button"), as well as dimensions of embodiment that are not under the control of the gallerygoer (e.g., one's corporeal "openness" to microbial forms of life and the dependency on the decisions of others to press or not press the button). By emphasizing both the embodied capacity-for-affecting and the capacity-for-being-affected, the concept of affect focuses attention on the continuum of affectability that vitalist bioart enables, rather than seeking to force this continuum into the either/or of psychology or biology.

AFFECT AND FRAMING I: READYMADES

Understanding the experience of bioart in terms of affect also allows us to focus more closely on the "artistic" conditions of possibility of contemporary vitalist bioart—that is, the ways in which recent vitalist bioart depends upon twentieth-century techniques of *framing* objects and experiences as "art" in order to prolong experiences of affect. This is an important aspect of vitalist bioart, for it is intended not simply to produce but also to prolong experiences of intensity. This goal distinguishes recent vitalist bioart from other experiences which may produce affect through a sense of becoming-a-medium. A contagious epidemic, for example, also produces affect, but then quickly resolves into what Massumi calls "[f]ormed, qualified, situated perceptions and cognitions," as people mobilize to check the spread of the infection.[13] Vitalist bioartworks, by contrast, seek to extend the experience of affect rather than allowing it to resolve into situated perceptions and cognitions.

This prolongation or perpetuation of affect depends in part on that aspect of "unverifiability" of elements of recent vitalist bioart to which both Mitchell and Gessert have pointed. It is often difficult to determine whether we are actually in the presence of artistically engineered life or not, and this uncertainty prevents us from knowing exactly how to situate our perceptions and cognitions ("Is this real or not? Is it dangerous or not?"). At the same time, though, it is a curious fact—and one that we should not take simply as a given—that placing assemblages of metal, plastic, glass, and fluids or fleshlike substances in an art gallery can produce suspensions of certainty and experiences of intensity. The ability of vitalist bioart to produce this effect in many gallerygoers is testimony to the fact that it does not simply

"directly present" living beings and tissues but instead *frames* them in ways that encourage in spectators a sense of reality (i.e., a sense of actually being in the presence of something living). To produce this sense of reality, recent vitalist bioart hybridizes two twentieth-century traditions of artistic framing, both aimed at confusing the distinction between "life" and "art": the technique of the readymade and the technique of performance.

Contemporary vitalist bioart is able to establish a sense of plausibility for its claim to use living beings and tissues as artistic media in part because it reframes biotechnological tools and techniques as "readymades" within the space of the gallery. The term "readymade" was coined by Marcel Duchamp in the early twentieth century to describe the practice of reframing industrially produced (i.e., "readymade") consumer items, such as bicycle wheels, bottle-drying racks, and urinals, within the space of the art gallery (fig. 4.2).[14] By introducing an object that was readymade elsewhere into the space of the gallery, Duchamp emphasized the extent to which the gallery itself serves as a medium for establishing objects *as* art. Art, the readymade suggests, does not preexist its exhibition in an artistic space; rather, the exhibition of something establishes its (possible) status as art. Individuals may not end up judging that everything exhibited in a gallery is indeed "art," but the readymade illuminates the fact that everything exhibited within a gallery becomes a plausible candidate for art status.[15] An implicit awareness of this fact was no doubt the reason that Duchamp's urinal readymade was rejected by the Society for Independent Artists for their inaugural 1917 exhibition in Grand Central Palace, New York: even though this rejection betrayed the society's stated principle of exhibiting *all* submissions, regardless of talent, the society itself clearly did not want to become the medium for granting art status to readymade objects such as urinals.

The readymade positions the artist less as autonomous "creator" than as an agent who *selects* objects from the realms of non-art and brings them into the space of the gallery. However, the specific objects that Duchamp chose as readymades, such as mass-produced urinals and combs, highlight the importance of one specific realm of non-art for this technique: namely, the realm of industrial production. The readymade is, in this sense, bound to the same late-nineteenth-century dynamics of industrial production of consumer goods that I outlined in chapter 2. I noted there that Edward Steichen's hybrid delphiniums had to be understood against the background of

FIGURE 4.2 Marcel Duchamp (American, born France, 1887–1968), *Fountain* (1950; replica of 1917 original). Porcelain urinal; 12 × 15 × 18 in. In this "readymade" work of art, Duchamp signed an industrially produced object with the name "R. Mutt" and submitted the work to an exhibition of the Society of Independent Artists. Image courtesy of Philadelphia Museum of Art (accession number 1998-74-1). Gift (by exchange) of Mrs. Herbert Cameron Morris, 1998; © 2009 Artists Rights Society (ARS), New York / ADAGP, Paris / Succession Marcel Duchamp. Photo: Graydon Wood.

a larger "industrialization" of food and ornamental plant production in the late nineteenth and early twentieth centuries. This process of industrialization was, however, one that affected consumer goods more generally, and it was a process that involved not simply the emergence of new technologies of mass production but also the development of new methods of distribution, marketing, and sales, as corporations sought to coordinate their increased capacity to manufacture "readymades" with markets in which they could sell those goods.[16] As Thierry de Duve has noted, Duchamp's readymades emphasized that this same industrialization of commodities affected the practice of art itself, particularly painting, since by the early twentieth century, most painters had come to rely on industrially produced paints.[17] However, by choosing readymades from the realm of non-art materials, Duchamp

was able to fold this more general transformation of consumerism into the "art" space of the gallery.[18]

Many contemporary vitalist bioartworks exploit the reframing technique of the readymade in at least two ways, drawing on this technique both to produce the sense that the work is using *real* biotechnology and using the gallery to establish the "art" status of its modes of biological experimentation. Vitalist bioart that involves considerable visible technology, such as *Genesis, Transgenic Bacteria Release Machine,* and *Disembodied Cuisine,* depends on the sense that the scientific elements of these projects (petri dishes, biological sustaining media, etc.) are indeed "readymade" biological techniques. The tradition of the readymade establishes the plausibility, in other words, that objects brought into the art gallery are indeed functional objects made for other contexts; for example, Duchamp's *Fountain* was indeed a real urinal and could have been used for its originally intended purpose had it been hooked up to plumbing. Recent vitalist bioart draws on this tradition to produce the sense that we are indeed in the presence of real biological equipment originally intended for, and used within, a biological laboratory but then subsequently appropriated by the artist for use within the space of the gallery.

Contemporary vitalist bioart also draws on the reframing technique of the readymade to invoke a sense that, however real its biological media and experimentation may be, the vitalist work of art is also *art*. Just as Duchamp's *Trap* (1917)—a readymade coatrack that was displayed at the Bourgeois Art Gallery show in New York—functioned as a coatrack but nevertheless was, within the space of the gallery, supposed to be "art" as well, vitalist bioartworks are intended to be understood as *artistic* biological experiments (i.e., real art, as well as art that is real). As Steve Kurtz's and Robert Ferrell's legal problems illustrate, the validation that "official" art spaces provide has become especially important in the post-9/11 period. Contemporary vitalist bioart needs validating "art" spaces in part so that bioartists can avoid the legal expenses and stress endured by Kurtz and Ferrell.[19] However, and more fundamentally, bioartists need some sort of "art" validation so that their projects can prolong affect. Without such validation, it becomes more likely that members of the public will indeed conclude that all bioresearch that is not directed by academic science departments or biotech corporations is indeed "bioterrorism"—and this conclusion in turn makes more difficult

that stance of expectant openness that is necessary for the prolongation of affect.

AFFECT AND FRAMING II: PERFORMANCES

At the same time as contemporary vitalist bioart appropriates the tradition of the readymade to produce a sense of reality and presence, it also draws on another tradition of reframing more associated with performance art (or "live art," as it is sometimes called). The technique of the readymade was established at roughly the same time as what I described as the first era of vitalist bioart; performance art emerged much closer to its second era. As initially practiced and theorized by artists such as Joseph Beuys, Allan Kaprow, and Chris Burden in the 1960s and 1970s, performance art was intended to expand the contexts in which "art" could occur by extending art beyond the space of the art gallery and making the "line between art and life . . . as fluid, and perhaps indistinct, as possible."[20] Keeping the line between art and life as fluid and indistinct as possible often meant undercutting the distinction between artists and spectators: Kaprow's *Household* (1964), for example, took place in an open field, and as part of this "happening," spectators were encouraged to help pull a car wreck from one point to another. Performance artists also often created "works" that existed only for the duration of an event rather than persisting as objects that could be collected and purchased.[21]

Other performance artists sought to fold art into life by creating performances that marked the artist's body in ways that would persist beyond the specific "art" performance. Chris Burden's performance pieces are among the most notorious examples of this tactic, for in works such as *Shoot* (1971) and *Trans-Fixed* (1974), he had himself shot in the arm by an assistant and nailed to the back of a Volkswagen car, respectively (figs. 4.3a–4.3b). Both of these "performances" extended beyond a specific event that could be seen or photographed, for both left lasting scars on Burden's body. Though not all performance pieces aim to mark the physical body in this way, the point of performance art is nevertheless to locate different ways of blurring the lines between "art" and "life." This frequently puts spectators in positions of uncertainty ("Has the performance started? Am I supposed to do something here?"), but also often encourages spectators to think of themselves as *part of* the work of art.

Trans-fixed
Venice, California: April 23, 1974

Inside a small garage on Speedway Avenue, I stood on the rear bumper of a
Volkswagon. I lay on my back over the rear section of the car, stretching my
arms onto the roof of the car. The garage door was opened and the car was
pushed half-way out into the Speedway. Screaming for me, the engine was run
at full speed for two minutes. After two minutes, the engine was turned off
and the car pushed back into the garage. The door was closed.

FIGURE 4.3 Chris Burden (American, 1946–), *Trans-Fixed* (1974). (a) A photograph of Burden nailed to his car, along with Burden's description of the performance. (b) Burden's postperformance scars. Relic: two nails. Case: 6 7/8 × 6 1/4 × 6 1/4 in. Collection: Jasper Johns, New York, New York. Images courtesy of the artist.

Where an early performance artist such as Kaprow seems to have understood the term "life" more in the sense of social relationships between people than in terms of biological processes, recent vitalist bioart takes his suggestion literally, moving the sense of performance to living matter.[22] For Kaprow, art could (and ought) to happen in any space inhabited or traversed by people, rather than being restricted to art galleries. Vitalist bioart, however, complicates this principle by moving art into the very biological processes that make people and their social relationships possible in the first place. By framing living matter as art, recent vitalist bioartworks produce an intense sense of "liveness" and "happening" even within the gallery.[23] And whereas Burden's projects implied that performances ought to alter the flesh of the artist in ways that would persist after the performance itself was over, contemporary vitalist bioart often *begins* with the creation of new forms of flesh, in the form of transgenic organisms or "semi-living" matter. The con-

clusion of *Disembodied Cuisine,* for example, in which the "victimless steak" was collectively consumed, joins Burden's interest in altering, or marking, living flesh with the quasi-ritualistic use of animal flesh in performances staged by the Austrian performance artist Hermann Nitsch in the 1960s. The result is a strange and unsettling hybrid "happening," in which a nonhuman form of semi-living marked flesh moves to the center of the performance.

Because recent vitalist bioartworks employ biotechnology to create "fluidity" between art and life, they often also produce a peculiar, and much more extended, sense of the space and time in which the work of art "happens."[24] Most of the vitalist bioartworks that I have described are intended to be exhibited within art galleries. Yet insofar as they involve the use of living matter and emphasize the media that are common to this living matter and the spectator (e.g., the air of the gallery), these works of art often seem to exceed the collection of physical objects located in front of the gallerygoer. The Internet interface of *Genesis,* for example, makes that work feel as though it is "happening" both within *and* outside the space of the gallery, while a work such as *Transgenic Bacteria Release Machine,* by emphasizing the "release" of bacteria, seems to extend its reach through the air that surrounds it. Insofar as many of these vitalist bioartworks make explicit the fact that their living matter was initially created in laboratories, rather than the gallery, the work of art often feels as though it began "happening" prior to its exhibition in the gallery, and the apparent autonomy of the living matter that many of these works of art employ—the capacity of organisms such as *E. coli* to replicate on their own, for example—enables a sense that the effects of the work of art might persist beyond the actual exhibition of the piece. This sense of temporal openness is exemplified by davidkremers's claim that the transgenic bacteria enclosed within the frame of *Gastrulation* are in "suspended animation," a description that suggests that the *art* aspect of the work occurs only during a temporary period of suspension of autonomous biological activity.

By hybridizing the tradition of the readymade with that of performance art, contemporary vitalist bioart is able to prolong the experience of affect, engendering in the gallerygoer an embodied oscillation between a sense of distance and a sense of overwhelming presence and between the sense that "this is just art" and the sense that "this is *real!*" Though most gallerygoers cannot be certain whether vitalist bioart truly redeploys biotechnological

equipment and processes, the tradition of the readymade ensures that this is at least plausible. And though one initially encounters most vitalist bioart-works as though they were discrete and concrete objects with clear borders, many of these same works are designed to produce a subsequent confusion about the precise borders of the work of art and to encourage a sense that both the origin and future of the work of art remain indeterminate and open. This sense of intensity and temporal openness is the experience of affect and is part of what makes it possible for bioartworks to alter the "com-positions of speed" among elements of the problematic of biotechnology.

KANT ON LIFE, ART, AND THE FRAME

The twentieth-century artistic traditions of the readymade and performance art constitute the affective historical conditions of possibility for contempo-rary vitalist bioart, in that it is by drawing on techniques associated with these traditions that these vitalist bioartworks are able to encourage in gallerygoers a sense of intensity and presence—a sense that some sort of strange life is present around, and perhaps even within, the spectator. Yet by "biologizing" that fluidity of the relationship between life and art at which the readymade and performance art aimed, recent vitalist bioartworks also revive an older approach to the relationship between art and life, one that dates back to the Romantic era of the late eighteenth and early nineteenth centuries.

An interest in blurring the lines between art and life first emerged in the work of Romantic-era literary and philosophical authors such as Novalis, F. W. J. Schelling, August Wilhelm Schlegel, and Karl Wilhelm Friedrich Schlegel, while the German philosopher Immanuel Kant contended that there was an intrinsic link between the experience of art and the "phenom-enology" of biological research (i.e., a link between the way in which art presents itself to spectators and the way in which scientists must approach living beings).[25] In hybridizing the traditions of the readymade and perfor-mance art by means of biotechnological media, contemporary vitalist bio-artists seem to be motivated by a similar sense of resonance between artistic and scientific approaches to life and the possibilities of using each as medium for the other. And as I shall discuss below, contemporary vitalist bioart is able to hybridize the traditions of the readymade and performance art in

part because it revives an approach to artistic *framing* first articulated by Kant—an approach to the frame that treats it, not solely as a border that "contains" the content of the work, but also as a vector that allows the materiality of the work of art to infect the spectator.

Kant's aesthetic theory is, at first glance, a somewhat surprising resource on which to draw for an analysis of vitalist bioart. Though Kant emphasized that aesthetics has to be understood in terms of its effects on one's "feeling of life," and though he connected aesthetics to the phenomenology of biological research, his aesthetic theory is also committed to the *formal* aspects of works of art in a way that seems at odds with the materiality of vitalist bioartworks.[26] Kant's aesthetic theory is formal in the sense that he argued that an aesthetic judgment that a particular work of art is "beautiful" or "ugly" does not depend upon the particular material existence or properties of the work of art but is instead based only on the *form* of the object.[27] As a consequence, Kant himself would have felt little attraction to a form of art that, like vitalist bioart, depends upon the actual, material redeployment of biological tools and techniques within the space of the gallery.

Nevertheless, Kant's account of disgust in the *Critique of Judgment* (1790) reveals a way in which artistic frames can sometimes be used against the grain, so to speak, to create a prolonged oscillation between a sense of distance and a sense of too-closeness that is reminiscent of the experience of vitalist bioart. Kant's discussion of disgust in the *Critique of Judgment* is quite brief and amounts to the seemingly simple claim that, though an aesthetic representation—for example, a painting of something—can make many kinds of ugly objects appear beautiful, it cannot make a *disgusting* object appear beautiful. Kant claimed, in other words, that, while it is possible to create a beautiful picture of many things that I would find ugly in reality, it is not possible to make a beautiful picture of an object that I find disgusting in reality, for (he claims) I will also find disgusting the *picture* of that object that I find disgusting in reality.

According to Kant, the reason that it is impossible to make a beautiful representation of a disgusting object is that the artistic frame of such a representation ends up engendering two contradictory responses in spectators. By positioning the picture as an *artistic* representation of something, the frame implicitly offers to provide a certain kind of experience, namely, the experience of the *form* of the represented object.[28] Such an experience, Kant

contends, can produce a kind of pleasure that is dependent on our ability to maintain a certain felt *distance* from the materiality of the object (i.e., those aspects of the object that offer themselves only to the senses). However, in the case of an artistic representation of a disgusting object, the *content* of the representation does not deliver on the offer made by the frame, and in fact provides quite the opposite experience. For Kant defines the disgusting as precisely that kind of ugly that always comes "too close" to us, for it "insists" that we engage something through our senses.[29] Thus, in the case of an *artistic* representation of a disgusting object, though the frame encourages me to expect to be able to cast a loving gaze on a distant beautiful form, instead it ends up drawing near to me the materiality of the disgusting content. An artistic representation of a disgusting object, as a consequence, produces a sort of embodied oscillation between my expectation of distance and my sensation of too-closeness.[30] This latter sense of too-closeness is, moreover, amplified by the fact that both my acceptance of the offer made by the frame and my senses themselves make me an accomplice in embracing the disgusting object.[31] Kant thus concludes:

> There is only one kind of ugliness that cannot be presented in conformity to
> nature without obliterating all aesthetic liking and hence artistic beauty: that
> ugliness which arouses disgust. For in that strange sensation, which rests on
> nothing but imagination, the object is presented as if it insisted, as it were,
> on our enjoying it even though that is just what we are forcefully resisting;
> and hence the artistic presentation of the object is no longer distinguished in
> our sensation from the nature of the object itself, so that it cannot possibly be
> considered beautiful.[32]

As Pierre Bourdieu has noted, this account of disgust helps us to understand why Kant devalues embodied forms of experience more generally. Bourdieu argues that Kant will consider as "art" only those kinds of works that allow individuals to retain a reflective distance. For Kant, the work of art must "treat the spectator in accordance with the Kantian imperative, that is, as an end, not a means. Thus, Kant's principle of pure taste is nothing other than a refusal, a disgust—a disgust for objects which impose enjoyment and a disgust for the crude, vulgar taste which revels in this imposed enjoyment."[33] Bourdieu also sees Kant's discussion of disgust as the key to

understanding the *class* basis of Kant's aesthetic theory. He notes that Kant ends up excluding from the category of art all those kinds of experiences that seem too "embodied," in the sense that they "impose" feelings. Yet not coincidentally, Bourdieu argues, this has the result of excluding from the category of art those embodied forms of experience that were at that time—and to some extent still are—associated with lower-class entertainment, such as carnivals, "light music," and "popular" forms of entertainment that demand "audience participation" (486–87). Bourdieu seems implicitly to agree with Kant that the experience of carnivals, light music, and popular entertainment really is more embodied than, for example, gazing at a painting in a museum. His point, though, is that Kant's theoretical account, though purporting to be an objective description of how people actually respond to different kinds of aesthetic experiences, is in fact an attempt to value one kind of experience over another, restricting the category of "art" to those experiences that do *not* "impose" feelings. For Kant, an object cannot be art—and, in fact, becomes disgusting—to the extent that it imposes itself upon the viewer, *forcing* a "spectator" to feel something.

Ironically, it is this same Kantian bias against imposition that seems to underwrite the criticisms of vitalist bioart that I outlined above. For critics such as Rifkin and Gigliotti, for example, as for Kant, something can be "art" only if it enables a reflective distance, and thus, the problem with vitalist bioart is that it "imposes" itself by dazzling and disturbing gallerygoers. Moreover, Brand's seeming confusion between the subject of a report on bioart and the report itself ("A report now that you might find just a little repugnant, morally or otherwise") simply echoes Kant's claim that in the representation of a disgusting object, the "presentation of the object is no longer distinguished in our sensation from the nature of the object itself."

Yet even as Bourdieu's analysis helps us to understand how Kant's distinction between "art" and "entertainment" has a class bias, and helps us to see as well the ways in which this bias is replicated in popular critiques of vitalist bioart, Bourdieu himself seems to miss the wider implications of Kant's analysis of disgust—namely, the way in which Kant positions the artistic *frame* itself as something that can, in certain circumstances, produce a sense of embodied oscillation. Kant's analysis of disgust, in other words, helps us move beyond an understanding of the frame either as something that *cuts off* that which is artistic from that which surrounds it or as some-

thing that simply "focuses attention."[34] As Kant's example of the artistic representation of a disgusting object highlights, frames make the stance of "distant appreciation" possible only because they first *link* the spectator and the object. In the case of the artistic representation of a disgusting object, for example, it is *because* there is an artistic frame that we become the "ally" of the disgusting object by actively drawing its representation close to ourselves. The frame ensures that, instead of refusing to engage with the representation, as would be the case if we saw a real instance of the disgusting object, we ourselves draw this object close and thereby allow ourselves to become caught up in its sensory qualities. The frame, in other words, can function as a vector for bringing something close, and it does so by suspending our habitual relationships to objects.

Kant himself had little interest in exploring, beyond his example of artistic representations of disgusting objects, other possible uses of the frame as vector. Yet his account nevertheless hints at other possibilities for art and its relationship to that "feeling of life" that he claims is at the basis of aesthetic experience. Though Kant himself focused almost exclusively on the organic, harmonious feelings of life that he claimed attended judgments of beauty (and, in a more mediated way, judgments of sublimity), his analysis of disgust points toward an alternative itinerary for artistic practice. In this alternative itinerary, art would aim at engendering another, different sense of life: a sense of being both embodied agent and medium at the same time.[35] This would no longer be a clear and distinct feeling of life as harmony and unity but rather a "strange," embodied sense of alien, nonorganic life.[36] This is a sense of life as fundamentally excessive, as beyond my own goals, intentions, and bodily capacities, and as something that threatens—or promises—to transform even my own agency into media for further transformations.

From this perspective, both the readymade and performance art emerge as two different twentieth-century techniques for producing a sense of the fluidity between "life" and "art" precisely by exploiting the capacity of the frame as vector.[37] And recent vitalist bioart, from this perspective, is a hybridization of these two traditions in order to explore how the "vector-frame" can be used to locate and amplify the points of affective openness to the strangeness of life itself. As I noted above, vitalist bioart often establishes an initial vector-frame by bringing gallerygoers into literal proximity with "readymade" biological equipment. Installing biological equipment within

the gallery space suspends the distinction between representation and reality, with the result that it becomes entirely plausible that works such as *Genesis* and *Transgenic Bacteria Release Machine* do not simply represent, but in fact *present*, microorganisms to gallerygoers. This suspension of the distinction between representation and reality is intensified by the use of additional frames of protective plastic and glass—for example, the biohazard-like protective tents employed in *Nature?* and *Disembodied Cuisine;* the Plexiglas petri dishes at the center of *Genesis* and *Transgenic Bacteria Release Machine;* or the sealed plastic frame of *Gastrulation*. Though the transparency of these frames initially seems to position a gallerygoer as "spectator," in fact it more fundamentally emphasizes the common media—for example, air—that potentially link the spectator with the living matter that is at the center of the work of art.[38] The relative fragility of these frames thus serves as a vector for illuminating the fragility of our own embodied ways of framing our surroundings through the membranes of the skin, eyes, lungs, and stomach. As a consequence, for gallerygoers the "artistic presentation of the object is no longer distinguished in our sensation from the nature of the object itself": we feel *that* we are in the presence of living beings.[39] Thus, though the experience of recent vitalist bioart is generally *not* one of disgust, it nevertheless exploits the same kind of embodied oscillation that Kant claimed takes place in the experience of artistic presentations of disgusting objects.

Where works such as *Nature?, Disembodied Cuisine, Gastrulation,* and *Transgenic Bacteria Release Machine* create a sense of "presence" by focusing primarily on connective media within the gallery, such as air, both *Genesis* and the *Biotech Hobbyist* emphasize the way in which these corporeal media are bound into other connective media, such as the Internet. The *Biotech Hobbyist* is particularly interesting in this regard, for it produces a sense of too-closeness by implicitly linking the Webpage visitor with amateur biological experimentation that might be happening "elsewhere," in unseen places. The primary medium of the *Biotech Hobbyist* project—the Internet—establishes that the tools and techniques of biological experimentation can be distributed in a decentralized manner, for the project gives anyone with access to the Internet access to these tools and techniques. As a consequence of the decentralized distribution of the Internet, no one can really know if other people are actually conducting these experiments. However, the project depends on my awareness that the Internet, however immaterial it may seem, has its

various nodes in concrete geographic space, and it indirectly connects me to these other spaces through the medium of people who travel within and between cities and other places of habitation. As a result, it is not necessary for me personally to conduct the experiments described on the Website (nor, in fact, is it necessary for anyone to perform these experiments) for this project to produce a sense of "too-closeness." Where *Transgenic Bacteria Release Machine* creates a sense of oscillation between distance and too-closeness by employing frames to reveal those media, such as air, that (potentially) link microorganisms to gallerygoers, the *Biotech Hobbyist* produces a similar sense by framing a medium of social interaction, the Internet, within those larger biological media upon which social relations depend.

MEDIA: ART AND THE WILD TYPE

Understanding the capacity of recent vitalist bioart to prolong affect as the result of its approach to framing helps to explain *why* it is able to hybridize the readymade and performance so seamlessly, for all three approach the frame as an "infectious" vector rather than prophylactic barrier. Neither the readymade nor performance art can do away with framing: without the gallery and the artist's signature, a urinal is just a urinal, and without some sort of mark or documentation of a "happening" *as* art, performance art disappears into "normal" life.[40] Yet both the readymade and performance art use the frame as a medium for drawing the "spectator" into the work: the readymade, by using gallerygoers as a medium for validating (or not validating) the work as "art"; performance art, by making onlookers *part of* the event. Contemporary vitalist bioart also requires some way of framing its biological experimentations *as* art (if only, in the post-9/11 period, to make clear its distinction from bioterrorism). However, in drawing its techniques of framing from both the readymade and performance art, recent vitalist bioart highlights the common ground of these two earlier approaches while at the same time intensifying the strange confusion of art and life at which both aim.

Understanding the frame as a vector also helps to explain why readymades, art performances, and vitalist bioart are sometimes interpreted as "disgusting," despite the fact that the content of such works of art rarely involves objects that, on their own, seem likely to disgust people.[41] It is hard to imagine, for example, that a new toilet displayed in a hardware store

would inspire many feelings of disgust, and in similar fashion, the metal and plastic assemblages of vitalist bioart do not, on their own, seem to involve materials that generally produce responses of repugnance. Kant's analysis suggests, however, that, when a frame is used as a vector, a confusion between "genus" and "species" can often result: that is, though not all uses of the frame as a vector necessarily produce disgust, because feelings of disgust *can* be produced by using the frame as a vector the affect produced by vector-frames can be (mis)interpreted as a feeling of disgust.

Finally, the approach to framing adopted by recent vitalist bioartworks illuminates the importance of what we might call the "affective history" of media—that is, a history that sees affect as a *generative* aspect of the processes of transformation that occur when new media emerge. Vitalist bioart is an attempt to amplify and modulate the affective experience of strange vitality, but as such, it also highlights "wild type" experiences of the strange vitality that often attends the introduction of new media technologies.[42] Cultural historians have been especially attentive to these experiences, yet they also frequently limit their interpretation of these experiences to "renegotiations" of social relations. In her wonderful description of the introduction of the telephone in late-nineteenth-century homes, for example, Carolyn Marvin documents the extent to which this then-new communication technology produced a disturbing, sometimes even threatening, sense of simultaneous closeness and distance: though the phone made it possible to talk with people far away, it also allowed "strangers" to make their way into the space of the home. However, Marvin interprets this affective experience through the lens of relatively familiar social conflicts, suggesting that the telephone simply served as a "medium" for negotiating conflicts about, for example, the proper role of women and what ought to count as a "profession."[43]

By ontologizing the affective experience of strange vitality, vitalist bioart enables a more capacious understanding of the problematics of which media are elements, emphasizing the extent to which problematics are always simultaneously social, technological, and biological. Moreover, by emphasizing the strange vitality of affective experiences of media, vitalist bioart points us toward a *generative* sense of media—that is, a sense of medium that moves beyond concepts of storage and communication and toward concepts of emergence.

5

THE STRANGE
VITALITY OF MEDIA

I SUGGESTED AT THE END OF THE LAST CHAPTER THAT THE STRANGE vitality of vitalist bioart enables a capacious understanding of media, one that emphasizes the *generative* capacities of media, and I would like to expand on that proposition here. The experience of the affective charge of vitalist bioart depends upon an awareness of this generative tendency of media, as one suddenly has a sense of becoming a medium oneself. But how ought we to understand this generative capacity of media, and how should we understand the relationship of these generative capacities to the arguably more dominant sense of media as means for communicating something from one point to another?

These questions are difficult to answer, not least because "medium" is itself an ambiguous term. Though the word is used both by biologists and by scholars in the social sciences and humanities, it has two quite different senses in these different realms of research. Traditionally, when scholars of culture or social scientists have discussed "print media," the "medium of painting," or "the medium of television," they have meant the material substrate—for example, printed paper, oil paint, or a system of television signal broadcast and reception—by means of which ideas, images, and sound are stored and transmitted from one place or time to another. For biologists, by contrast, "media" refers to nutritive fluids or solids used in experiments to isolate and keep cells and organisms alive. As I describe below, these two senses of "media" have a common origin, but they began to diverge sometime in the mid–nineteenth century.

Vitalist bioart brings these two meanings of "media" back together, employing biological media as part of an artistic medium. Yet by that same token, it confuses the question of what exactly the term "medium" ought to

mean. By asking us to think the biological and the cultural senses of "media" together at the same time, vitalist bioart brings the concept of medium in perplexing proximity to life, encouraging reflections on the vitality of media or the media of life.

This chapter is an effort at such a thinking-together of these two senses of "media." This is not an easy task, especially since it is tempting to confuse a biological conception of media with "biology" or, conversely, to subordinate a biological to a cultural sense of media. To avoid these two tendencies, I draw on the concepts of *metastability* and *individuation* developed by philosopher of technology Gilbert Simondon. These concepts help us to think media as what enable "vital communication"—that is, a kind of communication that has less to do with transmission of something from one point to another than with bringing into being a new state of a natural or social system. This conception of vital communication, in turn, allows us to understand the importance of media for those processes of folding that I described in chapter 4, and upon which vitalist bioart depends.

What also emerges from this rethinking, I suggest, is an approach to media that allows us to hold on to *both* the ways in which media help structure class, gender, and ethnic relationships between different groups of humans *and* the ways in which media bind humans into natural processes that occur either far below or far above the scales within which we habitually understand human relationships (e.g., processes that occur at the small scale of cellular biology or the large scale of ecology). Traditionally, media theorists have tended to emphasize the dynamics of human relationships, perhaps fearing that an emphasis on the scales of either biology or ecology would imply an overly deterministic and constrained sense of human action. However, my emphasis on vital communication helps us to avoid understanding these very small and very large scales solely in terms of "constraints" or "determinations." It also allows us to recognize and draw out what was in fact an interest in the generative capacities of media in older theoretical approaches, such as Hans Magnus Enzensberger's theory of media, and to link these with recent expansive conceptions of media as "infrastructures" or "ecologies."

THE EMERGENCE OF "MEDIA"

Both the cultural and the biological senses of the term "medium" have their origins in seventeenth- and early-eighteenth-century natural philosophy, for in the work of authors such as Francis Bacon and Isaac Newton, the term "medium" denoted the material space that enabled the transmission of something between two points.[1] Bacon, for example, described how different media, such as air or water, propagated sound, and he considered the effects of various media on the propagation of magnetism and "odours," while Newton discussed the effects of "rarer" and "denser" media on the refraction of light.[2]

In the later eighteenth century, this concept of medium as a means for transmission or communication was taken up by a number of authors interested in psychological and social phenomena, such as the workings of the mind or patterns of monetary exchange. In his 1798 *Enquiry concerning Political Justice,* for example, political philosopher William Godwin applied this conception of media as transmission to human psychology and physiology, arguing that "thought" is "the medium through which the motions of the animal system are . . . carried on," and he contended as well that the human body is "our medium of communication with the external universe."[3] Other authors drew on this conception of medium as means of transmission to explain the function of social institutions. Canals that connected geographic locales, for example, were described as "medi[a] of communication," while Adam Smith famously described paper money as a "medium" that allowed debt and credit to circulate in the British colonies.[4] And in the early nineteenth century, the German idealist philosopher Hegel described the various arts—for example, architecture, music, and poetry—as different "media" that allowed individuals to reflect back to themselves their participation in the Absolute Spirit (*Geist*).[5]

Yet the more that eighteenth- and early-nineteenth-century authors used the term "medium" to describe phenomena connected to *human* bodies and concerns, the more a quite different sense of the term came to the fore— namely, medium as that which promoted vital transformation. When William Godwin, for example, wanted to describe the effects of the "medium of unrestricted communication" between people, he turned to metaphors of organic transformation, arguing that unrestricted communication enabled

a "harvest of virtue" to be gathered.[6] In similar fashion, canals were called "media of communication" not simply because they facilitated the transport of goods from one geographic point to another but because, in so doing, they encouraged the growth of human commerce and invention, providing "the springs to industry [and the] energy to invention."[7] And though Hegel seems to have been one of the first authors to discuss art in terms of "media," he at the same time argued that such a discussion was possible only as the result of a dialectical movement that had elevated humans to a condition of "post-mediality," in which philosophical thinking allowed Spirit to represent itself to itself beyond the limitations of particular media.[8]

As these examples emphasize, a medium, when understood in the context of human affairs, tended to have two referents. On the one hand, a specific medium enabled a particular kind of activity, such as "communication" between individuals or "transportation" of goods from one place to another. On the other hand, this particular activity was itself understood as a medium or means for a more final "end" or value: communication between individuals, for example, was a medium for producing wisdom; transportation of goods from place to place was a medium for encouraging industry and invention; and the partial self-reflection of Spirit that the various artistic media enabled were the means by which Spirit elevated itself to a post-medium condition in which it was able fully to recognize itself as itself. In the context of human affairs, in short, the capacity of a medium to communicate something from one point to another was often understood as itself a means for the *growth* or *generation* of something.[9]

This latter view of medium—that is, medium as the condition for vital generation and transformation—was particularly important in what we would now call "biological" discussions of plants and animals. One late-eighteenth-century physician noted, for example, that plant seeds can remain in a "torpid state" for long periods of time, but as "soon as these seeds are placed in media fitted for their action," such as rich soil, then the "living principle" will again begin to act, producing growth and transformation.[10] For other late-eighteenth- and early-nineteenth-century authors, media accounted as well for the emergence of new kinds of living beings. In his "zoological philosophy," for example, Jean-Baptiste Lamarck argued that all life took place within the media [*milieux*] of gases, fluids, and solids that covered the earth.[11] However, these media changed over time, as an area of the earth

that was initially covered by the sea might become, after an immense period of time, part of a mountain. These changes in media exerted pressure on living beings, for if these latter wanted to continue to "stick" to their changing media, they had to alter their bodies in subtle ways. Over long periods of time, Lamarck contended, the effort of a species to stick to its shifting media ended up creating an entirely new species of living beings.[12]

Lamarck's zoological philosophy also illustrated the tendency of biological accounts of media to undermine traditional models of cause and effect. In Lamarck's philosophy, for example, changes in media *solicited* changes in living beings rather than causing those changes. Moreover, living beings themselves contributed to the changes in media that solicited these changes in living beings, both in the sense that "[l]iving bodies constitute, by their possession of life, nature's principal means [*le principal moyen*] for bringing into existence a number of different compounds which would never otherwise have arisen" and in the sense that, over time, the dead bodies of animals contribute to geological transformations of the earth.[13] Other authors complicated the causal relationships between media and living beings by suggesting that media should not always be understood as something separate from, and external to, the living body but rather also constituted a part of the living being. In the nineteenth century, for example, the physiologist Claude Bernard famously argued that the fluids of the body of living beings served as an "internal medium" (*milieu intérieur*), which protected the fragile cells of the body from the relatively harsh effects of external media such as water and air.[14] From this perspective, a medium was less a channel between two points than the surface by means of which an animal was bound into the shifting forces of the world, and the world bound into the vital dynamics of the living being.

By the end of the nineteenth century, biologists and physiologists—especially those interested in infectious organisms such as anthrax—had begun to isolate and develop "media" that could be used to sustain colonies of bacteria.[15] Some of these media were all-purpose and allowed most kinds of bacteria to thrive. (An example is the "Pasteur fluid," developed by Louis Pasteur, which was a combination of ash of yeast, ammonia, sugar, and water.) Other media were designed to isolate one specific kind of microorganism. In some cases, this involved using one species of living being as a medium for another. As historian of bacteriology William

Bulloch noted, one "early method of obtaining what were regarded as pure growths consisted of inoculating susceptible animals with some particular kind of infectious material" and then transferring the infective materials "from animal to animal in a series." (The German physician Robert Koch, for example, claimed that "one could separate bacillus and coccus by moving [infectious material] from a house mouse to a field mouse.")[16] In the early twentieth century, researchers began to employ some of these same techniques of artificial media to sustain "lines" of cells taken from multicellular organisms.[17]

Many of the artificial media developed at the end of the nineteenth and start of the twentieth centuries are essentially identical to those used in biology laboratories today, and for both biologists and physiologists, media remain a fundamental part of many experiments and diagnostic tools. In contemporary laboratory practice, for example, the term "media" generally denotes either a solid such as agar, which provides nutrients for prokaryotic organisms such as *E. coli* (fig. 5.1), or fluids such as DMEM or RPMI, which researchers employ to provide nutrients for eukaryotic cells (i.e., cells from multicellular organisms) (fig. 5.2).[18] Moreover, biologists continue to use media for a number of different purposes: "nutritive media," for example, simply grow and sustain microorganisms or cells, while "selective media" contain elements (e.g., specific antibiotics) that allow only particular microorganisms or cells to grow. "Differential media," by contrast, facilitate the growth of multiple kinds of microorganisms but contain colored elements that allow different kinds of microorganisms to be visually distinguished from one another.

From this biological point of view, though media may indeed enable something—for example, nutrients, vitamins, or energy—to move between two points, concepts of "transmission" or "communication" are of secondary importance. Whether in solid or liquid form, biological media provide cells or organisms with relatively homogenous fields of molecule-sized nutrients, such as salts, amino acids, and vitamins, which promote the vital processes of cells. Moreover, researchers employ biological media primarily so that they can then provoke biological changes and transformations through the introduction of "reagents" (substances that provoke chemical reactions). Biological media thus establish a homogenous field *so that* new axes of alignment

FIGURE 5.1 *E. coli* (Stratagene BL21(DE3) strain) growing on ampicillin-containing LB-agar plates. The image was produced after a 16-hour incubation at 37°C. Photo courtesy of Dr. Kalju Kahn. Photo: Dr. Kalju Kahn.

FIGURE 5.2 Media for eukaryotic cells. Photo courtesy of Mignon Keaton.

between reagents, living cells, and the elements of the medium can emerge. In this sense, biological media are less channels between distant points or mechanisms for storing information than environments that encompass a living entity, establishing for it physiological "problems" that the living being must then attempt to solve.

Moreover, within a biological experimental context, "media" and "reagent" are in fact relative terms: reagents denote the variables in an experiment, while media function as one of the constants of an experiment. As a consequence, a solid or liquid that functions as a medium in one experiment could in principle function as a reagent in another. Thus, though biologists tend to use the term "media" to refer to specific solids or fluids, such as agar or RPMI, in fact biological media are better understood as that part of an experimental system—a system that includes a growth medium, cells, reagents, the researcher, and some sort of visualizing mechanism—that establishes a "field" within which biological potentials can be actualized.

BIOLOGICAL CULTURE-MEDIA
AND CULTURAL BIOLOGY-MEDIA

Though the cultural and the biological understandings of "media" had a common origin in late-seventeenth-century natural philosophy, these two senses of the term nevertheless developed relatively independently of one another during the nineteenth and twentieth centuries. Thus, even by the mid–nineteenth century, what biologists meant by "media" was something quite different from what authors interested in economics, politics, or culture intended by the term.[19] However, in the last decade, authors in both the social sciences and the humanities have begun to try to think the biological and communicational senses of media together. Yet it seems fair to say that many of these efforts highlight primarily the difficulty of such an undertaking.[20]

In the social sciences, for example, sociobiologists and evolutionary psychologists have begun to take an interest in accounting for cultural institutions, such as art, on the basis of an understanding of humans as biological creatures formed in relationship with their surrounding environments.[21] Yet in the end, these accounts almost invariably position "art" (as well as other cultural institutions) as simply "media" for working out biological drives that are seen as essentially static, at least on the time scale of the existence of the human species.[22] For the evolutionary psychologist Geoffrey Miller, for example, humans create art simply as a means of "communicating" reproductive capacity, in the sense that potential sexual partners deem the skills necessary to create art as necessarily bound to more "useful" abilities.[23] As this example suggests, sociobiological and evolutionary psychological accounts are *not* interested in understanding art in terms of the sense of media that emerges in biological experimental practice (i.e., the use of media to create and investigate new biological possibilities). Rather, they are interested in explaining art in terms of "biology," with the latter understood as physiological traits that are, for all intents and purposes, stable, invariant, and inflexible.

Whereas social scientists have tended to think art and biology together by understanding the former as simply a medium for the latter, W. J. T. Mitchell's recent "vitalist" description of media exemplifies the opposite tendency. On the one hand, Mitchell gestures toward a biological conception of

media that in principle emphasizes change and transformation. He argues, for example, that we should understand a medium not as something that lies "*between* sender and receiver" but rather as something that "includes and constitutes them"; a medium, in other words, "*is both a system and an environment.*" Thus, we should think of media objects—images, for example—as "*resid[ing] within media the way organisms reside in a habitat.*"[24] Yet Mitchell then proposes to interpret the vitality of media in terms of a conception of communication that seems heavily to favor the humanities. Thus, for Mitchell, "images" turn out to be the sole "currency of media," and the "communication" that media enable is to be understood in terms of "discourse" and "conversation": "If we are going to 'address' media, not just study or reflect on them, we need to transform them into something that can be hailed, greeted, and challenged" (215, 208). Thus, where social scientists often end up subordinating a communicational sense of media to "biology," Mitchell ends up employing a traditional understanding of communication that does not allow him to take seriously his emphasis on the vitality of media.

Neither of these attempts to link a cultural and biological sense of medium seems able to account for the hybrid sense of medium that vitalist bioart instantiates. If, as sociobiological and evolutionary psychological accounts suggest, art is simply an expression of an effectively static "human nature" that has been produced by evolutionary forces, it is then quite difficult to understand a mode of art which itself utilizes tools that can be used to alter the elements and processes of heredity. By employing techniques that can alter processes of genetic selection, in other words, vitalist bioart complicates that distinction between biological "base" and cultural "superstructure" upon which sociobiological and evolutionary psychological accounts rely. Bioart thus feels dangerous or exciting (depending on one's point of view) precisely to the extent that one is aware that this form of art, though in principle simply part of the cultural superstructure, nevertheless seems able to alter the biological base of which it is purportedly only an expression.[25]

An overly cultural sense of media, on the other hand, seems unable to account for those material dynamics at play in vitalist bioart that operate below the mode of "discourse" and "conversation." An overly cultural sense of communication, for example, encourages an interpretation of the ontological innovations of vitalist bioart, such as Kac's "artist's gene" or Tissue Culture and Art Project's development of "disembodied cuisine," as simply

media for "making statements" or "generating debate" about biotechnology. Yet as I noted in chapter 3, vitalist bioart is more than just communication in this traditional sense. It is, in addition, a kind of communication that has *already* created new relationships among biological materials and techniques, research institutions, corporate endeavors, and members of the public, even prior to the debate that particular works of art may or may not inspire.

METASTABILITY AND INDIVIDUATION

Vitalist bioart, in short, points to the need for an account that explains how media produce *innovation* by means of communication. This means in part an account that attends to Mitchell's sense of media as an "environment"— that is, as an encompassing field that encourages some kinds of events and discourages others. However, it also means accounting much more explicitly for *how* media enable "communication" between previously unconnected potentials within earlier environments, such that new fields or environments can come into being. What we need, in other words, is a philosophy that allows us to understand how media facilitate a kind of communication that allows both new environments and new beings to come into existence.

Gilbert Simondon's philosophy of technology offers a promising means for understanding this sense of media as the condition for innovation. A student of the twentieth-century philosopher of medicine and biology Georges Canguilhem and the phenomenologist Maurice Merleau-Ponty, Simondon spent much of his academic life focusing on how new technological objects come into being and change over time. What makes Simondon's project particularly valuable, from the perspective of a new theory of media, is his interest in understanding technological innovation—that is, innovation that occurs within the realm of "culture"—as structurally similar in kind to the emergence of new forms in the inorganic and biological realms. As a consequence, Simondon was interested in accounting for the possibility of innovation in general, and this in turn led him to see all kinds of innovation as expressing a kind of "vitality."

Simondon's concern with innovation in general encouraged him to see change as the establishment of "communication" between previously unconnected parts of material systems. In the case of technology, for example, Simondon was interested in both the specific arrangements of materials,

such as woods, fabrics, metals, and plastics, that a technology established *and* the constellations of people and institutions that made these specific arrangements possible. Simondon argued that technological objects were not the result of the imposition of "form" upon "matter" but instead emerged from techniques that established communication between different scales. So, for example, even a low-tech object such as a brick is not created by imposing the "form" of a brick upon the pliable "matter" of clay. Instead, both the brick mold and the clay have to be prepared so that matter can "communicate" with form: the mold, for example, must be dusted so that the clay will not stick to it, while the clay itself must be "dried, pounded, sifted, soaked and kneaded for a long time."[26] It is only by preparing the matter of the clay such that it can accept *this* form, and preparing the form of the mold in such a way that it is compatible with *this* matter, that it is possible to establish a "communication" between the microscopic properties of the clay and the macroscale of the brick such that one ends up with a brick that actually hangs together.

Moreover, insofar as technologies are integrated into human collectivities, they themselves serve as media that make it possible for new arrangements of human beings to come into existence. To cite a well-known example, the integration of automobiles into daily life in the early twentieth century required not just the automobile itself but also new arrangements of work processes, such as assembly-line production, which allowed materials and people to be linked in new ways and at new speeds; new kinds of roads and traffic signals; and new financial arrangements for workers that made it possible for the latter to purchase these new technological objects.[27] Or, to return to an example from chapter 2, the use of colchicine by horticulturists in the 1930s should be understood, not simply in terms of the new "form" that this drug imposed on plant chromosomes, but in the context of late-nineteenth-century and early-twentieth-century transformations of the social, legal, and economic aspects of agricultural production. Technologies, in short, are "objects" that simultaneously link several different kinds of scales: the microscopic scale of the materials with the macroscale of the object itself, and the microscale of the object itself with the macroscale of the arrangements of humans necessary to create and maintain such objects.

To explain how it was possible for technologies to serve as media that established communication between different scales, Simondon proposed

the concept of *metastability*. He argued that earlier philosophical attempts to understand innovation, whether in the biological or the cultural realm, had tended to recognize only one form of equilibrium—namely, equilibrium that is stable. Simondon, by contrast, was interested in *meta*stability. In physics, metastability refers to states of tenuous equilibrium that are liable to significant change in the presence of small amounts of facilitating media. Supercooled water, for example, remains in a stable liquid state until the introduction of a tiny particle initiates a sudden process of ice crystal formation. Prior to the introduction of the particle, the supercooled water is indeed in a state of equilibrium, but one that "contains latent potentials and harbors a certain incompatibility with itself" (300 [4]). The particle that is introduced serves as a "medium" that actualizes these latent potentials, allowing crystals to form around it—and these initial crystals then serve as the media upon which further crystals can form, until the entire fluid has become a solid. Metastability thus denoted for Simondon an "equilibrium" that nevertheless harbored the potential for change. A metastable system has a kind of "unity," but one that is in a sense more than that unity, since it can also change its state. Metastability denoted, in short, states that were *"more than a unity and more than identity"* (312 [7]).[28]

For Simondon, the phenomenon of metastability provided a paradigm for understanding how innovation in *any* realm—the realm of inorganic matter, the realm of biology, or the realm of culture—was possible.[29] The concept of metastability, in other words, allowed one to see apparently stable systems, whether these were natural systems or human systems, as always capable of further change and transformation, for such systems were always "more than a unity and more than identity." Moreover, the concept of metastability highlighted the importance of *media* that were able to initiate change by establishing "communication" between two different scales of events. "Individuation" was the term that Simondon used to describe these processes of emergence within metastable systems. "The true principle of individuation," Simondon contended, "is mediation, which generally presumes the existence of the original duality of the orders of magnitude and the initial absence of interactive communication between them, followed by a subsequent communication between orders of magnitude and stabilization" (304 [8]). Thus, individuation "introduces a new regime of the system but does not destroy [*brise*] the system" (72–73).

Simondon provided a number of different examples of individuation, drawn from the physical, biological, and cultural domains. Crystals, for example, are individuations of a supersaturated fluid. A crystal forms when a small seed particle serves as a medium that allows the molecules immediately around it to assume a lower energy configuration by adopting a crystalline pattern. This initial crystal then "grows and extends itself in all directions in its mother-water [*eau-mère*]. Each layer of molecules that has already been constituted serves as the structuring basis for the layer that is being formed next, and the result is an amplifying reticular structure" (313 [18]). The small seed thus serves as the medium that "introduces a new regime of the system," enabling a transition of the system of supersaturated fluid from a higher to a lower energy state.

Inorganic individuation can often be understood in reference to a relatively closed system, but living beings are individuations that exploit a more general metastability. Thus, Simondon writes:

> In the domain of living things, the same notion of metastability can be employed to characterize individuation. But individuation is no longer produced, as in the physical domain, in an instantaneous fashion, quantumlike, abrupt and definitive, leaving in its wake a duality of milieu and individual—the milieu having been deprived of the individual it no longer is, and the individual no longer possessing the wider dimensions of the milieu. It is no doubt true that such a view of individuation is valid for the living being when it is considered as an absolute origin, but it is matched by a perpetual individuation that is life itself following the fundamental mode of becoming: *the living being conserves in itself an activity of permanent individuation*. It is not only the result of individuation, like the crystal or the molecule, but is a veritable theater of individuation. (305 [9])

Simondon's description of living beings as conserving in themselves an activity of permanent individuation represents, in a sense, an effort to integrate Jean-Baptiste Lamarck's early-nineteenth-century theory of media (*milieu*) with a post-Darwinian understanding of heredity. Thus, while Simondon accepts Darwin's account of the *mechanism* of heredity, he nevertheless argues that the activities of living beings should nevertheless be understood in terms of "problematics":

The living being resolves its problems not only by adapting itself, which is to say, by modifying its relationship to its milieu (something a machine is equally able to do)—but by modifying itself through the invention of new internal structures and its complete self-insertion into the axiomatic of organic problems. *The living individual is a system of individuation, an individuating system and also a system that individuates itself.* (305 [9–10])[30]

Thus, for Simondon, "life" should not be understood primarily as a quality of a particular kind of being that always remains itself but denotes instead processes of transformation. "Living," Simondon writes, "consists in being the agent, milieu, and element of individuation" (239). Living beings thus function as media that in a sense create their own milieu by linking larger systems. Living beings are vectors, that is, for linking the immanent potentials of systems, and they accomplish this by "inserting" themselves into the "axiomatic of vital problems."

Simondon also emphasized that in the case of social animals, such as humans, metastability and individuation help us to understand how individuals become media for transformations of collectives, or groups. "Both the psyche and the collectivity," Simondon writes, "are constituted by a process of individuation supervening on the individuation that was productive of life. *The psyche represents the continuing effort of individuation in a being that has to resolve its own problematic* through its own involvement as an element of the problem by taking action as a subject" (306 [11]). For beings that live in collectives, "the psychic being is not able to resolve its particular problematic within its own orbit" but must instead resolve tensions within collectives (306 [11]). And "[t]he collectivity," Simondon argues,

exists as individuation of the capacities of nature conveyed by individuals. . . . One could say that the individual participates in a second birth, that of the collectivity that incorporates the individual himself and constitutes the amplification of the scheme he carries. The individual translates himself in the collectivity as an effectuated meaning, as a problem solved, as information: in this way he extends himself laterally and elevates himself, rather than restricting himself in individuality. (244)

In the same way that a small particle serves as a medium for initiating

crystallization in a supersaturated fluid, individuals in collectivities can also link micro– with macro–social structures, creating "folds" that enable new modes of collective life.

METASTABILITY, INDIVIDUATION, AND MEDIA

Simondon's account points toward a new theory of media, one that, as I will note below, has a significant resonance with the practice of vitalist bio-art. Simondon's concepts of metastability and individuation were intended to describe the necessary conditions for innovation-in-general—that is, the emergence of new forms in the inorganic, biological, and cultural realms. Within his account, "media" denote a necessary condition for innovation. Simondon's understanding of "medium" should thus be understood as a hybrid of the biological and cultural senses of this term. For Simondon, media establish communication by linking otherwise-separated scales or elements of metastable systems, but this communication should not be understood as the "transmission" of information from one point to another. Rather, it is a kind of communication that brings into being a new state, resolving some tensions of a metastable system while at the same time establishing new problematics.

Simondon's account thus suggests a theory of media that is characterized by three principles:

First Principle: discussions of media should always include reference to problematics within metastable systems. Metastable systems are stable but nevertheless contain immanent tensions and problematics. Insofar as media denote the "seeds" around which resolutions of some of these tensions emerge, a discussion of media is useful only to the extent that it also refers to the larger problematics of which media are a part. In the context of human affairs, problematics will always be simultaneously "objective" and "subjective," in the sense that they involve both material dynamics and affective and conceptual tendencies.

Simondon's emphasis on the importance of problematics for an understanding of media shares significant common cause with Marxist accounts of media, such as that outlined by Hans Magnus Enzensberger in "Constituents of a Theory of the Media." Enzensberger insists that contemporary media cannot be usefully understood without reference to the "general contradic-

tion between productive forces and productive relationships" that characterizes contemporary capitalist society, for media both heighten the tension of this contradiction but also enable its resolution through the invention of new social forms and structures.[31] Enzensberger's reference to "productive forces" is especially useful, for it emphasizes the materiality of media—that is, the ways in which humans are able to exploit and channel the properties of natural forces and inorganic and organic materials.

Yet Simondon's approach suggests that Enzensberger's exclusive interest in the single "contradiction" between productive forces and productive relationships unnecessarily limits our understanding of the multiple problematics within which human endeavors are located. Enzensberger's approach relies upon a traditional notion of productive forces, one that understands technology in terms of the form/matter schema, treating the natural world largely as a kind of matter upon which humans impose form. As a consequence, Enzensberger's approach ends up ignoring problematics that cannot be understood in economic terms—for example, the ways in which contemporary media are also involved in ecological problematics, as the global production, distribution, and consumption of media devices produce large-scale and probably irreversible environmental effects.[32]

To acknowledge the existence of multiple problematics, of course, means altering as well the notion of what it means to "resolve" a tension. It means, for example, that one cannot claim a *necessary* link between the "resolution of tensions" and the emergence of a more equitable society. Yet it means as well that there is no "end" to metastability, and thus there can be no system of productive relationships that cannot be refolded from within.

Second Principle: a medium establishes communication between otherwise-separated scales or elements. From this perspective, a medium is not so much a particular kind of "thing" as that which produces a kind of material *effect*—namely, those processes of folding that I discussed in chapter 3. As a consequence, living bodies, techniques, physical tools—or even legal and political institutions, such as the changes in patent law I discussed in chapter 4—can all serve as "media."

An implicit recognition of the ways in which media create links between otherwise-separated scales underwrites some of the more innovative of recent theories of media, such as Brian Larkin's reconceptualization of media as "infrastructures" and Matthew Fuller's account of "media ecologies."[33]

Larkin's description of communication media such as film or videotape as "infrastructures" draws in part on an understanding of infrastructures as networks that employ the material properties of matter in order to create predictable and enduring links between people. Thus, just as a highway infrastructure employs the relative stability of concrete in order to facilitate predictable movement between different geographic points, or an electrical infrastructure captures energy otherwise largely unavailable to humans—for example, solar radiation or the energy locked in coal—and transforms it into both durations and scales that can be used to extend the working day, so too can the particular material features of communication media establish new links between people. However, Larkin also draws on the work of geographers who emphasize the ways in which infrastructures do not simply join, but also produce divisions between, people. He stresses that "the materiality of media, their physical properties and the possibilities these properties create, stands in a complex relation of complicity and independence from the intentions that go into its construction," and he explores ways in which rivalrous social groups are able to exploit "breakdowns" in the material functioning of official infrastructures in order to create new communities (he considers, for example, the role of pirated videotapes in Nigeria).[34] Fuller's description of media in terms of "ecologies" also emphasizes the linkage between micro- and microscales, for he uses the term "ecology" to focus our attention on both "the massive and dynamic interrelation of processes and objects, beings and things, patterns and matter" as well as the dynamic tendency of these interrelationships.[35] Fuller's approach to media thus focuses on situations in which "media elements possess ontogenic capacities as well as being constitutively embedded in particular contexts"—that is, situations in which media bring something new into existence—and he emphasizes that art can establish new uses for "standard objects" precisely because art "insist[s] on the possibility of the entirety or any part of life being always reinvented."[36]

Simondon's emphasis on individuation both helps us to account more fully for the materiality of media that is central to Larkin's understanding of media as infrastructure and also allows us to grasp better the sense of vitality that is intrinsic to Fuller's approach to media ecologies. The strength of Larkin's concept of "infrastructures" is its capacity to capture the "communication" between the lived scales of human life and the microscales of the

molecular properties of certain configurations of matter (e.g., the stability of concrete, the electron flows of electrical wires, or the magnetic patterns of videotapes). Yet Larkin arguably does not push his concept as far as he might, for his analysis of what he calls the "transformative effects of media" focuses almost exclusively on the ways in which competing social groups exploit either the smooth functioning of or breakdowns in infrastructures, rather than considering, for example, the ecological problematics within which these infrastructures are also embedded.[37] Thus, while the materialities of media may serve as *occasions* of transformation in Larkin's account, they are not really a part of processes of individuation, as they are in Simondon's account. Fuller's emphasis on ecology is, from this perspective, more useful, for his term emphasizes the fact that media link different scales and elements within a system while at the same time enabling new states of the system (what Fuller calls "ontogenesis"). At the same time, though, bioart, and the concepts of individuation and folding to which I have linked it, emphasize the *vitality* of these processes of linkage and communication, casting them as both technical and vital at the same time. Vitality and life, in other words, are more expansive and open-ended conceptual breeding grounds than concepts of either infrastructures or ecologies, for concepts of vitality and life encourage the invention of tactics that encompass, but also exceed, structures, "-logies," and systems.

Understanding media in terms of communication between otherwise-separated scales or elements also helps to account better for the "relativism" of definition that seems to characterize much recent media theory. Jay David Bolter and Richard Grusin, for example, define a "medium" as "that which remediates" other media—that is, "that which appropriates the techniques, forms, and social significance of other media and attempts to rival and refashion them in the name of the real."[38] (So, for example, television appropriated and refashioned the techniques—and, often, the content—of the earlier medium of film, just as cinema had appropriated and refashioned stage techniques.) Such appropriation and refashioning mean that no medium is purely itself—it always "remediates" other media—and they also indicate that media are always engaged in rivalries with one another. Rosalind Krauss has developed a similarly relativist conception of the medium in the context of art history. As I noted in chapter 1, Krauss argues that the history of modernism reveals a dialectic in which the attempt to isolate what

was specific to a given medium—for example, painting—tended instead to confuse the very notion of separate media. However, rather than abandon the notion of medium, Krauss argues that we should instead see a medium as "a set of conventions derived from (but not identical with) the material conditions of a given technical support." We should use the term "medium," in other words, to denote not the technical support of an artistic practice—for example, canvas and paint, in the case of painting—but rather the history of what groups of people have done with this "given technical support."[39] Insofar as this history reveals multiple uses of the "same" medium, a medium is thus necessarily "self-differing" and "aggregative, a matter of interlocking supports and layered conventions."[40]

Yet even as my second principle shares in this more general relativism of definition, I want to stress that my relativism should be understood as of the same kind that we encountered above in the biologist's sense of media, for whom media and reagents refer to functions rather than substances. Thus, what counts as a medium may be "relative"—but only in the sense that it is relative to a problematic. This suggests that though Bolter and Grusin may be correct when they claim that one medium is always bound to another medium—that is, mediation always requires remediation—there is no need to limit a theory of "media" to communication technologies such as film, television, and computers. Bolter and Grusin's tendency to limit their sense of media to these kinds of technologies seems to be a consequence of their desire to limit the differentials established by media to those that are easily understood by means of traditional categories of human action, such as "appropriation" and "rivalry." However, by expanding our sense of the problematics within which media emerge, we can at the same time see appropriation and rivalry as two among the many possible dynamic relationships that media establish among elements of the natural world, living beings, and human institutions.[41]

Third principle: the folds introduced by media are obscure until they are refolded. Insofar as media "solve problems" by altering the metastable systems of which they are part, they alter the topology of relationships between people, institutions, and parts of the biological and inorganic worlds. This engenders new relationships of pressure and relaxation among these elements, relationships for which prior concepts and conceptual schemas can only partially account.

This point was not lost on earlier media scholars, and it received an especially concise formulation in Marshall McLuhan's claim that media technologies "alter the ratio among our senses and change mental processes."[42] McLuhan's point was that media serve to channel sensory habits in particular ways—a culture in which print is the dominant communication medium, for example, will favor certain relationships of tactility, seeing, and hearing that are quite different from the "ratio" of senses encouraged by a culture in which television is the dominant medium. While the media toward which Simondon's approach points us arguably often introduce less dramatic physio-psychological changes than those that McLuhan claimed were the consequence of technologies such as radio and television, we can nevertheless say that these media too alter concepts, patterns of reflection, and "automatic" bodily habits. Moreover, insofar as the folds introduced by media lend some concepts, patterns of reflection, and bodily habits a kind of gravity, and place others in much more distant orbits, it becomes difficult to account for the folds that have engendered these new habits of thought and action. As I noted in my discussion of the Bayh-Dole legislation, for example, in the wake of the use of patents as media for making research activities "communicate" with corporate decision making, it is now much easier to imagine and discuss reforms of the innovation ecology than it is to return to a semantic field in which the very idea of an "innovation crisis" was still questionable.

Insofar as media necessarily render the folds that they create obscure, there is indeed, as Mark B. N. Hansen has recently put it, a need for "new philosophies for new media"—that is, a need to create new concepts or to fold old concepts into the existing topology in new ways. This cannot simply be accomplished by fiat but instead requires the assistance of media which themselves introduce new folds (thus, my use of the innovations of vitalist bioart as media for understanding the transformations of the innovation ecology that this art facilitates). This does not place thought and concepts always a step behind technology and media but rather situates thought and concepts within the same field as technology and media (rather than standing above or below this field).

VITALIST BIOART AND MEDIA

These three principles put us in a position to return to the question with which I opened this chapter—namely, what it means to say that vitalist bioart produces the feeling of *becoming* a medium. Drawing on the third principle, we can describe this feeling as itself the leading edge of the refolding that vitalist bioart introduces into the innovation ecology. It refolds in such a way, moreover, that this feeling comes close to a more "theoretical" desire to observe processes of individuation, for bioartworks explicitly highlight the phenomenon of "vital invention." In Kac's *Genesis,* for example, the insertion of a genetic sequence determines a "problematic" for the *E. coli,* as individual bacteria respond to the new genetic sequences contained in the plasmids, while at the same time the biological medium upon which the *E. coli* grow in this art installation allows this response to be distributed across the colony as a whole. The visualization mechanism enables gallerygoers to perceive this growth and transformation on the gallery wall, while communication technologies such as the Internet interface become part of the biological medium. Whereas commercial applications of biotechnology often attempt to *limit* individuation by using cells as "factories" for creating certain products, vitalist bioart seeks instead to illuminate what Simondon describes as the "theater" of biological individuation that characterizes living beings.[43]

Yet by employing biological media, vitalist bioart does not allow this theoretical interest to remain "purely" theoretical, for such works of art themselves position gallerygoers as potential media. To return to the second principle above, we can say that this sense of one's physical body as a potential environment of growth and individuation for another biological entity thus embodies for gallerygoers the processes of "communication" that make vitalist bioart possible in the first place. That is, vitalist bioartworks produce a feeling of tension because they serve as the media for a more general fold that links social institutions, technical devices, and embodied individuals in new ways.

6

BIOART AND THE
"NEWNESS" OF MEDIA

A S I NOTED IN THE INTRODUCTION TO THIS BOOK, MUCH OF THE appeal of bioart is its claim to have located a "new" medium for the purposes of art, exploiting elements of living bodies, such as genetic material, cells, and tissues, that until the very late twentieth century seemed intrinsically intractable to human control. As Randy Kennedy notes, whereas "video and computers" were the new media of the 1960s and 1970s, and "digital technology and the Internet" were the new media of the 1990s, bioart seems, in a sense, like the newest of new media art since it often relies on the even more cutting-edge technologies of biological manipulation.[1] From this perspective, if bioart indeed enables "unprecedented possibilities for art," as Eduardo Kac has claimed, this would be a consequence of its embrace of the new and its willingness to seek out novel modes of artistic media.[2]

Given this emphasis on the newness of the media of vitalist bioart, it is a bit surprising that this kind of art has been largely ignored by scholars working in "new media studies." As I note below, this disinterest is in large part a function of a focus on digital computer technologies, which have served as the rallying point for the emerging field of new media scholarship. However, it also seems to be due to an ambiguity in the very term "new," for it is often not clear whether this term is supposed to function primarily as a temporal marker ("X is the most recent medium") or as an index of the *impact* of a medium ("after X, everything has to be seen anew"). In this final chapter, I would like to bring vitalist bioart to bear on this question of the "newness" of media, drawing on the understanding of media that I developed in chapter 5. This perspective, I suggest, allows us to understand the newness of media in terms of the "metastable resolution" of tensions and contradictions by means of the invention of new social forms and structures.

NEW MEDIA

In the last decade, "new media studies" has emerged as an important term within academia, though it is not yet clear whether this phrase denotes a field of research, a methodological approach, a discipline, or some combination of these. Recent monographs on "new media" have focused on what seems to be an ever-expanding array of technologies, including digital video, film, and television; installation and performance art; video games; computer software and hardware; electronic literature; and digital sound technologies.[3] Yet the methodologies that undergird these volumes are diverse. On the one hand, most new media critics have eschewed the quantitative approaches to media favored in U.S. departments of social science, such as communications and sociology, favoring instead theoretically oriented approaches to new technologies that seem more typical of humanities departments. On the other hand, though, it is not clear whether new media criticism is itself a new mode of theory or, rather, the application of older theories to new objects. Thus, though some critics have explicitly advocated the need for rigorous "new philosophies" appropriate to new media technologies, many other new media critics have opted for a minimalist approach to methodological clarification.[4]

The disciplinary status of new media studies remains equally ambiguous. At present, as W. J. T. Mitchell has noted, new media studies, like its elder sibling, media studies, seems to occupy a "parasitical relationship to departments of rhetoric and communication and to film studies, cultural studies, literature, and the visual arts," in the sense that though many new media scholars have been hired within these academic departments, the relationship between new media and what these departments traditionally teach often remains largely implicit.[5] It is thus not clear whether the future of new media studies lies within existing academic departments or programs or whether the category of "new media" will itself serve as the catalyst for new disciplinary and administrative units within academic institutions.

If there is, nevertheless, a point of intersection between the otherwise various objects, methodologies, and disciplinary affiliations that have come to constitute a "canon" of new media scholarship, it appears to be a shared interest in the cultural uses of digital computing.[6] New media critics have been particularly interested in accounting for differences between digital

technologies, on the one hand, and "old" media, such as chemically based photography and film, sound inscription technologies (e.g., the phonograph), and analog broadcast media (e.g., television and radio), on the other. As a consequence, one of the key concepts of new media scholarship is that of "digitization." What is new about new media, many of these critics have suggested, is the capacity of computers to build up media objects from discrete (i.e., digital) units that can be individually manipulated. This process of digitization makes possible complicated searches and operations on the individual units of media objects, which in turn facilitate the generation of large databases of data. Digitization also makes it possible to translate—or, as Lev Manovich puts it, transcode—an "object" from one media platform to another. The data used to generate a digital still image, for example, can be presented as an image on a computer screen, used to print out a high-quality glossy piece of printed paper, or saved on a DVD, while a photograph produced by a digital camera can be sent over telephone lines or incorporated into a digital video.

BIOLOGICAL NEW MEDIA

Though the conception of digitization—and its corollary, the convertibility of content from one media platform to another—has proven quite fruitful in new media analyses of visual and aural entertainment and art forms, it has also discouraged interest in that history of media in the biological sciences that I outlined in the last chapter.[7] This disinterest is no doubt a function of several factors. Insofar as most new media critics have been trained in the humanities and social sciences, the use of media in biology is likely *terra incognita*. Moreover (and related to this first point), biological media do not seem to be part of *culture* in the same way as media such as photography, television, or computers are, if only because—Jeremijenko, Bunting, and Thacker's *Biotech Hobbyist* project notwithstanding—biological media rarely make their way beyond the laboratory. Nor do biological media seem to be "media" in quite the same sense as cultural media such as photography or television. As I noted in the last chapter, the term "biological media" refers, not to a specific set of chemicals or fluids, but rather to a contextually dependent set of relationships between living beings, chemicals, energy, and the goals of a particular experiment. The biological sense of media thus seems

different in kind from an understanding of media as specific material mechanisms for storing and transmitting sounds, images, and data.

Though these are no doubt valid reasons for the neglect of biological media by new media scholarship, this disinterest is nevertheless unfortunate. It is unfortunate in part because, even before computer databases had become a standard part of the biology laboratory, biologists had already developed ways of instantiating the logic of digital databases in "wet" forms, exploiting elements of living organisms to create complicated libraries of genetic code. Eugene Thacker describes one example of a wet database, the bacterial artificial chromosome (BAC) library, which was first developed in the 1970s:

> As its name indicates, the BAC involves using simple bacteria (which have a small, circular DNA or "plasmid" as [part of] their genome) as the host for a gene sequence from a human sample. Using the cut-and-splice techniques of genetic engineering, scientists can insert the human gene into the bacterial plasmid, thereby creating an in vitro database, making for a kind of bacterial copy machine.[8]

The BAC library has many of the same characteristics that Manovich attributes to digital computing and new media. So, for example, a researcher can perform an "automated" search for a sequence of interest, allowing the chemical bonding characteristics of DNA to do the work of searching. Yet these functions are instantiated in a biological form, which suggests that a logic that seemed particular to digital computing may in fact be a special case of a more general logic that operates across several different media.

If biological media call into question the particularity of the new media of digital computing, the recent feedback loops between biological and computational media in contemporary biology at the same time also suggest a promising model for rethinking the concept of "media convergence," which has served as a focus of recent new media theory. Media convergence generally has been seen as a consequence of the digital nature of computing technologies, for insofar as digitalization makes it possible to transcode a media object from one media platform to another, it also seems to suggest that formerly separate media are now "converging" toward one another. Some media theorists have attended primarily to the social implications of media convergence, considering, for example, the ways in which audi-

ences are willing to seek out and engage their favorite television programs across a variety of media.[9] Others, however, have focused on the philosophical implications of such convergence. Friedrich A. Kittler, for example, has argued that this convergence in fact spells the end of separate media, for insofar as "[t]he general digitization of channels and information erases the differences among individual media," then "a total media link on a digital base will erase the very concept of medium."[10] Kittler suggests, moreover, that humans themselves may soon become simply passive media for the transmission of data across this "total media link." Thus, as Mark B. N. Hansen notes, the concept of digital convergence, "pushed to its most radical extreme, as it is in Kittler's work," suggests that human perception itself has become obsolete, "as today's hybrid media system gives way to the pure flow of data unencumbered by any need to differentiate into concrete media types, or in other words, to adapt itself to the constraints of human perceptual ratios."[11] From this perspective, new media technologies are not simply a new form of media but one that positions human beings as vectors for flows of digital data.

Though Kittler's claim has drawn the scorn of many new media critics, it nevertheless presents a compelling logic, and it is probably fair to say that it has been more often dismissed than refuted. However, as my quotation above suggests, one new media critic who has taken Kittler's argument seriously is Mark B. N. Hansen. In his recent *New Philosophy for New Media,* Hansen argues that Kittler's claims ignore the ways in which digitization actually *emphasizes* the role of the human body in processing and framing. Hansen contends that where earlier media technologies provided their own built-in "frames" for the ways in which human bodies were to process information (painting, for example, framed information visually, while the phonograph framed information aurally), the media convergence enabled by digitization means that there is no longer any necessary, media-specific frame for information.[12] Yet this disappearance of the default frames previously offered by separate media allows the human body itself to take on actively the task of framing. Thus, "with the advent of digitalization . . . the body undergoes a certain empowerment, since it deploys its own constitutive singularity (affection and memory) not to filter a universe of preconstituted images, but actually to enframe something (digital information) that is originally formless (11)." In the age of media convergence, the body itself

must actively frame information, rather than having it framed by specific media beforehand.

As evidence for his claim, Hansen analyzes new media installation works of art by artists such as Jeffrey Shaw and Bill Viola and argues that these works exploit digital technologies in ways that solicit new bodily capacities. For his video installation *Quintet of the Astonished* (2000), for example, Bill Viola filmed a group of actors presenting different emotions. However, Viola used high-speed film—film that runs at 384 frames per second rather than the normal 24 frames per second—and then employed digital technologies to transfer this film to video and slow down the projection speed to 30 frames per second (the standard speed for video). Hansen argues that by filming the actors at such a high film speed, Viola was able to capture "micromovements" of emotional expression on the faces of the actors, micromovements that normally would be inaccessible to human perception, since they occur too quickly to be seen. However, by slowing down the video (by using film and digital technologies to extend the representation of an action that took one minute in real time to sixteen minutes in the space of the gallery), Viola "literally exposes the viewer to the imperceptible—to incredibly minute shifts in affective tonality well beyond what is observable by (non-technically supplemented) natural perception."[13] Viola's work, Hansen argues, thus allows us to "use technology to extend our own subjectivities simply by attending to the subtle, supersaturated affective shifts on the faces of the represented figures and responding to them in the only way we can—via the richly nuanced resonances they trigger in our bodies" (613). These "richly nuanced resonances," which are more felt than perceived, are, Hansen argues, the means by which the body expands its own capacities for sensation and perceptions.

Thus, in place of Kittler's model of digital convergence, in which humans become simply media for a media link that no longer accommodates itself to human perception, Hansen argues that humans are involved in a process of "coevolution" with technologies.[14] This coevolution allows humans to function as catalysts for the technological development of media, as Kittler suggests, but at the same time, new media themselves facilitate the emergence of new modes of human perception.[15] Humans and technology reciprocally serve as the encompassing media for one another, soliciting new technical developments (in the case of technology) and new perceptual abilities (in

the case of humans). As a consequence, no matter how much previously sep-
arate media may "converge," a constitutive difference between digital media
and the medium of the human body will always remain.

There is significant resonance between Hansen's account of new media
and the theory of media that I developed in the last chapter, and this is in
part a function of the fact that we both draw inspiration from Simondon.[16]
For Hansen too, human beings live in a metastable universe, and thus it is
always possible for humans to "alter the ratio of their senses" (to redeploy
McLuhan's phrase) and develop new sensory capacities. For Hansen too,
"affectivity introduces the power of creativity into the [otherwise automatic
processes of the] sensorimotor body" (8). And, as a consequence, *what* new
media works of art represent is for Hansen generally less important than
the ways in which they employ representation to produce an often-obscure
bodily "sense" that initiates new bodily and conceptual capacities (8).

At the same time, though, vitalist bioart highlights some of the possible
limitations of Hansen's approach to technology and embodiment. Though
his discussion of the coevolution of humans and technologies suggests a
capacious view of media, he nevertheless ends up relying on a relatively
restricted understanding of "framing" as a means for focusing one's atten-
tion and actions on one set of things rather than another (rather than, for
example, as a "vector" in the sense that I described in chapter 4). Moreover,
for Hansen, the human body is, in the final analysis, the source of all media.
Thus, he contends that the "'originary' act of enframing information" that
digitization and new media art highlights "must be seen as the source of all
[other and earlier] technical frames (even if these appear to be primary),
to the extent that these are designed to make information perceivable by
the body, that is, to transform it into the form of the image" (11). Though
Hansen's human body indeed inhabits the same metastable reality that I
described above, "media" for him end up referring only to those technical
devices that allow consciousness to experience itself.[17]

Vitalist bioart, by contrast, approaches the question of framing, not in
terms of isolation and the direction of attention, but rather in terms of "com-
munication" within metastable systems. As a consequence, the living body,
for vitalist bioart, is not simply a matter of embodied *perception,* as it is for
Hansen. In place of the relatively abstract form of embodiment that Hansen's
model suggests—his perceiving subject, however embodied it may be, nev-

ertheless seems to have few if any links with the space beyond the gallery—vitalist bioart emphasizes a living body that eats (and is concerned about *what* it eats: consider *Disembodied Cuisine* and *Free Range Grains*), that gets sick and infected (consider *Transgenic Bacteria Release Machine*), and that is bound to a world of other living organisms (consider *Nature?*).[18] As a consequence, though vitalist bioart can also illuminate the coevolution of technology and humans, it makes this relationship more concrete, allowing us to consider the multiple problematics within which technologies are situated.[19]

The concept of media upon which vitalist bioart is premised suggests as well that the apparent conflict between Kittler's and Hansen's approaches to digital convergence may be the result of each adopting an unnecessarily limited conception of media. Kittler, for example, understands media solely in terms of communication and storage. This is a consequence of the fact that he implicitly takes the cybernetic approach to communication developed in the 1930s and 1940s as revealing the true, transhistorical meaning of the term "media."[20] For Kittler, in other words, media must be understood in terms of a model of communication that distinguishes between (1) an "information source"; (2) a coding of that information; (3) the transmission of that coded information through a channel (this is the "medium"); (4) the receipt of that coded information by a receiver that is able to decode the information; and (5) an "information drain" (i.e., a device or person that makes use of the information). As a result of his commitment to this model, Kittler understands the "coupling" between humans and technology in terms of a rigid either/or: either humans are situated at both ends of this communicative process (in which case digital technologies can be used as media *by* humans), or digital technologies are situated at both ends of this communicative process (in which case humans become one of the media "used" by digital technologies). Because Kittler ignores the other theory of media that I discussed in the preceding chapter—that is, media as generative—his theory is unable to account for the immanent potentials that enable new forms of individuation in the relationships among humans, technologies, and the natural world.

Hansen's theory, for its part, employs a more capacious sense of media, one that holds open the possibility of always-new forms of linkage between technologies and humans. However, because Hansen understands the living body primarily in terms of consciousness and perception, his approach is not

as attentive to the larger problematics within which both living bodies and technologies are situated. Hansen thus seems to have relatively little interest in the problematics that encourage some groups of human beings to establish particular kinds of relationships with new media technologies while encouraging other groups to establish quite different kinds of relationships.[21] (It is not clear, for example, how the potentials offered by the new media works of art that he discusses relate to the uses of new media such as scanners and tracking software in contemporary labor practices, for these uses more often seem to constrain than to release bodily potentials.) A theory of media drawn from vitalist bioart, by contrast, allows us to consider both particular instances of new media technology and the processes of communication that enable and disable linkages between groups of human beings and particular uses of new media technologies.

ON THE NEWNESS OF MEDIA

Insofar as it helps us to develop a broader conception of the communication enabled by media, vitalist bioart also helps us understand anew the question of the relationship between the newness of media and what we might describe as their "liberatory" potentials. New media criticism has not uncritically assumed that simply because media are "new" they are by that token necessarily aligned with progressive social interests. Some critics, in fact, have suggested the converse, arguing that media have positive transformative potential only when they are *not* new—that is, when they have become obsolete. Rosalind Krauss has developed the most sophisticated version of this argument for the virtues of obsolescence. Drawing on Walter Benjamin's interest in the history of photography—and especially his interest in practices of photography that had become "outmoded" by Benjamin's own time—Krauss argues that in their periods of ascendancy, media are not so much understood as exploited by the forces of capitalism. It is only when a medium becomes obsolete—that is, only when it is being overtaken by another medium within circuits of capitalist exchange—that it can be redeployed for oppositional and transformative ends. It is only when media have become old, in short, that artists can locate the "imaginative capacity stored within [a given] technical support." Artists exploit this imaginative capacity when they employ an obsolete medium in ways that reveal the history of

conventions that underlie the apparently "objective" aspects of the medium, thereby engendering in their audiences a critical consciousness about a particular medium and media more generally.[22] (Krauss exemplifies the artistic repurposing of an obsolete medium with the work of James Coleman, who employs slide projections, of the sort earlier used in business presentations and commercial contexts, that depict actors depicting poses.)

Hansen's "new philosophy for new media" stakes out the other pole in this debate. Without necessarily disputing the accuracy of Krauss's claims for earlier media forms, Hansen contends that digital technology is different in a way that makes a difference. For Hansen, what makes digital media *new*—and thus, what makes it possible to understand them and release their liberatory potential *before* they become "obsolete"—is the fact that digital information lacks any default-medium frame. As a consequence, new media art, by emphasizing this formlessness, repositions the body as the origin of all media.[23] Rather than engendering a critical consciousness per se, though, these new media works of art solicit the productive and inventive powers of the body by creating new sensory capacities.

Yet the "newness" of the media of vitalist bioart suggests that this debate about innovation and obsolescence may in some sense miss its mark. To begin with, vitalist bioart is difficult to situate within the linear schema of innovation and obsolescence that both Krauss and Hansen seem to assume. Thus, from one perspective, vitalist bioart exploits the newest of the new media, employing cells, tissues, and organisms as forms of artistic expression. Yet from another perspective, the media that vitalist bioart employs are quite old. The actual biological media used in these works of art to keep microorganisms and cells alive (e.g., agar and RPMI) are essentially nineteenth-century technologies that have never quite gone out of fashion. However, the media employed by vitalist bioart are also old in the sense that cells and organisms are very ancient media indeed. *E. coli*—so far the favorite living medium of bioartists—itself instantiates this paradoxical temporality, for though bacteria are among the most ancient of living creatures, their short generation time enables rapid species change through mutation. (*E. coli* highlight as well the "mixed-media" nature of the human body itself, for within forty hours of birth, these bacteria have colonized the gut of most newborns.)

Even as vitalist bioart confuses the temporality upon which the inno-

vation-obsolescence debate is usually conducted, it at the same time helps to deepen our sense of what innovation and "newness" can mean. As I described in chapter 3, vitalist bioart is itself best understood as a refolding of the innovation ecology that was developed to facilitate constant and unending commercial innovation. Yet even as much vitalist bioart is opposed to the commercial enchainment of innovation that this ecology seeks to foster, its opposition does not take the form of a search among the debris of earlier media. Rather, vitalist bioart produces its own fold within this problematic, vexing the temporality of "old" and "new," and innovation and obsolescence, by functioning as a medium itself, establishing new points of communication within the metastable reality within which we live.

What this suggests, then, is that the newness of media ought not to be understood as dependent upon the particular features of a particular technology—for example, the digitization that computing technologies make possible—but must rather be understood with reference to the folds that a medium engenders. The newness of media, in short, should function less as a temporal marker than as an index of their vitality, their tendencies to create new constellations of things, people, and institutions.

Notes

Introduction: Living Art

The epigraph is from Randy Kennedy, "The Artists in the Hazmat Suits," *New York Times*, 3 July 2005, sec. Arts. I, 34.

1 Discussions of these terms can be found in Suzanne Anker and Dorothy Nelkin, *The Molecular Gaze: Art in the Genetic Age* (Cold Spring Harbor, NY: Cold Spring Harbor Laboratory Press, 2004); Patricia Solini, Jens Hauser, and Vilém Flusser, *L'art biotech* (Nantes: Filigranes Editions, 2003); Jens Hauser, "Bio Art—Taxonomy of an Etymological Monster," in *Ars Electronica 2005: Hybrid—Living in Paradox*, ed. Gerfried Stocker and Christine Schöpf (Portchester, Hampshire: Art Books International, 2005), 182–93; Melentie Pandilovski, ed., *Art in the Biotech Era* (Adelaide, SA: Experimental Art Foundation, 2008); and Eduardo Kac, *Signs of Life: Bio Art and Beyond* (Cambridge, MA: MIT Press, 2007).
2 "Cauterization" involves burning a part of a living body in a controlled way. De Menezes and the lab with which she was associated used a technique of very localized cauterization to make small burns in butterfly embryos, and these burns in turn affected some of the developmental processes of the embryos.
3 Artist davidkremers employed *E. coli* tb-1, agar, x-gal, and iptg in *Gastrulation* (1992), and cloned trees served as the medium of Natalie Jeremijenko's *One Tree* (1998 to present), both of which were exhibited in 2000 at the Paradise Now: Picturing the Genetic Revolution exhibition at Exit Art in New York. Julia Reodica used her own "body tissue" as well as "rat aortic smooth muscle cells, bovine cellular matrix, [and] cell media" in the *hymNext Designer Hymen Project* (2005), which was exhibited at the 2008 sk-interfaces exhibition, held in Liverpool, England, at the Foundation for Art and Creative Technology. (This list of media employed in Reodica's project is cited from Nicole C. Karafyllis, "Endogenous Design of Biofacts: Tissues and Networks in Bio Art and Life Science," in *Sk-Interfaces: Exploding Borders—Creating Membranes in Art, Technology, and Society*, ed. Jens Hauser [Liverpool: FACT and Liverpool University Press, 2008], 44.) "X-gal" is a chemical used by molecular biologists to determine whether a bacterium expresses a particular enzyme, and "iptg" is used to induce the expression of a particular gene.
4 Kac, *Signs of Life*, 1; Kennedy, "The Artists in the Hazmat Suits."
5 Kennedy, "The Artists in the Hazmat Suits."

6 Michael Crichton, *Next: A Novel* (New York: HarperCollins, 2006), 165.

7 For a comparative discussion of tissue economies in the United Kingdom and the United States, see Catherine Waldby and Robert Mitchell, *Tissue Economies: Blood, Organs, and Cell Lines in Late Capitalism* (Durham, NC: Duke University Press, 2006).

8 For Marta Lyall's more recent work, see http://martalyall.typepad.com/ (accessed 3 July 2008).

9 As my scare quotes around the word "spectators" suggest, I find "spectatorship," as well as its correlate "viewing," to be problematic concepts with which to describe an individual's relationship to bioart, since both terms suggest a form of distance that (I will argue) is undercut by bioart. Nevertheless, I have generally retained this term so as to avoid overly cumbersome alternatives.

10 For accounts of recent debates about how we ought to understand the term "life," see Lynn Margulis and Dorion Sagan, *What Is Life?* (Berkeley and Los Angeles: University of California Press, 1995); Stefan Helmreich, *Silicon Second Nature: Culturing Artificial Life in a Digital World* (Berkeley and Los Angeles: University of California Press, 1998); and the discussions of "life itself" in Eugene Thacker, *The Global Genome: Biotechnology, Politics, and Culture* (Cambridge, MA: MIT Press, 2005); and Melinda Cooper, *Life as Surplus: Biotechnology and Capitalism in the Neoliberal Era* (Seattle: University of Washington Press, 2008).

11 Though Beatriz da Costa's and Kavita Philip's *Tactical Biopolitics: Art, Activism, and Technoscience* (Cambridge, MA: MIT Press, 2008) appeared too late for me to take full advantage of it for my project here, my phrase "tactics of linkage" nevertheless resonates with what da Costa and Philip call "tactical biopolitics."

12 Though I focus primarily on the United States in my account of the folds that vitalist bioart introduces, bioart has become a global phenomenon—de Menezes, for example, is based primarily in Portugal, while Tissue Culture and Art Project is based in Australia—and Australia has recently come to the fore as arguably the center of training for would-be bioartists. However, focusing on technological, legal, and political transformations in the United States allows me to illuminate modes of "neoliberal" transformation that since the early 1990s have come to characterize many other countries. (For an extended discussion of the neoliberal transformation of the life sciences, see Cooper, *Life as Surplus*.)

13 Within epidemiological discourse, a "vector" refers to an organism that spreads a disease (e.g., ticks currently function in the United States as a vector for spreading Lyme disease, which is caused by the spirochete *Borrelia burgdorferi*), while molecular biologists use the term to refer to a living entity (or part of a living entity) that can be used to transport genetic material from one organism to another.

14 Friedrich A. Kittler, *Gramophone, Film, Typewriter* (Palo Alto, CA: Stanford University Press, 1999), 2. For an art historical discussion of the postmedium condition, see Rosalind E. Krauss, "Reinventing the Medium," *Critical Inquiry* 25, no.

2 (1999): 289–305; and Rosalind E. Krauss, *"A Voyage on the North Sea": Art in the Age of the Post-Medium Condition* (New York: Thames and Hudson, 2000). I discuss both Kittler's and Krauss's claims at greater length in chapter 5.

15 See Mark B. N. Hansen, *New Philosophy for New Media* (Cambridge, MA: MIT Press, 2004).

1 / Defining Bioart

1 The quotation is Rockman's description in the catalog for the Paradise Now exhibit, cited in W. J. Thomas Mitchell, *What Do Pictures Want? The Lives and Loves of Images* (Chicago: University of Chicago Press, 2005), 326.

2 davidkremers, "REPRO DUCTION," in *Signs of Life: Bio Art and Beyond,* ed. Eduardo Kac (Cambridge, MA: MIT Press, 2007), 296.

3 For Jeremijenko's description of *One Tree* and a map of the sites in which the clones were planted, see http://www.nyu.edu/projects/xdesign/onetrees/description/index.html (accessed 10 June 2008). In an interesting (and presumably unintended) twist, at least some of the *One Tree* plantings have effectively become part of the environmental background, as groups who originally served as "stewards" for the *One Tree* plantings have lost track of precisely which trees were part of the project. So, for example, though a 2003 newsletter from the group Canopy (a nonprofit "urban forest" advocacy group that served as one of the stewards of *One Tree* plantings) shows a picture of a *One Tree* sapling being planted in Mitchell Park in Palo Alto, California, a Palo Alto city park arborist whom I contacted in November 2008 was unaware of any Paradox walnuts in that park. For the image of the planting in Mitchell Park, see page 7 of the Canopy spring 2003 newsletter, available at http://www.canopy.org/newsletters/Spring03.pdf (accessed 22 March 2009). In November 2008 Canopy was no longer certain of the precise location of *One Tree* trees in Rinconada Park, the park for which the group was, in principle, serving as *One Tree* steward.

4 In similar fashion, davidkremers has suggested that the bacteria within the sealed acrylic frames of his biopaintings are in fact not dead but rather in a state of "suspended animation" and would again be revived were the frame of the biopainting to be unsealed (davidkremers, "REPRO DUCTION," 296).

5 davidkremers's *Gastrulation* and Jeremijenko's *One Tree*, for example, were exhibited at the large and well-publicized 2000 Paradise Now: Picturing the Genetic Revolution exhibition alongside many genetically themed works of art that employed more traditional media. A similar combination of traditional and biologically mediated works of art also made up the 1999 Ars Electronica symposium and exhibition LifeScience (see Gerfried Stocker and Christine Schöpf, *LifeScience [Ars Electronica 1999]* [New York: Springer, 1999]) and the 2002 Gene(sis): Contemporary Art Explores Human Genomics exhibition at the Henry Art Gallery in Seattle (which later traveled to several different cities). For

documentation on the Gene(sis) exhibition see the DVD-ROM *Gene(sis): Contemporary Art Explores Human Genomics* (Seattle: Henry Art Gallery, 2003).

6 See Solini, Hauser, and Flusser, *L'art biotech;* and Jens Hauser, ed., *Sk-Interfaces: Exploding Borders—Creating Membranes in Art, Technology, and Society* (Liverpool: FACT and Liverpool University Press, 2008).

7 Anker and Nelkin, *Molecular Gaze.* For an example of discussions of bioart in *Art Journal,* see the 1996 special issue (vol. 55, no. 1) "Contemporary Art and the Genetic Code." As Hauser notes, the term "bioart" has increasingly come to be disassociated from the earlier, and more limited, term "genetic art" as artists have begun to employ biological tools and techniques from subfields other than genetics (Hauser, "Bio Art," 182).

8 For less theoretically oriented accounts of bioart as unified by a common "theme," see Anker and Nelkin, *Molecular Gaze;* and Lori B. Andrews, "Art as Public Policy Medium," in Kac, *Signs of Life,* 125–49.

9 Mitchell, *What Do Pictures Want?* 326.

10 Mitchell's claim specifically addresses Eduardo Kac's *Genesis* (1999), a work of art that I discuss at more length in chapter 3. *Genesis* was commissioned for Ars Electronica 1999 and exhibited online and at the O.K. Center for Contemporary Art in Linz, Austria.

11 Krauss, *"Voyage on the North Sea,"* 11.

12 Kac, *Signs of Life,* 12. For other accounts of biomedia that insist on the importance of the medium, see many of the essays in Kac, *Signs of Life,* as well as Jens Hauser, "Gènes, génies, gênes," in Solini, Hauser, and Flusser, *L'art biotech,* 9–15; and Jens Hauser, "Observations on an Art of Growing Interest: Toward a Phenomenological Approach to Art Involving Biotechnology," in da Costa and Philip, *Tactical Biopolitics,* 83–104.

13 Bioartist and bioart historian George Gessert makes a similar point, arguing, "If we do attempt to engage work with unverifiable claims, a crucial question is whether the claims are within the realm of possibility"; see George Gessert, "Unverifiable Claims in Genetic Art," in Pandilovski, *Art in the Biotech Era,* 9.

14 For the notion of a problematic as something that is simultaneously objective and subjective, see Gilles Deleuze, *Difference and Repetition,* trans. Paul Patton (New York: Columbia University Press, 1995), 63–64.

15 Of course, works of art do not "situate themselves" but are rather *situated by* artists, curators, journalists, and other members of the public. Yet insofar as no one set of these groups has a monopoly on how a work of art ends up becoming situated vis-à-vis the problematic of biotechnology (or any other problematic), I would like to hold on to my admittedly ambiguous phrasing as a way of encompassing all of these possibilities.

16 My distinction between prophylactic and vitalist tactics has some parallels with Natalie Jeremijenko's distinction between two different camps of bioartists: "the Dystopics," who seek to reveal by means of their art the troubling

and often frightening futures of genetic and biological manipulation, and "the Inevitables," who use art to encourage the belief that genetic manipulation is nothing to fear and thus should be embraced and celebrated. See Natalie Jeremijenko and Eugene Thacker, *Creative Biotechnology: A User's Manual* (New York: Locus +, 2004), 15. Yet insofar as a bioartwork such as Jeremijenko's own *One Tree* does not seem to fit comfortably within either of these camps, I prefer a distinction that focuses more on the different modes of proximity—for example, prophylaxis versus "infection"—that bioart establishes between spectators and biotechnology.

17　The difficulties of the representation/presentation distinction are highlighted by Mitchell's suggestion that, insofar as many viewers remain uncertain of what, exactly, they are supposed to see in vitalist bioartworks, such works must be, in the final analysis, representational. Using the example of Kac's *Genesis*, Mitchell claims that *what* vitalist bioartwork represents is the impossibility of representing biotechnology: that is, "[t]he object of mimesis here is really the invisibility of the genetic revolution, its inaccessibility to representation" (Mitchell, *What Do Pictures Want?* 328). This strikes me as a rather vexed way to hold on to representation, and I am not sure how it would account for the peculiar sense of presence that—as I discuss at more length in chapter 4—vitalist bioartwork seems to invoke.

18　For examples of this kind of argument, see Jeremy Rifkin, "Dazzled by the Science," *Guardian*, 14 January 2003; and Jacqueline Stevens, "Biotech Patronage and the Making of Homo DNA," in da Costa and Philip, *Tactical Biopolitics*, 43–61.

19　For an account of Stein's goals for the Paradise Now exhibition, see Stevens, "Biotech Patronage," 44.

20　As I discuss at greater length in a work in progress entitled *Romanticism, Vitalism, and the Living Dead*, "vitalism" is a contested term within the history of science and biology. Some historians of vitalism define the term quite broadly, as any belief that the vital processes of living beings are in some way autonomous from the rest of the world of matter. From this perspective, the history of vitalism is a very long one, reaching back to Aristotle at least; see, e.g., Hans Driesch, *The History and Theory of Vitalism*, trans. C. K. Ogden (London: Macmillan and Co., 1914). Others have defined vitalism more narrowly, as the belief that matter is in some way living, and discern a more limited history of this mode of thought, tracing its origins back to the sixteenth and seventeenth centuries; see, e.g., John Rogers, *The Matter of Revolution: Science, Poetry, and Politics in the Age of Milton* (Ithaca, NY: Cornell University Press, 1996); and Peter Hanns Reill, *Vitalizing Nature in the Enlightenment* (Berkeley and Los Angeles: University of California Press, 2005). I am more persuaded by Michel Foucault's claim that "up to the end of the eighteenth century . . . life does not exist: only living beings"—that is, prior to the end of the eighteenth century, "[l]ife does not constitute an obvious threshold beyond which entirely new forms of knowledge are required"; see

Michel Foucault, *The Order of Things: An Archaeology of the Human Sciences* (New York: Vintage Books, 1973), 160, 161. However, Foucault argues that, from the late eighteenth century on (i.e., following the reorganization of the episteme that Foucault documents in *The Order of Things*), life becomes a sort of "transcendental," in the sense that it makes "possible the objective knowledge of living beings." "Life" is therefore "outside knowledge, but by that very fact [it is a condition] of knowledge" (244). Thus, Foucault argues, nineteenth-century vitalism cannot be understood as a "reaction against" an early mechanistic science; rather, "vitalism and its attempt to define the specificity of life are merely the surface effects" of a much more fundamental "archaeological" event that affected knowledge production as a whole (232). For a useful overview of some of the issues at stake in determining what ought to count as vitalism, see E. Benton, "Vitalism in Nineteenth-Century Thought: A Typology and Reassessment," *Studies in the History and Philosophy of Science* 5 (1974): 17–48.

21 For accounts of the links between vitalism and political conservatism in early-nineteenth-century Britain, see L. S. Jacyna, "Immanence or Transcendence: Theories of Life and Organization in Britain, 1790–1835," *Isis* 74, no. 3 (1983): 310–29. For a nuanced discussion of the politics of vitalism and other "holistic" philosophies in early-twentieth-century Germany, see Anne Harrington, *Reenchanted Science: Holism in German Culture from Wilhelm II to Hitler* (Princeton, NJ: Princeton University Press, 1996).

22 Hauser, "Bio Art," 186. Hauser's suggestion that *Disembodied Cuisine* instantiates a vision of the laboratory as *kitchen* resonates particularly with my own outsider's experience of biological labs, for I remember being very struck by the extent to which the "genre" of lab protocols (i.e., the printed instructions that bench scientists use to perform experiments) resembled a "genre" with which I was much more familiar: namely, kitchen recipes. The imperatives that characterize both genres are essentially identical: "take X units of substance A, add it to Y units of substance B, heat at Z temperature, let it sit for N minutes," etc.

23 As the molecular biologist and historian of biology François Jacob has noted, eighteenth- and nineteenth-century theoretical vitalists did not necessarily "produc[e] fewer observations than mechanists," but "their observations were very rarely made *because* of vitalism or in order to demonstrate a vital force. Vitalism generally came into the picture *after* observation, as an aid not to investigation but to interpretation." See François Jacob, *The Logic of Life: A History of Heredity*, trans. Betty E. Spillmann (Princeton, NJ: Princeton University Press, 1973), 39.

24 Driesch is an interesting figure, for his career exemplifies the switch from experimental to theoretical vitalism: when Driesch was unable to replicate in other organisms those embryological anomalies that he initially detected in sea urchins, he simply gave up experimentation and spent the rest of his career working out the logical structure and implications of the vitalism that he

claimed had been definitely established by his earlier series of experiments with sea urchins. For Driesch's account of his experiments, see Driesch, *History and Theory of Vitalism,* and for an account of Driesch's career, see Horst H. Freyhofer, *The Vitalism of Hans Driesch: The Success and Decline of a Scientific Theory* (Frankfurt am Main: P. Lang, 1982).

25 Hans-Jörg Rheinberger, "Experiment, Difference, and Writing: I. Tracing Protein Synthesis," *Studies in the History and Philosophy of Science* 23, no. 2 (1992): 324, my emphasis.

26 Rheinberger also notes that "the experimentalist does not deal with single experiments." Quoting Ludwig Fleck, Rheinberger notes: "Every experimental scientist knows just how little a single experiment can prove or convince. To establish proof, an entire *system of experiments* is needed, set up according to an assumption . . . and performed by an expert" (ibid., 309, emphasis in original). Rheinberger is quoting Ludwig Fleck, *Genesis and Development of a Scientific Fact,* trans. Fred Bradley, ed. Thaddeus J. Trenn and Robert King Merton (Chicago: University of Chicago Press, 1979), 96.

2 / The Three Eras of Vitalist Bioart

1 Of course, this statement too needs to be qualified, for even when contemporary artists use "old" materials, such as oil-based paint, they nevertheless generally often rely on systems of industrial production that date back only 150 years or so. So, for example, whereas painters in the eighteenth century generally mixed their own paints (and, thus, tended to paint primarily in studios), artists working post-1830–40 have tended to use industrially produced tubes of premixed paints. For a perceptive discussion of the importance of these kind of "ready-made" art supplies for twentieth-century art, see Thierry de Duve, *Kant after Duchamp* (Cambridge, MA: MIT Press, 1996), esp. 147–99.

2 For a useful discussion of bioart in the context of the history of "ornamentation," see Gunalan Nadarajan, "Ornamental Biotechnology and Parergonal Aesthetics," in Kac, *Signs of Life,* 43–55.

3 Ronald J. Gedrim, "Edward Steichen's 1936 Exhibition of Delphinium Blooms: An Art of Flower Breeding," in Kac, *Signs of Life,* 354. Gedrim's essay was originally published in *History of Photography* 17, no. 4 (1993): 352–63.

4 Edward Steichen, "Delphinium, Delphinium, and More Delphinium!" *Garden,* March 1949, cited in Gedrim, "Edward Steichen's 1936 Exhibition of Delphinium Blooms," 353.

5 Cited in Gedrim, "Edward Steichen's 1936 Exhibition of Delphinium Blooms," 356.

6 Cited in ibid., 347.

7 "Garden Notes and Topics," *New York Times,* 28 June 1936, sec. 9, 12X; cited in ibid. For short accounts of Steichen's work with delphiniums, see George

Gessert, "A History of Art Involving DNA," in Stocker and Schöpf, *LifeScience*, 228–36; and Anker and Nelkin, *Molecular Gaze*, 66.

8 "Bulliet's Artless Comment," *Chicago News*, 27 June 1936, cited in Gedrim, "Edward Steichen's 1936 Exhibition of Delphinium Blooms," 351.

9 Tuber-propagated plants, such as potatoes, were explicitly excluded from the act. For a short account of the background of this act, see Daniel J. Kevles, "Patents, Protections, and Privileges: The Establishment of Intellectual Property in Animals and Plants," *Isis* 89 (2007): 323–31. For more lengthy discussions, see Cary Fowler, "The Plant Patent Act of 1930: A Sociological History of Its Creation," *Journal of the Patent and Trademark Office Society* 82 (2000): 621–44; and Jack R. Kloppenburg Jr., *First the Seed: The Political Economy of Plant Biotechnology*, 2nd ed. (Madison: University of Wisconsin Press, 2004), esp. 132–33.

10 Gedrim, "Edward Steichen's 1936 Exhibition of Delphinium Blooms," 356.

11 Gessert, "History of Art Involving DNA."

12 For an account of early-twentieth-century genetics focused on fruit fly research, see Robert E. Kohler, *Lords of the Fly: Drosophila Genetics and the Experimental Life* (Chicago: University of Chicago Press, 1994).

13 For a detailed account of the emergence of molecular biology, see Lily E. Kay, *Who Wrote the Book of Life? A History of the Genetic Code* (Palo Alto, CA: Stanford University Press, 2000). For a shorter account of the history of key gene-mapping technologies, see Horace Freeland Judson, "A History of the Science and Technology behind Gene Mapping and Sequencing," in *The Code of Codes: Scientific and Social Issues in the Human Genome Project*, ed. Daniel J. Kevles and Leroy E. Hood (Cambridge, MA: Harvard University Press, 1992), 37–80.

14 Stanley N. Cohen et al., "Construction of Biologically Functional Bacterial Plasmids *in Vitro*," *Proceedings of the National Academies of Science* 70, no. 11 (1973): 3240–44.

15 Joe Davis, "Cases for Genetic Art," in Kac, *Signs of Life*, 257.

16 Joe Davis, "Microvenus," *Art Journal* 55, no. 1 (1996): 70, 74.

17 Richard Doyle, "LSDNA: Consciousness Expansion and the Emergence of Biotechnology," in *Data Made Flesh: Embodying Information*, ed. Robert Mitchell and Phillip Thurtle (New York: Routledge, 2004), 121–36. Doyle's larger point, which has significance for this chapter, is that the pragmatic perspective on DNA appeared in the realm of creative literature (e.g., in Timothy Leary's interest in linking DNA with LSD "trips") long before research scientists engaged this approach.

18 For labs that create made-to-order genetic sequences, see, e.g., http://www.genscript.com/gene_synthesis.html (accessed 26 June 2008).

19 For a nuanced and influential account of the way in which information was disembodied in the postwar period, see N. Katherine Hayles, *How We Became Posthuman: Virtual Bodies in Cybernetics, Literature, and Informatics* (Chicago: University of Chicago Press, 1999). For an account of the more recent reembodiment

of information, see Mitchell and Thurtle, *Data Made Flesh*.

20 Eugene Thacker, *Biomedia* (Minneapolis: University of Minnesota Press, 2004), 17.

21 Thacker employs the felicitous term "biomedia" to refer to these reciprocal linkages between biological and computational media.

22 Eduardo Kac, "Transgenic Art Online," in Mitchell and Thurtle, *Data Made Flesh*, 259.

23 To describe Steichen as "working on his own" is, of course, arguably inaccurate, for he employed a number of people to work on his many acres of farms. However, these were, so far as I can determine, primarily wage-labor relationships rather than the "gift" relationships that link more recent bioartists with research communities. For a discussion of the gift economy in the context of both science and bioart, see Robert Mitchell, Helen Burgess, and Phillip Thurtle, *Biofutures: Owning Body Parts and Information* (Philadelphia: University of Pennsylvania Press, 2008).

24 For a comprehensive account of the case and trial, see the Critical Art Ensemble Defense Fund Website: http://www.caedefensefund.org/ (accessed 16 June 2008).

25 "On with the Show: Why Scientists Should Support an Artist in Trouble," *Nature* 429, no. 6993 (2004): 685.

26 For an account of informed consent as a means for establishing property rights in patient samples, see Waldby and Mitchell, *Tissue Economies*, 69–79.

27 For a brief discussion of the history of MTAs in the university environment, see Victor Rodriguez, "Merton and Ziman's Modes of Science: The Case of Biological and Similar Material Transfer Agreements," *Science and Public Policy* 34, no. 5 (2007): 355–63.

28 Jane Rees, "Cultures in the Capital," *Nature* 451 (2008): 891.

3 / Bioart and the Folding of Social Space

1 Bradley Graham, "Patent Bill Seeks Shift to Bolster Innovation," *Washington Post*, 8 April 1979, 1. For accounts from the 1970s about this purported innovation crisis, see Walter Sullivan, "Loss of Innovation in Technology Is Debated," *New York Times*, 25 November 1976, 44; and Victor K. McElheny, "An Industrial 'Innovation Crisis' Is Decried at M.I.T. Symposium," *New York Times*, 10 December 1976, 85.

2 For a discussion of the background to the Bayh-Dole legislation, see Ashley J. Stevens, "The Enactment of Bayh–Dole," *Journal of Technology Transfer* 29 (2004): 93–99; Waldby and Mitchell, *Tissue Economies*, 101–4; and Robert Mitchell, "Sacrifice, Individuation, and the Economics of Genomics," *Literature and Medicine* 26, no. 1 (2007): 129–31.

3 The Bayh-Dole Act was intended to facilitate innovation generally rather than biotechnology specifically, and its implications for patient samples and informa-

tion were developed subsequent its passage through court cases such as *Moore v. Regents of the University of California* (1990). However, in the interests of brevity, my discussion of the logic of Bayh-Dole combines both its initial legislative articulation and latter expansion through legal cases and policy decisions.

4 Some of these flows were to move in one direction only: members of the public, for example, were to give money, tissues, and information to research institutions, but they would not receive anything directly back from these institutions. Other flows were to be relatively "free": for example, the free flow of information and biological materials among researchers at different institutions and the free flow of information about the strengths and weaknesses of different products from corporations to the public.

5 I draw my primary inspiration for this terminology from Gilles Deleuze and Félix Guattari, *A Thousand Plateaus: Capitalism and Schizophrenia,* trans. Brian Massumi (Minneapolis: University of Minnesota Press, 1987), esp. 39–74; and Gilles Deleuze, *The Fold: Leibniz and the Baroque,* trans. Tom Conley (Minneapolis: University of Minnesota Press, 1993); as well as the discussion of "folds in space and time" in Phillip Thurtle, *The Emergence of Genetic Rationality: Space, Time, and Information in American Biological Science, 1870–1920* (Seattle: University of Washington Press, 2007), 266–68.

6 Intellectual property rights provide a particularly "immaterial" example of a medium that enables a fold. However, we should more generally think of folds as movements that depend upon interactions of human practices, technical objects, and elements of the natural world over which humans have relatively little control (weather, geographic distribution of resources, and so on).

7 This same double-bind can occur as well at the level of the institutions. On the one hand, basic research purportedly requires the free flow of information and materials between scientists at different research institutions. Yet on the other hand, technology transfer offices are supposed to maintain control of all potentially proprietary information and material produced in their institutions, which tends to discourage the free flow of information upon which basic research is supposed to depend. This is, in a sense, another variant of the paradox of free-market information ownership outlined in James Boyle, *Shamans, Software, and Spleens: Law and the Construction of the Information Society* (Cambridge, MA: Harvard University Press, 1996). For the argument that the "free" exchange of scientific information has been affected by the Bayh-Dole Act, see Arti K. Rai and Rebecca S. Eisenberg, "Bayh-Dole Reform and the Progress of Biomedicine," *Law and Contemporary Problems* 66, no. 1 (2003): 1–38. For the argument that "post-academic science" does not require the "free exchange" that characterized earlier modes of science, see Rodriguez, "Merton and Ziman's Modes of Science."

8 For discussion of these more global criticisms of the Bayh-Dole Act and innovation ecology, see Waldby and Mitchell, *Tissue Economies,* 88–109, 60–80; and Mitchell, "Sacrifice, Individuation, and the Economics of Genomics."

9 Mitchell, *What Do Pictures Want?* 330.

10 Andrews, "Art as Public Policy Medium," 127; "On with the Show."

11 See, e.g., the Bioart and the Public Sphere project, sponsored by da Costa, Jeremijenko, and others: http://www.publicsphere.parasitelab.net/ (accessed 7 July 2008).

12 Though this premise that bioartists retain a critical distance from their object of critique frequently remains implicit, some commentators have reflected more explicitly on how such a position of relative disinterest might be possible. Jeremijenko, for example, argues that, because bioartists seek neither career advancement within research institutions nor profit within the corporate sphere, they are able to detach themselves from governmental and corporate interests in biotechnology (Jeremijenko and Thacker, *Creative Biotechnology*).

13 Anker and Nelkin develop a different reading of Wagner's image: citing the fact that the image was originally commissioned for the Tokyo branch of Comme des Garçons (a Japanese fashion shop), they imply that Wagner's image is best read as a critique of the commodification of biological and genetic research (Anker and Nelkin, *Molecular Gaze,* 175). Though certainly plausible, such a reading seems only minimally attentive to the phenomenology of an actual viewing of the work, which requires a mode of "concern" on the part of the spectator.

14 I am using "art gallery" as a shorthand for the physical space of the gallery and related institutions, exhibition Websites and catalogs, and further uses of the work of art in other venues (such as, e.g., in this book itself).

15 This is true whether a given spectator is aware of this fact or not, for even if one fails to notice the Website by means of which one can alter the ultraviolet environment of the *E. coli,* this lack of awareness becomes a sort of "unintentional decision" not to click on the Web button.

16 It is worth emphasizing that it is in fact quite difficult to position spectators as part of the environment of the *E. coli* in anything but a trivial sense. An art gallery is an incredibly harsh environment for *E. coli,* and were the bacteria not protected from the gallery air and spectators by means of the protective glass of the petri dish, they would quickly die. Thus, Kac's use of an ultraviolet light—which changes as a result of spectator decisions about whether to click on a button or not—is a way of modulating the otherwise-extreme environmental effects of the spectator into a form that actually establishes an "ontological horizon" for the *E. coli.*

17 Jeremijenko also relates the *Biotech Hobbyist* to images of Bill Gates and Steve Jobs experimenting with homemade computers in their garages in the 1970s, which in turn suggests a view of "innovation" that understands it as dependent less on academic and corporate environments than on more decentralized processes of "tinkering." See Jeremijenko and Thacker, *Creative Biotechnology;* and the chapter "Alba, the Glowing Bunny and Other Bioart" in Mitchell, Burgess, and Thurtle, *Biofutures.*

18 For an extended elaboration of this point with an application to art more gener-
ally, see Pierre Bourdieu, *Distinction: A Social Critique of the Judgement of Taste,*
trans. Richard Nice (Cambridge, MA: Harvard University Press, 1984). While
Bourdieu acknowledges that people consume art differently than they consume
other kinds of commodities, he argues that "appreciating" art is simply a way
of establishing forms of social capital that have more or less direct relations to
other, more literal forms of capital. (I discuss Bourdieu at greater length in the
next chapter.)

19 Some vitalist artists have argued that bioart nevertheless can also function as a
mode of scientific research in its own right, leading to perspectives on biologi-
cal processes that might otherwise be ignored. Bioartist Marta de Menezes, for
example, notes that, in her collaboration with Dutch scientists, she employed
multiple-site cauterization of butterfly embryos, whereas scientists in the lab
had tended to employ single-site cauterization in order to minimize the number
of variables with which they had to contend. De Menezes reports that members
of the lab were intrigued, however, by biological processes that seemed to result
from interactions between de Menezes's multiple cautery sites. In this case,
at least, de Menezes suggests, bioart focused attention on biological processes
that had previously been systematically ignored. For de Menezes's account, see
"Alba, the Glowing Bunny and Other Bioart" in Mitchell, Burgess, and Thurtle,
Biofutures. For a more general discussion of art as research, see Stephen Wilson,
Information Arts: Intersections of Art, Science, and Technology (Cambridge, MA: MIT
Press, 2002).

20 Rheinberger, "Experiment, Difference, and Writing," 324.

21 From this perspective, even if *Nature*'s editorial defense of Kurtz and the Critical
Art Ensemble appealed explicitly to the importance of art for a healthy democ-
racy and a vibrant public sphere, it seems likely that the editors of this key
scientific journal also recognized the familial resemblance between their own
work and that of an artist such as Kurtz.

4 / Affect, Framing, and Mediacy

1 Though the use of *E. coli* in *Transgenic Bacteria Release Machine* and Kac's *Genesis*
seems to be primarily a function of the importance of this organism for the
history of twentieth-century genetics, *Transgenic Bacteria Release Machine* also
exploits the fact that many people will associate this term (at least in the United
States) with illnesses caused by contaminated food.

2 In his often-cited essay "The Work of Art in the Age of Mechanical Reproduc-
tion," Walter Benjamin suggests that we define "aura" "as the unique phenom-
enon of a distance, however close [an object] may be"; see Walter Benjamin,
"The Work of Art in the Age of Mechanical Reproduction," in *Illuminations* (New
York: Schocken Books, 1968), 222–23. For Benjamin, writing in the 1930s, the

fact that works of art could now be reproduced mechanically entailed a *loss* of aura, insofar as the feeling of distance that formerly separated individuals from works of art was attenuated. However, in his discussion of what he calls the age of "biocybernetic reproduction," W. J. T. Mitchell argues that the relationship between copies and aura has reversed since Benjamin's time. Mitchell claims that "if aura means recovering the original vitality, literally, the 'breath' of life in the original," then in our age, in which (Mitchell argues) computer and biological "copies" often represent *improvements* on the original, "we have to say that the copy has if anything, even *more* aura than the original" (Mitchell, *What Do Pictures Want?* 320). Yet it is not clear to me how "the unique phenomenon of a distance, however close [an object] may be"—that is, that sense of distance that is central to Benjamin's concept of aura—factors into Mitchell's argument. I thus prefer to introduce a term such as "charge" to describe the affect of bioart.

3 This is, at any rate, my impression of audience response, having discussed *Disembodied Cuisine* in the course of several lectures. Readers of this book can, of course, determine for themselves their own reaction to the description of this project above.

4 The terms appear in the following accounts: Rifkin, "Dazzled by the Science"; Carol Gigliotti, "Leonardo's Choice: The Ethics of Artists Working with Genetic Technologies," *AI and Society,* no. 20 (2006): 32; Eric Spaulding's "A Living Art" series of reports on bioart, available at http://bioethics.com/?author=20 (accessed 23 October 2008); Kennedy, "The Artists in the Hazmat Suits."

5 Rifkin acknowledges that many bioartists "hope that their work . . . will provoke an emotional response from the audience and force people to think about the many implications of [in this case] the new science" (Rifkin, "Dazzled by the Science"). However, he asserts that bioart will not accomplish this goal of forcing people to think about the implications of biotechnology but will instead simply "legitimize" biotechnology.

6 Brand's warning precedes the podcast version of the report "Bioartists' Flesh Sculptures Draw Fans and Critics," available at http://www.npr.org/templates/story/story.php?storyId=17097173 (accessed 23 October 2008). I shall return below to the peculiarity of Brand's framing comment, which seems to confuse the content of the report—that is, what the report is *about* (namely, vitalist bioart)— with the report itself.

7 This quotation, from Kass's 14 March 1997 testimony before the National Bioethics Advisory Commission, appears in the transcripts archived at http://bioethics.georgetown.edu/nbac/transcripts/index.html#mar97 (accessed 23 October 2008).

8 I draw the terminology of "oscillation" from Hauser, "Observations on an Art of Growing Interest," 83. For Hauser, vitalist bioart encourages a "phenomenological oscillation" between what Hans Ulrich Gumbrecht has described as "meaning effects" and "presence effects." Though I approach this oscillation from a different framework, I nevertheless see Hauser's analysis as consonant with my

own, and I appreciate his willingness to share with me his work on this topic prior to its publication. For Gumbrecht's discussion of meaning and presence effects, see Hans Ulrich Gumbrecht, *Production of Presence: What Meaning Cannot Convey* (Palo Alto, CA: Stanford University Press, 2004).

9 I follow the discussion of affect developed most fully in Deleuze and Guattari, *A Thousand Plateaus;* Gilles Deleuze and Félix Guattari, *What Is Philosophy?* trans. Hugh Tomlinson and Graham Burchell (New York: Columbia University Press, 1994); and Brian Massumi, *Parables for the Virtual: Movement, Affect, Sensation* (Durham, NC: Duke University Press, 2002).

10 Deleuze and Guattari, *A Thousand Plateaus,* 400, my emphasis.

11 As Massumi notes in his dense, but illuminating, discussion of "the autonomy of affect," affect can be understood as "the simultaneous participation of the virtual in the actual and the actual in the virtual. . . . *as seen from the side of the actual thing,* as couched in its perceptions." As a consequence, "[f]ormed, qualified, situated perceptions and cognitions fulfilling functions of actual connection or blockage are the capture and closure of affect. Emotion is the most intense (most contracted) expression of that capture—and of the fact that something has always and again escaped" (Massumi, *Parables for the Virtual,* 35).

12 For an example of the ways in which the concept of affect helps focus attention on dynamic systems, see Anna Munster's discussion of Adam Zaretsky's "musical fermentation" experiments and bioartworks. In a series of "art experiments" that he conducted with the Tissue Culture and Art Project, Zaretsky exposed *E. coli* to the music of Engelbert Humperdinck. As Munster notes, "[i]n playing Humperdinck to *E. coli* cells and observing the rapid production of antibodies by the bacteria, Zaretsky highlights life, growth and change as processes in a biological system which are the results of affective relations and interactions. . . . The point is not whether bacteria possess innate vibration receptors but that they grow contingently in relation to the sensation of musical vibration." See Anna Munster, "Bioaesthetics as Bioethics," in Pandilovski, *Art in the Biotech Era,* 19. For descriptions of several of Zaretsky's solo and joint works, see http://www.emutagen.com/ (accessed 23 October 2008).

13 Massumi, *Parables for the Virtual,* 35.

14 For a compelling account of the history of Duchamp's famous urinal readymade (*Fountain*) and the importance more generally of the readymade for twentieth-century art, see Duve, *Kant after Duchamp,* esp. 89–143, 327–68.

15 As Duve notes, "[t]o speak of art *after* Duchamp is to speak of a situation in which the 'experts' are ready to grant *beforehand* art *status* to anything whatever, regardless of medium or skill: in the sentence 'this is art,' anything can come to occupy the position of reference pointed at by the word 'this.' Not so, of course, when art *quality* is at stake: then 'this' has a precise referent and the prejudice [i.e., prejudgment] needs to be re-judged" (ibid., 335n4).

16 Historian James Beniger notes in his account of the late-nineteenth-century

"control revolution" that one of the key problems faced by corporations during this period was the development of information systems that would make it possible to avoid *over*producing goods (i.e., producing far more goods than could be sold). See James R. Beniger, *The Control Revolution: Technological and Economic Origins of the Information Society* (Cambridge, MA: Harvard University Press, 1986), esp. 169–290.

17 Duve, *Kant after Duchamp*, 147–99.

18 From this perspective, Steichen's hybrid delphiniums emerge as "proleptic" readymades. As I noted in chapter 2, the very possibility of exhibiting flowers as art depended upon the fact that, by the 1930s, "the 'experts' [were] ready to grant *beforehand* art *status* to anything whatever" (ibid., 335n4), and this was in large part due to Duchamp's influence. However, insofar as Steichen eventually employed the hybridizing techniques that he used for his MoMA exhibition in industrial-scale breeding production of these flowers, his exhibited delphiniums take on the character of readymades that were exhibited before they actually became commercially available.

19 Some projects seek to draw on other validating traditions: for example, Jeremijenko, Bunting, and Thacker's *Biotech Hobbyist* draws on the tradition of amateur scientific "hobbyism." See, e.g., the video interview with Jeremijenko in the "Alba, the Glowing Bunny and Other Bioart" chapter in Mitchell, Burgess, and Thurtle, *Biofutures*.

20 Allan Kaprow, *Assemblage, Environments, and Happenings* (New York: H. N. Abrams, 1966), 188–89.

21 As a consequence of the limited duration of happenings and performances, performance art often relies on photographic documentation as a means of making nonparticipants aware of its existence. For a brief discussion of the tension that photographic documentation establishes for performance art, see Laurie Anderson's "Foreword" to RoseLee Goldberg, *Performance: Live Art since the '60s* (New York: Thames and Hudson, 2004), 6–7, as well as Goldberg's own discussion (32–33).

22 There are a number of direct links between performance art and bioart: Eduardo Kac, for example, began his artistic career in Brazil as a performance artist, while many Critical Art Ensemble projects are designed in the style of performances and happenings. For Kac's account of his early career, see "PERFORMANCES (1980–1982)," available at http://www.ekac.org/performance.html (accessed 23 October 2008). For a reflection on the ways in which he subsequently has sought to complicate the notion of performance, see Eduardo Kac, *Telepresence and Bio Art: Networking Humans, Rabbits, and Robots* (Ann Arbor: University of Michigan Press, 2005), 3–58. For discussions of the relationship between performance art and bioart, see Hauser, "Bio Art"; and Hauser, "Observations on an Art of Growing Interest."

23 As Hauser has noted, "Bio Art is increasingly attracting the interest of perfor-

mance artists specializing in Body Art" (Hauser, "Bio Art," 184). The Australian body artist Stelarc, for example, has recently worked with Tissue Culture and Art Project in the hopes of having an "extra ear" attached to his head. For Stelarc's description of "The Extra Ear" project, see http://www.stelarc.va.com.au/extra_ear/index.htm (accessed 23 October 2008).

24 This is in keeping with Kaprow's suggestion that a happening could be extended over multiple times and places: the "performance of a Happening should take place over several widely spaced, sometimes moving and changing, locales," and the time of a happening "should be variable and discontinuous" (Kaprow, *Assemblage, Environments, and Happenings*, 189, 190).

25 For an account of the merging of life and art in literature and philosophy, see Philippe Lacoue-Labarthe and Jean-Luc Nancy, *The Literary Absolute: The Theory of Literature in German Romanticism* (Albany: State University of New York Press, 1988). For an account that links the aspirations of German Romanticism directly to twentieth-century art practices such as Dada and performance art, see Duve, *Kant after Duchamp*, esp. 283–325. For Kant's account of the link between art and the scientific study of living beings, see Immanuel Kant, *Critique of Judgment*, ed. Werner S. Pluhar (Indianapolis: Hackett Publishing Co., 1987), 32–35 and 235ff. (§§61ff.).

26 For Kant's account of the ways in which aesthetic experiences depend upon modulations of the "feeling of life" (*Lebensgefühl*), see *Critique of Judgment*, 44 (§1), as well as discussion of the difference between judgments of beauty and sublimity: Kant argues that where judgments of beauty depend upon "a feeling of life's being furthered [*ein Gefühl der Beförderung des Lebens*]," the sublime "is produced by the feeling of a momentary inhibition of the vital forces [*das Gefühl einer augenblicklichen Hemmung der Lebenskräfte*] followed immediately by an out-pouring of them that is all the stronger" (98 [§23]).

27 Kant's attempt to distinguish the form of the work of art from its material aspects was itself the result of his desire to distinguish "disinterested" judgments of beauty from judgments that are based on one's "interest" in the actual existence of an object. Kant argued that judgments that are based on the fact that an object actually exists are always in some way judgments of "interest"—that is, they are judgments about the ways in which an existing object contributes to (or does not contribute to) one's individual, subjective interests. He therefore concluded that *aesthetic* judgments cannot depend upon the actual material existence of an object. However, it is worth stressing that Kant is not therefore suggesting that aesthetic judgments of beauty can be made only about objects that do not exist. Rather, he is interested in the *basis* of a judgment about an object: that is, does one's judgment depend upon the fact that the object exists, or would one's judgment hold even if the object did not exist?

28 For Kant, the frame promises beauty, and beauty "carries with it the concept of an invitation to the most immediate union with the object, that is, to immedi-

ate enjoyment"; see Immanuel Kant, *Anthropology from a Pragmatic Point of View,* trans. Manfred Kuehn, ed. Robert B. Louden (New York: Cambridge University Press, 2006), 139.

29 We might take as paradigmatic for this ambivalence Kant's description of the sense of smell in his *Anthropology,* in which he notes that smelling requires that we "inhale air that is mixed with foreign vapors." Thus, insofar as we breathe, we cannot help but assist odors—even those that are disgusting—in making their way into us (ibid., 49). See also, in the *Critique of Judgment,* both Kant's explanation of the low status he awards music in the hierarchy of the arts—music, he writes, "extends its influence (on the neighborhood) farther than [some] people wish, and so, as it were, imposes itself on others"—and his related critique of the earlier custom of "pull[ing] a perfumed handkerchief" from one's pocket (such a custom, Kant complains, "gives all those next to and around him a treat whether they want it or not, and compels them, if they want to breathe, to 'enjoy' [*genießen*] [this odor] at the same time" [200 (§53)]; my scare quotes).

30 By describing this as an *embodied* oscillation, I am stressing that this tension, or sense of resistance, *remains* a tension, and it cannot be resolved. It is thus quite different from Kant's explanation of the sublime, in which an initial "vibration" is resolved in a subsequent experience of pleasure: see ibid., 115 (§27).

31 As Derrida has noted, though Kant presents the disgusting as simply a "species" of the genus "ugly," one nevertheless "quickly observes that it is not a species that would peacefully belong to its genus"; see Jacques Derrida, "Economimesis," *Diacritics* 11, no. 2 (1981): 22.

32 Kant, *Critique of Judgment,* 180 (§48).

33 Bourdieu, *Distinction,* 488.

34 My discussion of the frame is indebted to Derrida's analysis of the role of the "parergon" in Kant's philosophy; see Jacques Derrida, *The Truth in Painting* (Chicago: University of Chicago Press, 1987), 15–147. However, where Derrida's analysis is intended to illuminate the aporetic role of the frame in Kant's thought, I am more interested in "phenomenologizing" Derrida's account, in the sense of employing the logic of his account as a description of our experience of certain kinds of frames.

35 The generation of German philosophers who followed Kant were often much more attentive to this latter possibility. Hegel, for example, had nothing but scorn for an approach to art that focused only on "taste," arguing that "[s]o-called 'good taste' takes fright at all the deeper effects [of art]"; see Georg Wilhelm Friedrich Hegel, *Aesthetics: Lectures on Fine Art,* trans. T. M. Knox, 2 vols. (New York: Clarendon Press, 1998), 1:34. As I discuss in the next chapter, Hegel was also quite interested in the ways in which the media of art could produce a sense of becoming-medium. For a useful discussion of Kant and Hegel on the question of disgust, see Arthur Danto, "Marcel Duchamp and the End of Taste:

A Defense of Contemporary Art," *Tout-Fait: The Marcel Duchamp Studies Online Journal*, no. 3 (2003).

36 For discussions of "nonorganic life," see Gilles Deleuze, *Francis Bacon: The Logic of Sensation*, trans. Daniel W. Smith (London: Continuum, 2003); and Manuel DeLanda, "Nonorganic Life," in *Incorporations*, ed. Jonathan Crary and Sanford Kwinter (New York: Zone Books, 1992), 129–67.

37 Some performance artists, and some art historians, trace the lineage of performance art back, by way of the Dada movement, to the Duchampian readymade (see, e.g., Goldberg, *Performance*, 37). However, I follow Duve's reading of Duchamp's readymade as quite different in principle from Dada techniques, for the latter are motivated by an iconoclasm that still holds to the possibility of immediacy, but Duchamp's readymade is, by contrast, based on the primacy of mediacy (Duve, *Kant after Duchamp*, 338). Thus, though performance art may indeed be heir to Dada, it nevertheless remains distinct from the readymade. This distinction is important, because by hybridizing these two traditions, vitalist bioart is able to avoid falling prey to the vexing (but irresolvable) worries about "immediacy" that often plague discussions of performance art.

38 Drawing on Michel Foucault's notion of biopolitics, we can say that bioart produces an oscillation between a sense of being *a member of a public* (i.e., a rational actor within a larger communicative sphere) and *a part of a population* (i.e., simply one data point within mappings of health, longevity, and mortality across large groups of people). For Foucault's account of the relationship between populations and biopolitics, see Michel Foucault, *The History of Sexuality*, vol. 1, *An Introduction* trans. Robert Hurley (New York: Pantheon Books, 1978); Michel Foucault, *Security, Territory, Population: Lectures at the Collège de France, 1977–78*, trans. Graham Burchell, ed. Michel Senellart (New York: Palgrave Macmillan, 2007); and Michel Foucault, *Society Must Be Defended: Lectures at the Collège de France, 1975–76*, trans. David Macey (New York: Picador, 2003), esp. 239–64. (My thanks to Bishnupriya Ghosh and the other members of the Speculative Globalities research group for help on this point.)

39 The framing of vitalist bioart as *both* "art" *and* "living" also vexes the distinction that Kant sought to draw between "the beautiful in art" and "the beauty of nature" (*Critique of Judgment*, 165 [§42]). Using the example of a flower, Kant argued that a judgment of beauty concerning it depends upon an implicit understanding of it as "produced by nature"; should one later discover that "we had secretly played a trick on this lover of the beautiful, [by] sticking in the ground artificial flowers," then the judgment would be instantly altered. Vitalist bioart—whether or not it aims at judgments of beauty—both reverses and significantly complicates the process of reframing that Kant describes, for it presents spectators with an "art" object that is then revealed to be in part something "natural" and living; yet it also turns out that this living component has itself been altered by humans. Rather than allowing spectators to resolve whether the

object is "art" or "nature," vitalist bioart instead prolongs indefinitely this question of framing.

40 Duve exemplifies the dilemma of performance art through the "career" of performance artist Lee Lozano: because Lozano's performances were so similar to everyday events, and because her performances were, in general, not "communicated to the artworld" or documented, she eventually disappeared from the world of performance art (Duve, *Kant after Duchamp*, 298). For descriptions of Lozano's performance pieces, see Lucy R. Lippard, *Six Years: The Dematerialization of the Art Object from 1966 to 1972* (Berkeley and Los Angeles: University of California Press, 1997). For an analysis of this tension in terms of a contradictory desire on the part of performance art for both mediacy and immediacy, see Bernadette Wegenstein, "If You Won't Shoot Me, at Least Delete Me! Performance Art from 1960s Wounds to 1990s Extensions," in Mitchell and Thurtle, *Data Made Flesh*, 201–28.

41 For a discussion of judgments of disgust in the context of Duchamp's *Fountain,* see Danto, "Marcel Duchamp and the End of Taste."

42 In biological research, "wild type" is often used to refer to organisms (or parts of organisms, such as a stretch of genetic code) that are understood as "normal"—that is, not the result of experimental practices.

43 Carolyn Marvin, *When Old Technologies Were New: Thinking about Electric Communication in the Late Nineteenth Century* (New York: Oxford University Press, 1988), 27–32.

5 / The Strange Vitality of Media

1 The trajectory of the term "medium" within English-language natural philosophy (and, later, biology) has significant parallels with the history of the term "milieu" in French natural philosophy (and, later, biology). The history of this latter term has been outlined by historian of biology Georges Canguilhem in his important essay "The Living and Its Milieu," in which Canguilhem notes that "milieu" was "imported from mechanics to biology in the second half of the eighteenth century"; see Georges Canguilhem, "The Living and Its Milieu," *Grey Room* 03 (2001): 7. However, the fact that English authors eventually imported the term "milieu" from French while also retaining "medium" complicates Canguilhem's account. Nor was Canguilhem interested, in his history, in the cultural sense of the term "medium."

2 For Bacon's accounts of the media of sounds, magnetism, and odors, see Francis Bacon, *The Philosophical Works of Francis Bacon,* ed. Peter Shaw, 3 vols. (London: printed for J. J. and P. Knapton et al., 1733), 3:277, 122, 155. For an example of Newton's use of the term "medium," see Isaac Newton, *Optical Lectures Read in the Publick Schools of the University of Cambridge* (London: printed for Francis Fayram, 1728), 5ff.

3 William Godwin, *Enquiry concerning Political Justice, and Its Influence on Modern*

Morals and Happiness, 3rd ed., ed. Isaac Kramnick (Baltimore, MD: Penguin, 1976), 363, 771.

4 Robert Fulton, *A Treatise on the Improvement of Canal Navigation* (London: I. and J. Taylor, 1796), 4; Adam Smith, *An Inquiry into the Nature and Causes of the Wealth of Nations,* ed. R. H. Campbell and A. S. Skinner, 2 vols., Glasgow Edition of the Works and Correspondence of Adam Smith (Indianapolis, IN: Liberty Fund, 1981), V.3.81.

5 See Hegel, *Aesthetics,* 1: esp. 30, 46–47. For the original German, see Georg Wilhelm Friedrich Hegel, *Werke in zwanzig Bänden: Theorie-Werkausgabe* (Frankfurt: Suhrkamp, 1970), 13:50, 71.

6 Godwin, *Enquiry concerning Political Justice,* 674. For a useful account of eighteenth-century understandings of "communication" that also stresses the "organic" undergirding of this concept, see Armand Mattelart, *The Invention of Communication,* trans. Susan Emanuel (Minneapolis: University of Minnesota Press, 1996), esp. xiii–111.

7 George Adams, *Lectures on Natural and Experimental Philosophy, Considered in It's Present State of Improvement,* 5 vols. (London: printed by R. Hindmarsh, 1794), 2:3.

8 I have not been able to locate any English, French, or German philosophers or authors who explicitly discussed art in terms of "media" prior to Hegel. Eighteenth-century theories of art tended instead to focus more on subjective responses, with relatively little regard to medium (e.g., Edmund Burke's *A Philosophical Enquiry concerning the Beautiful and the Sublime*), or on techniques for generating beauty within a particular medium (e.g., Joshua Reynolds's *Lectures on Painting*). In her work on our own "postmedium condition," Rosalind Krauss rediscovers a quasi-Hegelian dialectic within the history of modernist art, outlining a movement that leads from an early interest in the specificity of particular media to conceptual art, which sought to "purif[y] art of its material dross . . . producing it as a mode of theory-about-art" (Krauss, *"Voyage on the North Sea,"* 10). (See chapter 1 for a discussion of Krauss's argument.)

9 In *Madness and Civilization: A History of Insanity in the Age of Reason,* trans. Richard Howard (New York: Vintage Books, 1973), Michel Foucault suggests that the concept of milieu played an important role in late-eighteenth-century attempts to understand the causes of madness (212–20), and in the recently published *Security, Territory, Population,* he argues that the term was important in the development of the early-nineteenth-century concept of human "populations." Foucault's accounts are complicated, however, by his acknowledgment in *Security, Territory, Population* that the authors of the sources that he cites "did not actually employ the notion of milieu" (21).

10 Richard Saumarez, *A New System of Physiology, Comprehending the Laws by Which Animated Beings in General, and the Human Species in Particular, Are Governed, in Their Several States of Health and Disease,* 2nd ed., 2 vols. (London: sold by J. Johnson, 1799), 1:23.

11 The term that Lamarck uses throughout his work is *milieu* rather than the French term *medium*. However, as Denis Diderot and Jean Le Rond d'Alembert noted in their entry for "medium" in the *Encyclopédie* (1751–65), *medium* was a term used synonymously with *milieu* within eighteenth-century natural philosophy, though *milieu* was the term "more frequently employed" (*beaucoup plus usité*). For the sake of linguistic simplicity, I have translated Lamarck's *milieu* with *medium*.

12 As Canguilhem noted, Lamarck understood living beings as existing in a "distressful and distressed" relationship to their media, for "life and the medium [*milieu*] that is unaware of it are two asynchronous series of events. The change of circumstances [of the medium] comes first, but it is the living being itself that, in the end, initiates the effort to not be let go by its medium [*milieu*]. Adaptation is a repeated effort on the part of life to continue to 'stick' to an indifferent medium [*milieu*]" (Canguilhem, "The Living and Its Milieu," 12, translation modified). For Lamarck, the shifting nature of the media within which living beings existed meant that every apparently stable "species" of animal was in fact always a transition point, as each individual body functioned as a medium for experimenting with new relationships between external media and living beings. For this reason, Lamarck argued against an ontological understanding of species, contending that species were simply epistemological labels that humans used to denote relative points of stability within a general condition of change. See the discussion of the term "species" in Jean-Baptiste Lamarck, *Zoological Philosophy: An Exposition with Regard to the Natural History of Animals,* trans. Hugh Samuel Roger Elliot (Chicago: University of Chicago Press, 1984), 35–46.

13 Lamarck, *Zoological Philosophy,* 190. For a discussion of the role of dead bodies in geological change, see Jean-Baptiste Lamarck, *Hydrogeology,* trans. Albert V. Carozzi (Champaign: University of Illinois Press, 1964), esp. 83–136.

14 For an account of Claude Bernard's influential concept of the "internal milieu," see Frederic L. Holmes, "Claude Bernard and the Milieu Intérieur," *Archives internationales d'histoire des sciences* 16 (1963): 369–76.

15 For discussion of the development of artificial media in the context of bacteriology, see William Bulloch, *The History of Bacteriology* (1938; reprint, New York: Dover Publications, 1979), 217–30.

16 Ibid., 225–26.

17 For a very early history of the development of tissue culture and tissue culture media, see Albert Fischer, *Tissue Culture: Studies in Experimental Morphology and General Physiology of Tissue Cells in Vitro* (Copenhagen: Levin and Munksgaard, 1925). More recent accounts of tissue culture that bear somewhat upon the development of media include Susan M. Squier, "Life and Death at Strangeways: The Tissue-Culture Point of View," in *Biotechnology and Culture: Bodies, Anxieties, Ethics,* ed. Paul E. Brodwin (Indianapolis: Indiana University Press, 2000), 27–52; and Hannah Landecker, *Culturing Life: How Cells Became Technologies* (Cambridge, MA: Harvard University Press, 2007).

18 DMEM is an acronym that stands for Dulbecco's Modified Eagle Medium. RPMI stands for Rapid Prototyping and Manufacturing Institute.

19 This division between cultural and biological senses of media, in fact, helps to explain the similarities between two otherwise quite different mid-nineteenth-century "new media," namely, the telegraph and the "spiritual medium" who claimed to be able to link the terrestrial with the astral planes and the living with the dead. As Jeffrey Sconce notes in *Haunted Media: Electronic Presence from Telegraphy to Television* (Durham, NC: Duke University Press, 2000), these two communication media emerged in tandem, both premised on the principle that "flows" of electrical spirit could extend human consciousness beyond the normal scales of bodily existence (7, 29–30). Though the telegraph and spiritual medium differed radically in their perceived legitimacy, and though the spiritual medium linked the living and the dead through the human body, both of these new media were understood through the schema of communicational, rather than biological, media (even if, as Sconce astutely notes, each of these two media in fact ended up serving as media for transformation of social relations: see 54). For more on spiritual mediums, see the exhibition catalog Clément Chéroux, Andreas Fischer, Pierre Apraxine, Denis Canguilhem, and Sophie Schmit, eds., *The Perfect Medium: Photography and the Occult* (New Haven, CT: Yale University Press, 2005).

20 Thacker's *Biomedia* represents a significant and welcome exception to this general rule. However, it is worth stressing that Thacker's term "biomedia" is intended to illuminate contemporary linkages between biological and computational media rather than a more general theory of cultural-biological media per se.

21 See, e.g., Edward O. Wilson, *Consilience: The Unity of Knowledge* (New York: Knopf, 1998), 229–59; Steven Pinker, *How the Mind Works* (New York: Norton, 1997), 521–26; and Geoffrey F. Miller, *The Mating Mind: How Sexual Choice Shaped the Evolution of Human Nature* (New York: Doubleday, 2000), 258–91.

22 As my scare quotes around "art" are meant to highlight, one of the problems that plagues many of these accounts is the relative ambiguity of the reference for this term. It is often not clear, in other words, what precisely counts as "art" in a given sociobiological or evolutionary psychological theory. Is a given theory attempting to account, for example, for *all* objects or practices that have been called "art" by at least one person? If not, what then is the criterion for counting only a subset of this larger set as art? And assuming that this problem has been solved, is a given theory an attempt to account for (*a*) why someone *produced* an object or experience that he/she or others have called art; (*b*) a subjective *experience* that is understood as tied to seeing, hearing, etc. what people have called art; or (*c*) why some people seem to *value* these objects or experiences? Finally, sociobiological and evolutionary psychological accounts of art almost invariably implicitly privilege one kind of aesthetic experience, which then serves as the

paradigm for all art. Wilson, for example, implicitly takes the visual arts as his paradigm for art, while Miller takes architecture as his paradigm. Yet the fact that this paradigm remains implicit then makes it difficult for these theories to account for other aesthetic forms: it is not clear, for example, how Wilson would account for music, or how Pinker would account for abstract painting. (My thanks to Jordan Evanston for his discussion of some of these topics.)

23 Miller, *Mating Mind,* 269.

24 Mitchell, *What Do Pictures Want?* 204, 16.

25 This confusion of base and superstructure is emphasized by bioartists' frequent use of *E. coli,* an organism that transfers genetic material laterally, between existing individuals, as well as from one generation to the next.

26 Gilbert Simondon, *L'individuation à la lumière des notions de forme et d'information* (Paris: Presses Universitaires de France, 1964), 30, my translation. When possible, I cite from the English translation of the introduction to Simondon's *L'individuation à la lumière des notions de forme et d'information,* available in English as Gilbert Simondon, "The Genesis of the Individual," trans. Mark Cohen and Sanford Kwinter, in *Incorporations,* ed. Jonathan Crary and Sanford Kwinter (New York: Zone Books, 1992), 297–319, and indicate in parentheses or brackets the corresponding passage in *L'individuation.* Citations drawn from sections of the book other than the introduction are to *L'individuation,* and the translations are my own.

27 Simondon suggests that the understanding of technology as the imposition of "form" on "matter" first emerged in classical Greek philosophy, in large part as a function of social economic hierarchies, which meant that those who developed these theories of technologies had little experience with the actual processes necessary to produce, for example, bricks (Simondon, *L'individuation,* 62–63).

28 This phrase is in italics in the original, though not in the translation.

29 Simondon's work thus instantiates a significantly different understanding of how to comprehend the relationship between physics and biology than the one that came to dominate the research program of molecular biology established in the 1940s and 1950s. Whereas molecular biology aspired to translate the characteristics of living organisms into the language of physics—an approach encouraged by reflections on biology by physicists such as Erwin Schrödinger and George Gamow—Simondon was more interested in creating new concepts for both physics and biology by establishing relationships of "transduction" between the two. For the importance of Schrödinger and Gamow for molecular biology, see Kay, *Who Wrote the Book of Life?* 38–72, 128–92; and Richard Doyle, *On Beyond Living: Rhetorical Transformations of the Life Sciences* (Palo Alto, CA: Stanford University Press, 1997), 35–63. For an account of Simondon's concept of transduction, see Adrian Mackenzie, *Transductions: Bodies and Machines at Speed* (New York: Continuum, 2002).

30 Simondon emphasizes that, though Lamarck was incorrect about the mecha-
 nism of organic change, his concept of "adaptation" nevertheless continues
 to present a useful template for understanding living beings: "The theory of
 active adaptation developed by Lamarck . . . offers an important advantage over
 Darwin's [theory of adaptation]: the former considers the activity of the indi-
 viduated being as playing a key role in adaptation; adaptation is a permanent
 ontogenesis. However, Lamarck's doctrine does not grant sufficient impor-
 tance to conditions determined by the problematic aspect of vital existence"
 (Simondon, *L'individuation,* 235). From the perspective of metastability, in fact,
 Lamarck's account of organic change over time is not fundamentally opposed
 to Charles Darwin's. The differences between Lamarck and Darwin occur
 primarily in two other registers. On the one hand, Lamarck and Darwin dif-
 fered in their understandings of the *mechanism* that produced corporeal novelty:
 Lamarck believed that animal desire produced corporeal changes, while Darwin
 believed that change was produced by random variations. Lamarck and Darwin
 also differed in their emphasis on the importance of relationships between
 animals: Lamarck was primarily interested in medium-animal relationships
 and had relatively little to say about animal-animal relationships, while Darwin
 saw competition between animals as vital for "clearing the field" of unsuccess-
 ful corporeal experiments. As Canguilhem notes, "[t]he fundamental biological
 relationship, in Darwin's eyes, is a relationship between living things and other
 living things. It trumps the relationship between living and milieu, conceived
 of as a collection of physical forces. The primary milieu an organism lives in is
 the set of living things around it that are enemies or allies, prey or predators"
 (Canguilhem, "The Living and Its Milieu," 13). Yet as Deleuze and Guattari
 emphasize, Darwin's model of organic change also assumes the principle of
 metastability (see Deleuze and Guattari, *A Thousand Plateaus,* 47–58).

31 Hans Magnus Enzensberger, "Constituents of a Theory of the Media," in *Elec-
 tronic Culture: Technology and Visual Representation,* ed. Timothy Druckrey (New
 York: Aperture, 1996), 62.

32 This is a point emphasized by Manuel Castells in his massive three-volume
 account of media, *The Information Age*. For his discussion of problematics beyond
 those of the economic, see Manuel Castells, *The Information Age,* vol. 1, *The Rise of
 the Network Society* (Cambridge, MA: Blackwell Publishers, 1996), 1–27.

33 Brian Larkin, *Signal and Noise: Media, Infrastructure, and Urban Culture in Nigeria*
 (Durham, NC: Duke University Press, 2008); Matthew Fuller, *Media Ecologies:
 Materialist Energies in Art and Technoculture* (Cambridge, MA: MIT Press, 2005).
 Recognition of the importance of connections across scales also arguably has
 guided many of the most vital of older approaches to media, such as Harold
 Innis's still-compelling media theory, developed across *The Fur Trade in Canada:
 An Introduction to Canadian Economic History* (Toronto and Buffalo: University of
 Toronto Press, 1999), originally published in 1930, and *Empire and Communica-*

tions (Lanham, MD: Rowman and Littlefield, 2007), originally published in 1950. Where *The Fur Trade in Canada* emphasized the importance of macroscale geographical features such as ocean inlets and drainage basins on the development of imperial networks, *Empire and Communications* focused more on the importance of media differences for structures of empire, distinguishing between media that emphasize time (such as stone or clay tablets) and those that emphasize space (such as paper).

34 Larkin, *Signal and Noise,* 47.

35 Fuller, *Media Ecologies,* 2. Fuller notes that he prefers "ecology" to "environment," insofar as the latter term is too often understood to denote "a state of equilibrium" (4).

36 Ibid., 22–23, 169.

37 Larkin, *Signal and Noise,* 220.

38 Jay David Bolter and Richard Grusin, *Remediation: Understanding New Media* (Cambridge, MA: MIT Press, 2004), 65.

39 Krauss, "Reinventing the Medium," 296.

40 Krauss, *"Voyage on the North Sea,"* 44, 53.

41 Exploring the many kinds of dynamics that media encourage will also guard us from the tendency, noted by Lev Manovich, to assume that new media technologies will always lead to "better democracy"; see Lev Manovich, "Old Media as New Media: Cinema," in *The New Media Book,* ed. Dan Harries (London: BFI Publishing, 2002), 19. What Manovich is pointing to is a tendency to confuse the widespread "communication" that many contemporary media enable with a particular kind of politics.

42 Marshall McLuhan, *The Gutenberg Galaxy: The Making of Typographic Man* (Toronto: University of Toronto Press, 1962), 24.

43 It is worth noting that even within commercial settings, the immanent potential for individuation of living beings can only be limited, not foreclosed, for technicians must contend with the problem of "phenotypic drift": that is, the tendency of mutations to emerge across generations even in the absence of reagents.

6 / Bioart and the "Newness" of Media

1 Kennedy, "The Artists in the Hazmat Suits."

2 Kac, *Signs of Life,* 1.

3 Focusing only on monographs, examples of recent new media studies that explore digital video, film, and television include Bolter and Grusin, *Remediation;* and Lev Manovich, *The Language of New Media* (Cambridge, MA: MIT Press, 2001). Accounts of the role of new media in installation and performance art include Hansen, *New Philosophy for New Media.* Relationships between new media and video games are discussed in Alexander R. Galloway, *Gaming: Essays on Algorithmic Culture* (Minneapolis: University of Minnesota Press, 2006); and

Ian Bogost, *Unit Operations: An Approach to Videogame Criticism* (Cambridge, MA: MIT Press, 2006). Computer software and hardware are discussed in Friedrich A. Kittler, *Literature, Media, Information Systems: Essays,* ed. John Johnston (Amsterdam: G+B Arts International, 1997); and Kittler, *Gramophone, Film, Typewriter.* Electronic literature is (in part) the subject of N. Katherine Hayles, *My Mother Was a Computer: Digital Subjects and Literary Texts* (Chicago: University of Chicago Press, 2005). Discussions of digital sound technologies include Aden Evens, *Sound Ideas: Music, Machines, and Experience* (Minneapolis: University of Minnesota Press, 2005); and Lisa Gitelman, *Always Already New: Media, History, and the Data of Culture* (Boston, MA: MIT Press, 2006). As is evident from this list, both MIT Press and the University of Minnesota Press have played central roles in determining the new "canon" of new media studies monographs.

4 Hansen's *New Philosophy for New Media* is the most prominent example of the call for more explicit development of new theoretical approaches. Both Bolter and Grusin's *Remediation* and Manovich's *Language of New Media,* by contrast, are more chary in announcing their methodological principles, relying on what seems to be an essentially liberalist vision (of the John Perry Barlow "information wants to be free" variety).

5 Mitchell, *What Do Pictures Want?* 205. The relationship of "new media studies" to the older term "media studies" is also vexed. So, for example, while Wardrip-Fruin and Montfort position new media studies as the natural outgrowth of earlier theorizations of media, their emphasis on the computer ends up excluding the work of, for example, Frankfurt School media critics and favoring figures such as Jorge Luis Borges and Vannevar Bush. See Noah Wardrip-Fruin and Nick Montfort, eds., *The New Media Reader* (Cambridge, MA: MIT Press, 2003).

6 Lev Manovich, for example, argues that what distinguishes old from new media is the "programmability" of the latter, while the recent genealogy of new media studies outlined in Wardrip-Fruin and Montfort's *New Media Reader* positions the computer, and its capacities for digitization, as the key to new media.

7 As I noted in the last chapter, Thacker's *Biomedia* represents an important exception to this general trend.

8 Thacker, *Global Genome,* 17.

9 Henry Jenkins, for example, contends that the convergence of media means first and foremost a new understanding of media audiences: "convergence represents a cultural shift as consumers are encouraged to seek out new information and make connections across dispersed media content"; see Henry Jenkins, *Convergence Culture: Where Old and New Media Collide* (New York: New York University Press, 2006), 3.

10 Kittler, *Gramophone, Film, Typewriter,* 1–2.

11 Hansen, *New Philosophy for New Media,* 1.

12 As Hansen puts it, "the so-called digital image explodes the stability of the technical image in any of its concrete theorizations" (ibid., 8).

13 Mark B. N. Hansen, "The Time of Affect, or Bearing Witness to Life," *Critical Inquiry* 30 (2004): 614.

14 The importance of the concept of "coevolution" for Hansen's approach to new media is more explicitly developed in Mark B. N. Hansen, *Bodies in Code: Interfaces with Digital Media* (New York: Routledge, 2006).

15 In *New Philosophy for New Media,* Hansen argues more generally that contemporary relationships between digital technologies and the human body serve to "actualiz[e] the potential of the [digital] image" while at the same time "virtualiz[ing] the body" (130).

16 See, e.g., the discussion of Simondon in ibid., 8, 129, 265–66.

17 One curious consequence of this approach is that the body itself becomes essentially a technical device for consciousness. Hansen emphasizes, for example, the "essential technicity of the skin," for it is by means of skin that consciousness is able to encounter the world and others (Hansen, *Bodies in Code,* 263, 59–67).

18 This difference between my position and Hansen's is in large part a function of our differing sense of how best to situate Simondon. Hansen sees Simondon as a "bio-phenomenologist" working in a tradition of interest in "embodied cognition" initiated by Bergson's *Matter and Memory* (1896) (see Hansen, *New Philosophy for New Media,* 8, 129). By contrast, my version of Simondon has more in common with the Bergson of *Creative Evolution* (1907) than with the Bergson of *Matter and Memory.* Moreover, I see both Bergson and Simondon as part of a tradition of thought about the relationship between media, complexity, and time that begins with Lamarck's zoological philosophy.

19 For examples of the role of new media in contemporary labor practices, see Alan Liu, *The Laws of Cool: Knowledge Work and the Culture of Information* (Chicago: University of Chicago Press, 2004).

20 This commitment is especially clear in Friedrich Kittler, "The History of Communication Media," *cTheory.net* (1996), http://www.ctheory.net/articles. aspx?id=45 (accessed 1 November 2008).

21 Hansen engages the question of social differentials more explicitly in *Bodies in Code,* especially in the chapter "Digitizing the Racialized Body, or the Politics of Common Impropriety" (139–73). However, this analysis too focuses primarily on the opportunities that new media offer to consciousness, rather than linking these opportunities to larger problematics.

22 Krauss, "Reinventing the Medium," 304.

23 There is a sort of uncanny triangulation between Hansen's position and those of Kittler and Krauss, for one could adopt a Kraussian position to argue that Hansen could theorize the liberatory potential of the body *now* only if Kittler is indeed correct that human perceptual abilities have become "obsolete" in the era of the "total media link."

Works Cited

Adams, George. *Lectures on Natural and Experimental Philosophy, Considered in It's Present State of Improvement.* 5 vols. London: printed by R. Hindmarsh, 1794.

Andrews, Lori B. "Art as Public Policy Medium." In *Signs of Life: Bio Art and Beyond,* edited by Eduardo Kac, 125–49. Cambridge, MA: MIT Press, 2007.

Anker, Suzanne, and Dorothy Nelkin. *The Molecular Gaze: Art in the Genetic Age.* Cold Spring Harbor, NY: Cold Spring Harbor Laboratory Press, 2004.

Bacon, Francis. *The Philosophical Works of Francis Bacon.* Edited by Peter Shaw. 3 vols. London: printed for J. J. and P. Knapton et al., 1733.

Beniger, James R. *The Control Revolution: Technological and Economic Origins of the Information Society.* Cambridge, MA: Harvard University Press, 1986.

Benjamin, Walter. "The Work of Art in the Age of Mechanical Reproduction." In *Illuminations,* 217–52. New York: Schocken Books, 1968.

Benton, E. "Vitalism in Nineteenth-Century Thought: A Typology and Reassessment." *Studies in the History and Philosophy of Science* 5 (1974): 17–48.

Bogost, Ian. *Unit Operations: An Approach to Videogame Criticism.* Cambridge, MA: MIT Press, 2006.

Bolter, Jay David, and Richard Grusin. *Remediation: Understanding New Media.* Cambridge, MA: MIT Press, 2004.

Bourdieu, Pierre. *Distinction: A Social Critique of the Judgement of Taste.* Translated by Richard Nice. Cambridge, MA: Harvard University Press, 1984.

Boyle, James. *Shamans, Software, and Spleens: Law and the Construction of the Information Society.* Cambridge, MA: Harvard University Press, 1996.

Bulloch, William. *The History of Bacteriology.* 1938. Reprint, New York: Dover Publications, 1979.

Canguilhem, Georges. "The Living and Its Milieu." *Grey Room* 03 (2001): 7–31.

Castells, Manuel. *The Information Age.* Vol. 1, *The Rise of the Network Society.* Cambridge, MA: Blackwell Publishers, 1996.

Chéroux, Clément, Andreas Fischer, Pierre Apraxine, Denis Canguilhem, and Sophie Schmit, eds. *The Perfect Medium: Photography and the Occult.* New Haven, CT: Yale University Press, 2005.

Clausen, Jens, David D. Keck, and William H. Hiesey. *Experimental Studies on the Nature of Species.* Vol. 3, *Environmental Responses of Climatic Races of Achillea.* Washington, DC: Carnegie Institution of Washington, 1948.

Cohen, Stanley N., Annie C. Y. Chang, Herbert W. Boyer, and Robert B. Helling. "Construction of Biologically Functional Bacterial Plasmids *in Vitro.*" *Proceedings of the National Academies of Science* 70, no. 11 (1973): 3240–44.

Cooper, Melinda. *Life as Surplus: Biotechnology and Capitalism in the Neoliberal Era.* Seattle: University of Washington Press, 2008.

Crichton, Michael. *Next: A Novel.* New York: HarperCollins, 2006.

da Costa, Beatriz, and Kavita Philip, eds. *Tactical Biopolitics: Art, Activism, and Techno-science.* Cambridge, MA: MIT Press, 2008.

Danto, Arthur. "Marcel Duchamp and the End of Taste: A Defense of Contemporary Art." *Tout-Fait: The Marcel Duchamp Studies Online Journal,* no. 3 (2003).

davidkremers. "REPRO DUCTION." In *Signs of Life: Bio Art and Beyond,* edited by Eduardo Kac, 295–300. Cambridge, MA: MIT Press, 2007.

Davis, Joe. "Cases for Genetic Art." In *Signs of Life: Bio Art and Beyond,* edited by Eduardo Kac, 249–66. Cambridge, MA: MIT Press, 2007.

———. "Microvenus." *Art Journal* 55, no. 1 (1996): 70–74.

DeLanda, Manuel. "Nonorganic Life." In *Incorporations,* edited by Jonathan Crary and Sanford Kwinter, 129–67. New York: Zone Books, 1992.

Deleuze, Gilles. *Difference and Repetition.* Translated by Paul Patton. New York: Columbia University Press, 1995.

———. *The Fold: Leibniz and the Baroque.* Translated by Tom Conley. Minneapolis: University of Minnesota Press, 1993.

———. *Francis Bacon: The Logic of Sensation.* Translated by Daniel W. Smith. London: Continuum, 2003.

Deleuze, Gilles, and Félix Guattari. *A Thousand Plateaus: Capitalism and Schizo-phrenia.* Translated by Brian Massumi. Minneapolis: University of Minnesota Press, 1987.

———. *What Is Philosophy?* Translated by Hugh Tomlinson and Graham Burchell. New York: Columbia University Press, 1994.

Derrida, Jacques. "Economimesis." *Diacritics* 11, no. 2 (1981): 2–25.

———. *The Truth in Painting.* Chicago: University of Chicago Press, 1987.

Diderot, Denis, and Jean Le Rond d'Alembert. *Encyclopédie ou dictionnaire raisonné des sciences, des arts et des métiers, par une société de gens de letters.* Compact ed. 5 vols. Elmsford, NY: Pergamon Press, 1969.

Doyle, Richard. "LSDNA: Consciousness Expansion and the Emergence of Biotechnology." In *Data Made Flesh: Embodying Information,* edited by Robert Mitchell and Phillip Thurtle, 121–36. New York: Routledge, 2004.

———. *On Beyond Living: Rhetorical Transformations of the Life Sciences.* Palo Alto, CA: Stanford University Press, 1997.

Driesch, Hans. *The History and Theory of Vitalism.* Translated by C. K. Ogden. London: Macmillan and Co., 1914.

Duve, Thierry de. *Kant after Duchamp.* Cambridge, MA: MIT Press, 1996.

Enzensberger, Hans Magnus. "Constituents of a Theory of the Media." In *Electronic*

Culture: Technology and Visual Representation, edited by Timothy Druckrey, 62–85. New York: Aperture, 1996.

Evens, Aden. *Sound Ideas: Music, Machines, and Experience.* Minneapolis: University of Minnesota Press, 2005.

Fischer, Albert. *Tissue Culture: Studies in Experimental Morphology and General Physiology of Tissue Cells in Vitro.* Copenhagen: Levin and Munksgaard, 1925.

Fleck, Ludwig. *Genesis and Development of a Scientific Fact.* Translated by Fred Bradley. Edited by Thaddeus J. Trenn and Robert King Merton. Chicago: University of Chicago Press, 1979.

Foucault, Michel. *The History of Sexuality.* Vol. 1, *An Introduction.* Translated by Robert Hurley. New York: Pantheon Books, 1978.

———. *Madness and Civilization: A History of Insanity in the Age of Reason.* Translated by Richard Howard. New York: Vintage Books, 1973.

———. *The Order of Things: An Archaeology of the Human Sciences.* New York: Vintage Books, 1973.

———. *Security, Territory, Population: Lectures at the Collège de France, 1977–78.* Translated by Graham Burchell. Edited by Michel Senellart. New York: Palgrave Macmillan, 2007.

———. *Society Must Be Defended: Lectures at the Collège de France, 1975–76.* Translated by David Macey. New York: Picador, 2003.

Fowler, Cary. "The Plant Patent Act of 1930: A Sociological History of Its Creation." *Journal of the Patent and Trademark Office Society* 82 (2000): 621–44.

Freyhofer, Horst H. *The Vitalism of Hans Driesch: The Success and Decline of a Scientific Theory.* Frankfurt am Main: P. Lang, 1982.

Fuller, Matthew. *Media Ecologies: Materialist Energies in Art and Technoculture.* Cambridge, MA: MIT Press, 2005.

Fulton, Robert. *A Treatise on the Improvement of Canal Navigation.* London: I. and J. Taylor, 1796.

Galloway, Alexander R. *Gaming: Essays on Algorithmic Culture.* Minneapolis: University of Minnesota Press, 2006.

Gedrim, Ronald J. "Edward Steichen's 1936 Exhibition of Delphinium Blooms: An Art of Flower Breeding." In *Signs of Life: Bio Art and Beyond,* edited by Eduardo Kac, 347–69. Cambridge, MA: MIT Press, 2007.

Gene(sis): Contemporary Art Explores Human Genomics. DVD-ROM. Seattle: Henry Art Gallery, 2003.

Gessert, George. "A History of Art Involving DNA." In *LifeScience (Ars Electronica 1999),* edited by Gerfried Stocker and Christine Schöpf, 228–36. New York: Springer, 1999.

———. "Unverifiable Claims in Genetic Art." In *Art in the Biotech Era,* edited by Melentie Pandilovski, 8–12. Adelaide, SA: Experimental Art Foundation, 2008.

Gigliotti, Carol. "Leonardo's Choice: The Ethics of Artists Working with Genetic Technologies." *AI and Society,* no. 20 (2006): 22–34.

Ginsburg, Faye D., Lila Abu-Lughod, and Brian Larkin, eds. *Media Worlds: Anthropology on New Terrain.* Berkeley and Los Angeles: University of California Press, 2002.

Gitelman, Lisa. *Always Already New: Media, History, and the Data of Culture.* Boston, MA: MIT Press, 2006.

Godwin, William. *Enquiry concerning Political Justice, and Its Influence on Modern Morals and Happiness.* 3rd ed. Edited by Isaac Kramnick. Baltimore, MD: Penguin, 1976.

Goldberg, RoseLee. *Performance: Live Art since the '60s.* New York: Thames and Hudson, 2004.

Graham, Bradley. "Patent Bill Seeks Shift to Bolster Innovation." *Washington Post,* 8 April 1979, 1.

Gumbrecht, Hans Ulrich. *Production of Presence: What Meaning Cannot Convey.* Palo Alto, CA: Stanford University Press, 2004.

Hansen, Mark B. N. *Bodies in Code: Interfaces with Digital Media.* New York: Routledge, 2006.

———. *New Philosophy for New Media.* Cambridge, MA: MIT Press, 2004.

———. "The Time of Affect, or Bearing Witness to Life." *Critical Inquiry* 30 (2004): 584–626.

Harrington, Anne. *Reenchanted Science: Holism in German Culture from Wilhelm II to Hitler.* Princeton, NJ: Princeton University Press, 1996.

Hauser, Jens. "Bio Art—Taxonomy of an Etymological Monster." In *Ars Electronica 2005: Hybrid—Living in Paradox,* edited by Gerfried Stocker and Christine Schöpf, 182–93. Portchester, Hampshire: Art Books International, 2005.

———. "Gènes, génies, gênes." In *L'art biotech,* edited by Patricia Solini, Jens Hauser, and Vilém Flusser, 9–15. Nantes: Filigranes Editions, 2003.

———. "Observations on an Art of Growing Interest: Toward a Phenomenological Approach to Art Involving Biotechnology." In *Tactical Biopolitics: Art, Activism, and Technoscience,* edited by Beatriz da Costa and Kavita Philip, 83–104. Cambridge, MA: MIT Press, 2008.

———, ed. *Sk-Interfaces: Exploding Borders—Creating Membranes in Art, Technology, and Society.* Liverpool: FACT and Liverpool University Press, 2008.

Hayles, N. Katherine. *How We Became Posthuman: Virtual Bodies in Cybernetics, Literature, and Informatics.* Chicago: University of Chicago Press, 1999.

———. *My Mother Was a Computer: Digital Subjects and Literary Texts.* Chicago: University of Chicago Press, 2005.

Hegel, Georg Wilhelm Friedrich. *Aesthetics: Lectures on Fine Art.* Translated by T. M. Knox. 2 vols. New York: Clarendon Press, 1998.

———. *Werke in zwanzig Bänden: Theorie-Werkausgabe.* 20 vols. Frankfurt: Suhrkamp, 1970.

Helmreich, Stefan. *Silicon Second Nature: Culturing Artificial Life in a Digital World.* Berkeley and Los Angeles: University of California Press, 1998.

Holmes, Frederic L. "Claude Bernard and the Milieu Intérieur." *Archives internation-*

ales d'histoire des sciences 16 (1963): 369–76.

Innis, Harold Adams. *The Fur Trade in Canada: An Introduction to Canadian Economic History.* Toronto and Buffalo: University of Toronto Press, 1999.

———. *Empire and Communications.* Lanham, MD: Rowman and Littlefield, 2007.

Jacob, François. *The Logic of Life: A History of Heredity.* Translated by Betty E. Spillmann. Princeton, NJ: Princeton University Press, 1973.

Jacyna, L. S. "Immanence or Transcendence: Theories of Life and Organization in Britain, 1790–1835." *Isis* 74, no. 3 (1983): 310–29.

Jenkins, Henry. *Convergence Culture: Where Old and New Media Collide.* New York: New York University Press, 2006.

Jeremijenko, Natalie, and Eugene Thacker. *Creative Biotechnology: A User's Manual.* New York: Locus +, 2004.

Judson, Horace Freeland. "A History of the Science and Technology behind Gene Mapping and Sequencing." In *The Code of Codes: Scientific and Social Issues in the Human Genome Project,* edited by Daniel J. Kevles and Leroy E. Hood, 37–80. Cambridge, MA: Harvard University Press, 1992.

Kac, Eduardo. *Signs of Life: Bio Art and Beyond.* Cambridge, MA: MIT Press, 2007.

———. *Telepresence and Bio Art: Networking Humans, Rabbits, and Robots.* Ann Arbor: University of Michigan Press, 2005.

———. "Transgenic Art Online." In *Data Made Flesh: Embodying Information,* edited by Robert Mitchell and Phillip Thurtle, 259–62. New York: Routledge, 2004.

Kant, Immanuel. *Anthropology from a Pragmatic Point of View.* Translated by Manfred Kuehn. Edited by Robert B. Louden. New York: Cambridge University Press, 2006.

———. *Critique of Judgment.* Edited by Werner S. Pluhar. Indianapolis: Hackett Publishing Co., 1987.

Kaprow, Allan. *Assemblage, Environments, and Happenings.* New York: H. N. Abrams, 1966.

Karafyllis, Nicole C. "Endogenous Design of Biofacts: Tissues and Networks in Bio Art and Life Science." In *Sk-Interfaces: Exploding Borders—Creating Membranes in Art, Technology, and Society,* edited by Jens Hauser, 43–58. Liverpool: FACT and Liverpool University Press, 2008.

Kay, Lily E. *Who Wrote the Book of Life? A History of the Genetic Code.* Palo Alto, CA: Stanford University Press, 2000.

Kennedy, Randy. "The Artists in the Hazmat Suits." *New York Times,* 3 July 2005, sec. Arts. I.

Kevles, Daniel J. "Patents, Protections, and Privileges: The Establishment of Intellectual Property in Animals and Plants." *Isis* 89 (2007): 323–31.

Kittler, Friedrich A. *Gramophone, Film, Typewriter.* Palo Alto, CA: Stanford University Press, 1999.

———. "The History of Communication Media." *cTheory.net* (1996). http://www.ctheory.net/articles.aspx?id=45 (accessed 1 November 2008).

———. *Literature, Media, Information Systems: Essays*. Edited by John Johnston. Amsterdam: G+B Arts International, 1997.

Kloppenburg, Jack R., Jr. *First the Seed: The Political Economy of Plant Biotechnology*. 2nd ed. Madison: University of Wisconsin Press, 2004.

Kohler, Robert E. *Lords of the Fly: Drosophila Genetics and the Experimental Life*. Chicago: University of Chicago Press, 1994.

Krauss, Rosalind E. "Reinventing the Medium." *Critical Inquiry* 25, no. 2 (1999): 289–305.

———. *"A Voyage on the North Sea": Art in the Age of the Post-Medium Condition*. New York: Thames and Hudson, 2000.

Lacoue-Labarthe, Philippe, and Jean-Luc Nancy. *The Literary Absolute: The Theory of Literature in German Romanticism*. Albany: State University of New York Press, 1988.

Lamarck, Jean-Baptiste. *Hydrogeology*. Translated by Albert V. Carozzi. Champaign: University of Illinois Press, 1964.

———. *Zoological Philosophy: An Exposition with Regard to the Natural History of Animals*. Translated by Hugh Samuel Roger Elliot. Chicago: University of Chicago Press, 1984.

Landecker, Hannah. *Culturing Life: How Cells Became Technologies*. Cambridge, MA: Harvard University Press, 2007.

Larkin, Brian. *Signal and Noise: Media, Infrastructure, and Urban Culture in Nigeria*. Durham, NC: Duke University Press, 2008.

Lippard, Lucy R. *Six Years: The Dematerialization of the Art Object from 1966 to 1972*. Berkeley and Los Angeles: University of California Press, 1997.

Liu, Alan. *The Laws of Cool: Knowledge Work and the Culture of Information*. Chicago: University of Chicago Press, 2004.

Mackenzie, Adrian. *Transductions: Bodies and Machines at Speed*. New York: Continuum, 2002.

Manovich, Lev. *The Language of New Media*. Cambridge, MA: MIT Press, 2001.

———. "Old Media as New Media: Cinema." In *The New Media Book,* edited by Dan Harries, 209–18. London: BFI Publishing, 2002.

Margulis, Lynn, and Dorion Sagan. *What Is Life?* Berkeley and Los Angeles: University of California Press, 1995.

Marvin, Carolyn. *When Old Technologies Were New: Thinking about Electric Communication in the Late Nineteenth Century*. New York: Oxford University Press, 1988.

Massumi, Brian. *Parables for the Virtual: Movement, Affect, Sensation*. Durham, NC: Duke University Press, 2002.

Mattelart, Armand. *The Invention of Communication*. Translated by Susan Emanuel. Minneapolis: University of Minnesota Press, 1996.

McElheny, Victor K. "An Industrial 'Innovation Crisis' Is Decried at M.I.T. Symposium." *New York Times*, 10 December 1976, 85.

McLuhan, Marshall. *The Gutenberg Galaxy: The Making of Typographic Man*. Toronto:

University of Toronto Press, 1962.

Miller, Geoffrey F. *The Mating Mind: How Sexual Choice Shaped the Evolution of Human Nature*. New York: Doubleday, 2000.

Mitchell, Robert. "Sacrifice, Individuation, and the Economics of Genomics." *Literature and Medicine* 26, no. 1 (2007): 126–58.

Mitchell, Robert, Helen Burgess, and Phillip Thurtle. *Biofutures: Owning Body Parts and Information*. Philadelphia: University of Pennsylvania Press, 2008.

Mitchell, Robert, and Phillip Thurtle, eds. *Data Made Flesh: Embodying Information*. New York: Routledge, 2004.

Mitchell, W. J. Thomas. *What Do Pictures Want? The Lives and Loves of Images*. Chicago: University of Chicago Press, 2005.

Munster, Anna. "Bioaesthetics as Bioethics." In *Art in the Biotech Era*, edited by Melentie Pandilovski, 14–21. Adelaide, SA: Experimental Art Foundation, 2008.

Nadarajan, Gunalan. "Ornamental Biotechnology and Parergonal Aesthetics." In *Signs of Life: Bio Art and Beyond*, edited by Eduardo Kac, 43–55. Cambridge, MA: MIT Press, 2007.

Newton, Isaac. *Optical Lectures Read in the Publick Schools of the University of Cambridge*. London: printed for Francis Fayram, 1728.

"On with the Show: Why Scientists Should Support an Artist in Trouble." *Nature* 429, no. 6993 (2004): 685.

Pandilovski, Melentie, ed. *Art in the Biotech Era*. Adelaide, SA: Experimental Art Foundation, 2008.

Pinker, Steven. *How the Mind Works*. New York: Norton, 1997.

Rai, Arti K., and Rebecca S. Eisenberg. "Bayh-Dole Reform and the Progress of Biomedicine." *Law and Contemporary Problems* 66, no. 1 (2003): 1–38.

Rees, Jane. "Cultures in the Capital." *Nature* 451 (2008): 891.

Reill, Peter Hanns. *Vitalizing Nature in the Enlightenment*. Berkeley and Los Angeles: University of California Press, 2005.

Rheinberger, Hans-Jörg. "Experiment, Difference, and Writing: I. Tracing Protein Synthesis." *Studies in the History and Philosophy of Science* 23, no. 2 (1992): 305–31.

Rifkin, Jeremy. "Dazzled by the Science." *Guardian*, 14 January 2003.

Rodriguez, Victor. "Merton and Ziman's Modes of Science: The Case of Biological and Similar Material Transfer Agreements." *Science and Public Policy* 34, no. 5 (2007): 355–63.

Rogers, John. *The Matter of Revolution: Science, Poetry, and Politics in the Age of Milton*. Ithaca, NY: Cornell University Press, 1996.

Saumarez, Richard. *A New System of Physiology, Comprehending the Laws by Which Animated Beings in General, and the Human Species in Particular, Are Governed, in Their Several States of Health and Disease*. 2nd ed. 2 vols. London: sold by J. Johnson, 1799.

Sconce, Jeffrey. *Haunted Media: Electronic Presence from Telegraphy to Television*. Durham, NC: Duke University Press, 2000.

Simondon, Gilbert. "The Genesis of the Individual." Translated by Mark Cohen and

Sanford Kwinter. In *Incorporations,* edited by Jonathan Crary and Sanford Kwinter, 297–319. New York: Zone Books, 1992.

———. *L'individuation à la lumière des notions de forme et d'information.* Paris: Presses Universitaires de France, 1964.

Smith, Adam. *An Inquiry into the Nature and Causes of the Wealth of Nations.* Edited by R. H. Campbell and A. S. Skinner. 2 vols. Glasgow Edition of the Works and Correspondence of Adam Smith. Indianapolis, IN: Liberty Fund, 1981.

Solini, Patricia, Jens Hauser, and Vilém Flusser. *L'art biotech.* Nantes: Filigranes Editions, 2003.

Squier, Susan M. "Life and Death at Strangeways: The Tissue-Culture Point of View." In *Biotechnology and Culture: Bodies, Anxieties, Ethics,* edited by Paul E. Brodwin, 27–52. Indianapolis: Indiana University Press, 2000.

Steichen, Edward. "Delphinium, Delphinium, and More Delphinium!" *Garden,* March 1949.

Stevens, Ashley J. "The Enactment of Bayh-Dole." *Journal of Technology Transfer* 29 (2004): 93–99.

Stevens, Jacqueline. "Biotech Patronage and the Making of Homo DNA." In *Tactical Biopolitics: Art, Activism, and Technoscience,* edited by Beatriz da Costa and Kavita Philip, 43–61. Cambridge, MA: MIT Press, 2008.

Stocker, Gerfried, and Christine Schöpf. *LifeScience (Ars Electronica 1999).* New York: Springer, 1999.

Sullivan, Walter. "Loss of Innovation in Technology Is Debated." *New York Times,* 25 November 1976, 44.

Thacker, Eugene. *Biomedia.* Minneapolis: University of Minnesota Press, 2004.

———. *The Global Genome: Biotechnology, Politics, and Culture.* Cambridge, MA: MIT Press, 2005.

Thurtle, Phillip. *The Emergence of Genetic Rationality: Space, Time, and Information in American Biological Science, 1870–1920.* Seattle: University of Washington Press, 2007.

Waldby, Catherine, and Robert Mitchell. *Tissue Economies: Blood, Organs, and Cell Lines in Late Capitalism.* Durham, NC: Duke University Press, 2006.

Wardrip-Fruin, Noah, and Nick Montfort, eds. *The New Media Reader.* Cambridge, MA: MIT Press, 2003.

Wegenstein, Bernadette. "If You Won't Shoot Me, at Least Delete Me! Performance Art from 1960s Wounds to 1990s Extensions." In *Data Made Flesh: Embodying Information,* edited by Robert Mitchell and Phillip Thurtle, 201–28. New York: Routledge, 2004.

Wilson, Edward O. *Consilience: The Unity of Knowledge.* New York: Knopf, 1998.

Wilson, Stephen. *Information Arts: Intersections of Art, Science, and Technology.* Cambridge, MA: MIT Press, 2002.

Index

Page numbers in italics refer to figures.